NORTHUMBERLAND
VIEWPOINTS

NORTHUMBERLAND VIEWPOINTS

STAN BECKENSALL

AMBERLEY

First published 2010

Amberley Publishing
Cirencester Road, Chalford,
Stroud, Gloucestershire, GL6 8PE

www.amberley-books.com

British Library Cataloguing in Publication Data.
A catalogue record for this book is available from the British Library.

ISBN 978-1-84868-860-5

Typesetting and origination by Amberley Publishing
Printed in Great Britain

CONTENTS

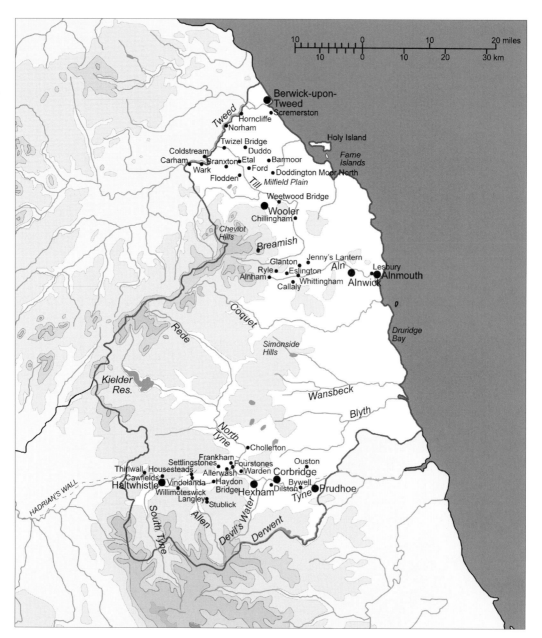

Some of the places named in the book. (*Marc Johnstone*)

INTRODUCTION

Viewing a landscape from above, either from aircraft or from the tops or slopes of hills, enables us to see beyond one small spot, and to place everything in a wider context. Intimate knowledge of a site, whether it be a small house or large estate, provides us with the fine detail that may arouse our interest in the first place. Combining this exploration with the wider and higher viewpoints is the way this book is arranged – a celebration of Northumberland's rich landscapes and history.

I have considered many ways of presenting these perspectives, the results of many, many visits, research, photographs and flying, under possible thematic headings (such as geology, industries, buildings, communications), but have decided to deal with specific areas of the county where all the themes, or most of them, combine naturally. On the whole, I have tried to avoid writing again about some of the areas I have already covered in many other works, although there is bound to be an overlap.

Each area is chosen to represent the many-layered histories and landscapes of the county. I have included the meaning of many field and place-names, because this important aspect of our history is too often ignored.

Northumberland seems to divide itself into two major influences: its countryside and its heavily urbanised areas. The latter are the result of heavy industry, fed by a rapid growth in population in what are recent times. The basic industry throughout history has been, and still remains, agriculture, on which the structure of most towns and villages has been built, forming on the whole self-sufficient groups in terms of occupations that cater for many needs, from which it was not necessary for people to travel far. The rhythm of the seasons, the great amount of labour needed to make the land productive, and the need to live in one place have been important factors in people's way of life. The limitations of transport have contributed to this settled way of life.

'Settled' up to a point, for the nature of the English-Scottish Border, of warfare and raids, have been anything but settling influences, and the need to drive cattle to distant markets, giving an experience of other parts and other people, the call to go to war, and the need sometimes to seek work elsewhere, even temporarily, have widened horizons in different ways. The nature of the county, its varied scenery and resources, has ensured that not every place or way of life has been or is the same.

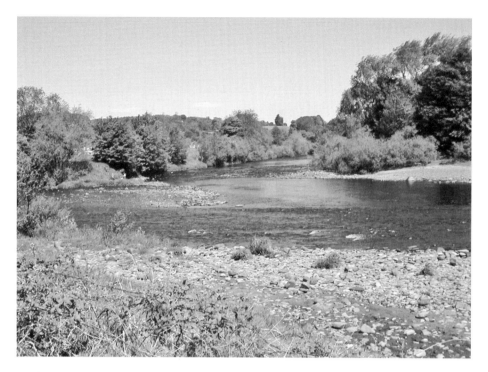

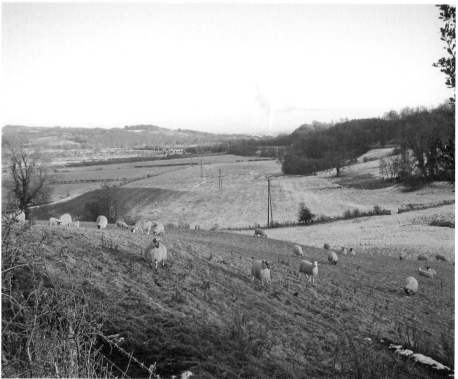

Top: 1a. Meeting of the Waters: the North and South Tyne rivers meet near Warden.
Bottom: 1b. The south bank of the Tyne looking further east towards Hexham.

1

THE SOUTH TYNE VALLEY

THE BROAD PICTURE

The River South Tyne, flowing east for all but its early stages, is joined by the North Tyne, and flows out to sea via the built-up areas of Tyneside.

Many people associate its course, naturally, with the Hadrian's Wall 'corridor', which the Romans regarded as a buffer zone between their civilisation and the land of the *Brittunculi* – the savage Brits to the north. Completely mistaken by some in our day as the modern national boundary between England and Scotland, this concept avoids historical fact, as much of that boundary lies along the River Tweed. The Wall frontier, now a World Heritage site, attracts thousands of visitors, many of whom choose to walk the length of it by defined routes through varied country and weather. Although modern tourism has chosen largely to depict this attraction with ferocious soldiery, the military side of the occupation is only part of the story, as we see, for example, south of the wall at the Vindolanda settlement, where so much of everyday life has been unearthed by skilled excavation. The same distortion of emphasis on what happened in history is also evident at Holy Island, that extraordinary cradle of English Christianity and learning, by concentrating recently on the Viking hordes which sacked it.

The frontier was in a sense an admission of failure to subjugate the whole of Britain, and says, 'Empire stops here'. It remained firm as such, through periods of rebuilding, using local and recycled material. After the legions departed, life continued for the local people, the history of the period vague, until the Wall and its buildings became a convenient quarry for dressed and decorated stone that is still found in buildings along its course. Some parts gradually became covered over, but upstanding buildings were recycled for hundreds of years, to find their way into churches – especially the crypt of Hexham Abbey, where in the seventh century St Wilfrid had his magnificent building supported largely by masonry taken from nearby Coria (Corbridge). It still remains to be seen, and so do Roman stones in churches along the Tyne such as Warden, Corbridge, Bywell and Ovingham. One dramatic use of the Wall was by the English government in the early eighteenth century when they used its masonry, its foundations and its course to construct a road that ran east to west to enable troops to move more effectively to deal with further Jacobite rebellions after the failed one in 1715. By that time the hundreds of fortified farms, houses and castles in Northumberland,

a sure sign of a disturbed frontier region bordering Scotland, built with the help of Roman stone the closer they are to the Wall, were in decline once England and Scotland were united under James I. People wanted to live in something more comfortable than a draughty tower or castle. All these changes can be seen, some signs more subtle than others.

Rivers are important for all kinds of reasons, whether they are used for fishing, for enabling people to penetrate inland from the coast, or as barriers to be crossed at fords, by road and railways, bridges and viaducts. The Tyne cuts through land that is not only good for agriculture, but is rich in minerals, the basis of many industries. Lead, witherite, coal, and lime are some that have been exploited, and although now abandoned, their sites still have a story to tell. There is also good natural roadstone, sandstone and slabs for building. Agriculture has always been the mainstay of life, however, no matter what changes take place in the rise and fall of other industries.

The River Tyne does not dry up, for it is fed by hundreds of streams from surrounding hill country. However, it floods. It has one of the earliest documented names, *Tinea* in 700, and *Tinan* in 1000. It is pre-English and means 'to melt, to flow'.

Defence and aggression are very much part of our island's story, none more so than in the Border region. Everywhere there are prehistoric earthworks, not necessarily needed for defence all the time, but also providing enclosures for meetings and the control of animals. They have long histories, as a good defensive site remains so. Today they are grown over, some have been destroyed by modern farming, but there are surprisingly many enclosures left. Later military works are much more in evidence, with the Romans adding their unique geometry of order and strength, and the Normans establishing their castles to keep the local people in subservience. In the thirteenth century the particular threat of Scottish invasion was equalled by smaller-scale warfare and thievery which kept parts of the Border seething and life very precarious. We see the strings of castles and towers along the river, such as Thirlwall, Featherstone, Blenkinsopp, Haughton, the Moothall at Hexham, Bywell, and Prudhoe. Their survival has relied, in some cases, on an alternative use being found for them, such as homes, businesses or museums.

The Wall passes through some of the finest walking country and scenery in the county, a mixture that includes the flat alluvial plains (called 'haughs') and gravel terraces left by ice sheets, that lie on either side of the river. The carboniferous rocks – limestone, sandstone, millstone grit, shale, clay and the minerals within

Roman Wall corridor scenery. (*See also* Plate 3)
Opposite, top: 2a. East of Steel Rigg.
Opposite, middle: 2b. Crag Lough.
Opposite, bottom: 2c. West towards Cawfields.

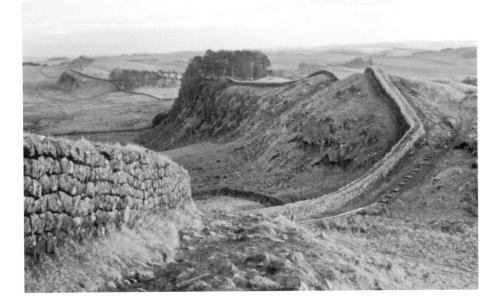

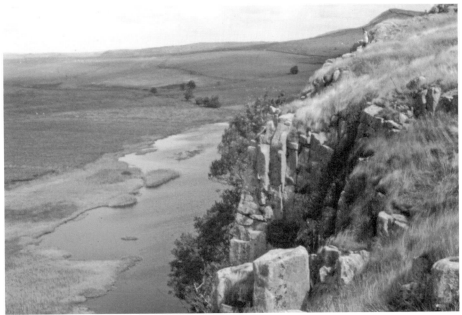

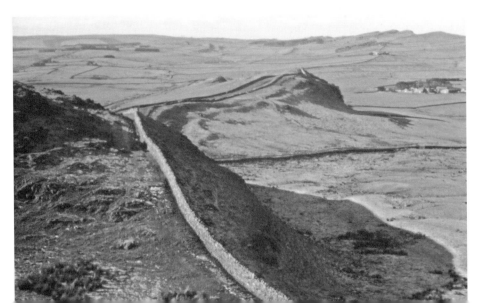

them – provide layers of undulating deposits, broken in places by faults and by the intrusion of the strongly visible 'sill' of whinstone on which much of the Wall runs. This hard volcanic rock, now providing material for road-building, crops up all over the county; where it is most concentrated, such as here and at Bamburgh, it creates a unique landscape.

The many smaller rivers and streams that feed into the Tyne have their own individuality and charm, such as the Allen valleys or the smaller Devil's Water. Too often, the origin and meaning of names is neglected, yet they are such a vital part of our history. Just to take some of the names I have already mentioned, Thirlwall is a gap in the wall, Devil's Water is a black stream, Allen means to flow; a prehistoric cromlech (part of a burial chamber) may account for Featherstone, Blenkinsopp takes its name from an otherwise unknown Saxon called Blenkin, Haltwhistle is a place where streams join by a hill, Bywell is a spring at the bend of a river, and Prudhoe is Pruda's projecting ridge. These are just a few of those which lie in the area; the field names are even more numerous, and many still remain to be recorded and to be explained, if possible. These, in the area under discussion, would take a book in itself.

The rivers are channels along which people can travel, but there has been a greater reliance on the roads and railways that gradually replaced the drove roads (for the movement of beasts) and primitive trackways. It is so clear within this corridor that many fine railway lines have been abandoned, and we see impressive structures such as the Lambley viaduct preserved as a tribute to the age of steam.

The huge industrial changes of the late eighteenth century onwards exploited mineral wealth and attracted people from the rural areas to towns along the coast. All such changes were dependent on a more efficient transport system which this area gave to the world, such as the steam locomotive and railways that link Newcastle to Carlisle, its modern descendants still following the same route. Other lines have gone out of use, although, in the case of Langley, the station serves as a garden centre on the old South Tynedale line – one example of re-use.

History, of course is about people, and many generations have made their impact on the Tyne valley from prehistoric times to the present, providing examples of the ways in which people have adapted to, and used, whatever is available to enable them to survive and, if they are lucky, to produce a surplus that can give their lives an added quality. It is only recently that self-sufficiency of communities has broken down, when they used not to have to move far to have the basic necessities of life.

PREHISTORY

There are some quite obvious remains of the prehistoric past, but there are also minute traces of people's presence that require some skill and dedication to seek out. For people who relied largely on hunting and gathering food without having

the use of more recent agricultural technology, the river valley was a great asset. From settlements on the coast, people living here about 8,000 years ago would have used the river course to move into the interior in the spring to hunt and fish, living in flimsy shelters that might have to be carried to suit their nomadic life. There would have been more woodland, and wild edible plants. Clearings could be made with fire to encourage growth within the spaces created, perhaps for the following season. The valley slopes, especially those facing south, would have been warm and close to the river, and it is here where we find the flints knapped by 'Middle Stone Age' people, especially the tiny blades broken skilfully from a core for use as arrow tips and barbs. Flint remained crucial to prehistoric technology, for a lump could produce many blades, saws, scrapers and axes that enabled them to kill and skin animals and use all parts of the carcasses for clothing and tents. It is likely that many of these sites have not been recognised as the traces are so small, but there are two such, for example, at Warden Hill and Whittle Dene which have been quite well investigated. On the former, my first encounter with their tools was through rabbit burrows and mole hills, but most are found by systematic walking after ploughing or harvesting. It is difficult to comprehend the extent to which people lived in this valley and what they were like from such scanty evidence and from the sheer length of time since they were here, but they are our earliest people, living at the end of the Ice Age when a land bridge still united Britain to the Continent.

With the coming of serious cultivation of crops through ploughing and sowing, and improved methods of rearing and looking after stock, there is a different emphasis: people became more rooted to settlements and places in fertile areas, still using less productive, higher ground for their hunting and pasturing, and in this more secure environment population increased a little and skills such as the making of pottery and tools developed. It was still called 'The Stone Age' because it saw the development of uses of flint, quartz and other stones. There have been many finds of these tools and weapons throughout the valley, which archaeologists have been able to date and to trace their development. The knapping techniques and shapes are remarkably uniform throughout Britain, as are their pottery styles. Where the implements, ornaments and pottery are buried with the dead, we are able now to date them from the burials and cremations.

The discovery of metal-working, beginning with copper, bronze, and, later, iron, have given them the names Bronze Ages and Iron Age. These metal-users were the ones encountered by the Romans in their invasion and eventual settlement. Unlike the Roman, the basic early house was circular. So were other important pre-Roman structures such as enclosures for animals, small villages and religious centres. Even their burial mounds were circular. It was a tribal, metal-using society with a developed and successful farming system that the Romans encountered and defeated. Land, however, varies considerably in quality. The fertile tracts of alluvial soil on either side of the rivers still produce an impressive grain yield, but our area includes bleak upland areas of poor soil that are not much good for

farming. They did, however, have minerals that could be extracted, a process that was to intensify as time passed.

The evidence of people living in the Wall corridor before the Romans occupied it and after is sparse, but there is one small settlement on the line of the Wall at Milking Gap near Housesteads which is 'native' and still to be seen. Built of stone, it has a large hut at the centre of an enclosure, outside which five other circular huts were added.

In prehistory we are looking at thousands of years of history before the Romans came, in which people learned to use the natural resources on offer to survive. As fields and woodlands are used over and over again, one generation can obliterate the traces of another, so that there may be great gaps in our knowledge.

BURIALS

One sure fact is that people die, and that some of their burials survive. About 4,000 years ago it was common practice to cover burials with mounds of earth or stone. Many have been cleared away and flattened by farming, but occasionally a survival is discovered by accident or design.

The earliest type of burial is the 'long barrow', which usually contains many burials. Some had stones and earth piled over a 'cromlech' burial chamber, a large slab like a table top supported by three uprights. This may account for the meaning of 'Featherstone'. Warden Hill has a large, long mound that may yet prove to be a long barrow, but it has not been sufficiently excavated, although it is unlikely to be natural. Its position dominates a view of the Tyne from a ledge on the hill slope, and as flints from the Middle Stone Age surround it and occur in other fields nearby, and as there are terraces, a large pre-Roman enclosure and as yet unidentified earthworks on Warden Hill, the area was obviously well-used before the coming of the Romans.

Later a body could be buried ('inhumed') or cremated, put into a cist (a stone-lined box in a pit), then covered with a pile of stones. A good example is that of a cist burial on a gravel knoll above the north bank of the River Tyne at Allerwash, where a young woman's body was placed in a cist on a bed of rushes, accompanied by a bronze dagger that had three rivets to fix it to its handle. The knife was similar to one found nearby at Haydon Bridge and is very distinctive. The burial, made up of four slabs of sandstone sealed with clay, was discovered by accident, but it was excavated professionally in 1973.

Further east at West Wharmley, an adult was buried in a similar cist with a Beaker.

Further along the river, a cemetery of burials was sited just above the junction of the Rivers North and South Tyne (known locally as The Meeting of the Waters), at Howford Lane. Again, the 'grave goods' included a fine pot, dated to about 4,000 years ago, although much of the contents were unfortunately dispersed

(a local dentist having been given some of the teeth and some of the cist slabs landing up in a garden in Hexham). Three cists were recorded in 1947 and 1950 in a cluster, and this led to further enquiries that resulted in the reporting of two graves discovered on the banks of North Tyne during the building of the Border Counties railway. A skull and a number of bones and clay pot had been buried, and yet another had a crouched skeleton with an urn 'of uncommon type'. These were unearthed in 1856. There is yet another record of empty twin cists in the same area, so it looks as though the 'meeting of the waters' was a special place in the landscape about 4,000 years ago.

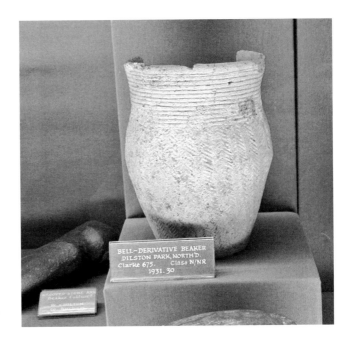

3. Prehistoric grave goods: an Early Bronze Age Beaker from Dilston Haughs.

Usually, recent uncovering of graves has had the advantage of professional treatment, but in the nineteenth century, especially when people were searching for artefacts and treasure, it was only pots, tools and ornaments that were saved. Thus, the contents of some graves found on the Dilston haughs found their way to the Museum of Antiquities, Newcastle, a nice collection of the pottery being made in the late Neolithic/early Bronze Age period (c. 4,000 years ago). There were three cists with an inhumation, a cremated adolescent with three Beakers in one cist, and another cremation with two Beakers. There were many others found in the corridor, with plenty of examples from Barrasford, Gunnerton, Colwell, Chollerford, and Corbridge. At Swinburne a jet necklace was found in a cist under a mound. There is no simple answer to the question of why 'grave goods' were buried with the dead. It is plausible that they may need them in the afterlife, but might it not also be because no one could bear to inherit such things? Among

the objects are those like knives, arrows and scrapers which were essential to their lives, items of jewellery being rare. The jet in a necklace would have been brought from the Whitby area of Yorkshire in exchange for something else, such as animal skins or high-quality tools. These people were not static, and such is the extent of trade that desirable polished stone axes quarried at the Pike O' Stickle in Cumbria are found not only in Northumberland, but in Ireland and Europe. A particularly fine example was found at Great Whittington, just north of the Wall, among scattered stone in a field. This is how many discoveries are made, and fine arrowheads may well have been lost during a hunting trip. This is not the same as a site where the flint flakes are scattered around in a concentration, as this would have been the place where the work of shaping them was carried out. Some of the best flint would have been imported, too.

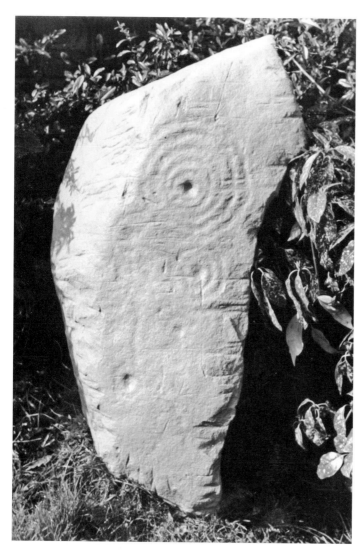

4. St John Lee decorated prehistoric stone, now in the church, near Hexham.

There are still many large and, hopefully, undisturbed mounds in the valley. One particularly interesting discovery was made at Ouston, when a mound was excavated at Pike Hill. The mound covered two cists, one of which had a 'cup-mark' on the side stone, and on the underside of the cist cover was a pattern of pecked cups linked to each other by grooves, now on display at the Great North Museum. The term given to this decoration is 'rock-art', and Northumberland is one of the finest areas in Europe for it. Elsewhere in this area there is not much rock-art, but the church of St John Lee outside Hexham has a fine example of outcrop rock decorated with complex linked circles and cups; it lay until recently under a large beech tree, and was removed to safety – where it can be seen just inside the north entrance. It has chain marks of the tractor which dragged it out of the field. The photograph is of a replica made of fibreglass.

At Corbridge Roman site there is a large boulder decorated with cups inside an almost square groove, and at Prudhoe a decorated stone with a pattern of rings was found re-used in a fourteenth-century wall of the hall during excavation.

One of the most interesting discoveries of rock-art was made at an outcrop known as Carr Hill, Frankham, just south of the Roman Wall; after I had recorded some good cup-and-ring designs there and clusters of cup-marks, a re-survey of the area located a figure of a Roman warrior god on the same outcrop. Whether the Romans had spotted the earlier decoration is conjectural, but they did place their god in a dominant position looking over an extensive landscape.

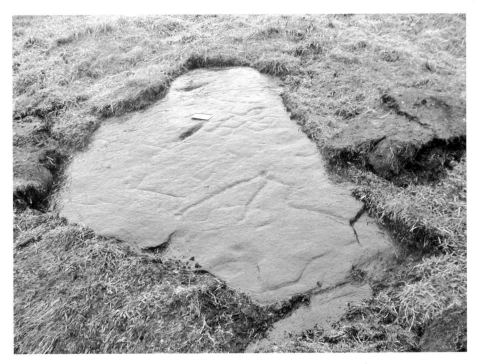

5. Frankham Fell: a Roman god and other motifs, including another human-type figure.

How people bury their dead is very important, and in very early history it paradoxically tells us much about life. It is possible that not many people were buried in such style, and many may have been left to nature out in the open; what we have left is a tiny proportion of the population.

Perhaps the best way to appreciate what survives of prehistory outside the sites themselves is to visit the Great North Museum, where among the varied objects on display are many from this corridor. They are typical of the rest of the county, although a gold 'earring' from Kirkhaugh found with a burial is very rare.

These monuments are all important to this valley; some, like prehistoric standing stones at Matfen or Inghoe, have no recorded ancient names, and we can only surmise what they meant to the people who erected them.

There are known cemeteries of the Romans in this area, but perhaps most emphasis has been placed on the memorials to dead Romans that give such an insight into where people originated, for the Roman army was recruited world-wide. Site museums like Chesters and Vindolanda are rich in such things.

The 2009 excavations at Vindolanda, for example, found a very heavy stone set in a shrine within the fort, with a thank-you from the cohort leader to Jupiter of Doliche for services rendered (see below). Elsewhere in the grounds are well-displayed replicas of tombstones. One other might be mentioned: the Flavinus memorial in Hexham Abbey, dedicated to a young standard bearer from Coria, probably brought in from that site as re-cycled building material.

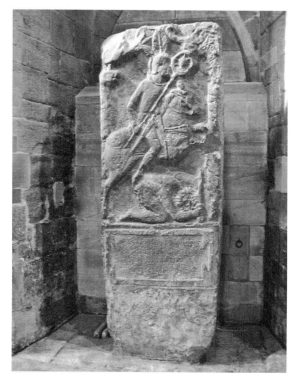

6. Flavinus: Hexham Abbey, brought from Coria.

THE ROMAN WALL

So much has been written about 'The Wall' that I hesitate to add to that literature. However, more discoveries are made each year, and some sites can be re-interpreted in the light of recent scholarship, which has produced masses of papers on all aspects of the Roman frontier, not only in Britain, but wherever the Romans established a frontier. In this corridor there are not only visible aspects of all stages of its construction, changes and logic, but also we have a unique collection of written documents excavated at Vindolanda which put the people who lived and worked there for a while at the centre of the story. As with the later Anglian place-names that cover the landscape, revealing what the settlers were called, the tablets uncover not only names that would otherwise have been unheard, but such intimate details as how many soldiers were ill in a garrison at one time, what they ate and wore, who was in charge, and what invitations their wives issued to friends for a party.

All walkers along the course of the Wall will be aware of the regularity with which the forts, milecastles, and turrets were sited. Not many buildings have survived to a very great height, but ground plans and many details of what buildings were used for are plentiful. As the Roman occupation lasted for hundreds of years, there were naturally changes and modifications according to the political and military situation. For example, the first role of the frontier posts was to house

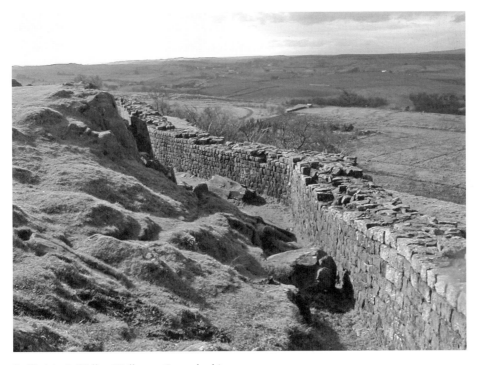

7. Hadrian's Wall at Walltown Crags, looking west.

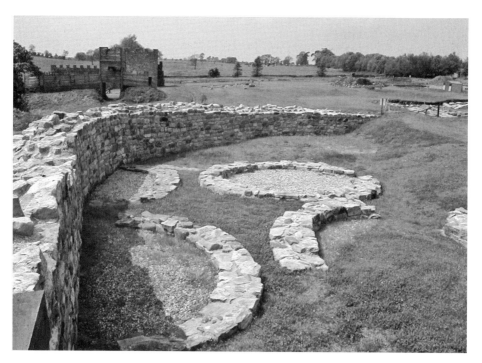

8. The Vindolanda 'rounds': earlier than the wall that overlies them.

the occupying army and their followers. At first there would have been about 30,000 troops spread over the seventy-mile-long frontier, all busily employed in building, and, no doubt, feeling some pride in their achievement as they saw the huge creation snaking up and down hills. Until accommodation was complete they would have lived in auxiliary forts. Their superiors had accepted that the far north was not to be conquered, but there were frontier posts, some in Northumberland, whose garrisons would keep an eye open for signs of danger. As there was money to be had among the legionaries and auxiliaries, people who had something to trade or sell might have set up temporary camps nearby that may have become more permanent buildings outside the fort. Although Roman engineers favoured straight lines in their plans, the locals lived in round houses, and many stone 'rounds' are uniquely incorporated into military sites at Vindolanda.

Basically, the Wall was a skin of ashlar blocks in two parallel rows filled in with stone and any other rubble and clay available. There was no shortage of sandstone in the Wall corridor here, and there was timber, coal, and limestone for making mortar. As they worked, the troops, no doubt, were fed up from time to time with the difficulties of their tasks and changed the plan. The Wall, for example, abandoned the planned wide base in some places and it was made thinner. When the regulation ditch was being cut through very hard rock west of Carrawburgh, the workers gave up and left us with a good insight into how they cut and moved rock.

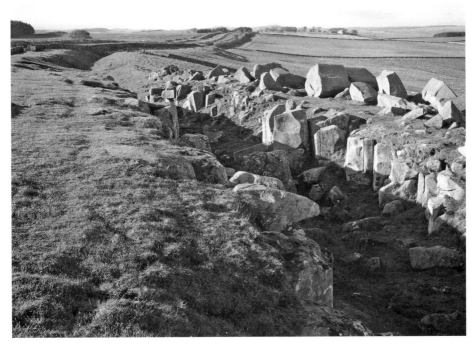

9. Limestone corner: not well-named, as the unfinished ditch cuts through basalt.

The ashlar stones were chipped into a triangular shape which was both economical in the way the biggest surface was facing outwards, and the tapered faces held the interior material together. In parts the wall didn't quite join, as different gangs had their own sections to build. Groups marked their sections, and sometimes individual stones, to show who had done what, and sometimes added a phallus for good luck. One such inscribed stone *in situ* at the quarry came from Fallowfield, north of Hexham: *Petra Flavi Carantini*, with a phallus and a local additional name, is now outside Chesters Museum.

Parts of the Wall were made of turf and wood, to be replaced by stone when practicable, but here there was material easily available. The line of the wall was well-chosen, riding the tops of the Whin Sill. The forts were the main line of attack and defence; built to contain infantry and cavalry, they were garrisons from which the armies could surge out to meet an enemy, using their tactics of locked shields, javelin-throwing, and hand-to-hand combat with short stabbing swords, tactics rehearsed over and over again. In the forts, the troops drew rations, cooked their food, looked after their equipment, used the well-ordered lavatories and bath houses, and no doubt gambled away some of their pay. It was policy to draw troops from many parts of the Roman world, and they swore allegiance to emperors and revered a selection of gods. It was a strictly hierarchical world, but at the end of twenty-five years service the troops would look forward to becoming full citizens, and perhaps settle down on a piece of land near a fort, where they could also be

called on to help defend it. Routine was, and is, an essential part of military life. This helped to focus their minds. Loyalty was vital, and rival emperors at a later stage in Rome's history knew well the value of giving financial rewards for loyalty.

Because we are looking at such a vast time-span for this occupation, it is impossible to generalise and make each period the same. Although the vallum – ditches and linear mounds behind the wall – is still spectacular today, in parts like tram lines running across country, not all the work was so well thought of when parts of the ditches were filled in to allow traffic to pass over them. It remained a demarked military zone, but not much of a barrier.

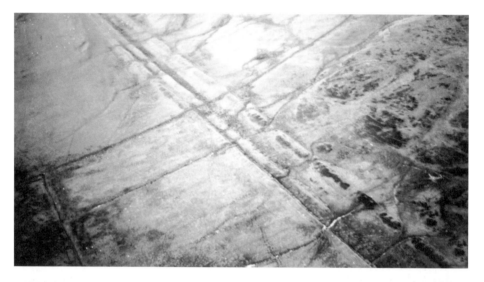

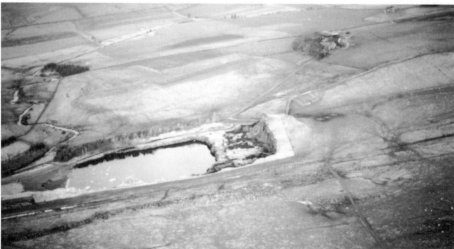

The vallum at Cawfields.

Top: 10a. The vallum, running from west to east (left to right) looks like a train line here.

Bottom: 10b. Cawfields quarry is water-filled, with the vallum nearer the camera.

The same is true of the Wall, which was not built to keep the enemy out at every point, but to give a wide view over the landscape, to control traffic coming through it both ways (for taxes?). The real strength was the ability to spot trouble coming and to ensure that the right amount of force was hurled against it, whether from a milecastle or a fort.

Many of the forts show a change in plan on the inside. At first there were rows of barrack blocks with the officers' quarters at one end. These were rectangular, with doors opening on to a narrow passage. Later some of these were modified to make way for family homes. Remember that the troops were not fighting all the time, and that their forts became more like towns. There was a special area for parades and the orders of the day, a chapel for the sacred military standards, and the all-important strong-room from which the soldiers were paid. The commander lived in some luxury, with his own bathhouse, and suite of rooms, all with underfloor heating, and this occupied a large part of the centre of the fort. For the day, hospital facilities were good, and hygiene partly achieved by a clean water supply from springs through aqueducts, and there were many drains.

If we want to know more about life on the frontier, we go to Vindolanda, to supplement what was already known from many other sites. Here discoveries are being made every year, and we are told that there are about 100 years of excavation to go. The site is not on the Wall, but is on an earlier frontier marked

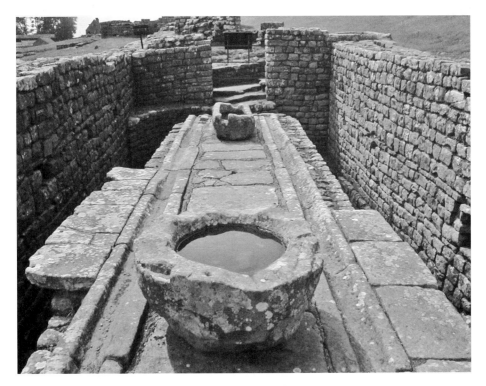

11. The famous, much-admired latrine at Housesteads fort.

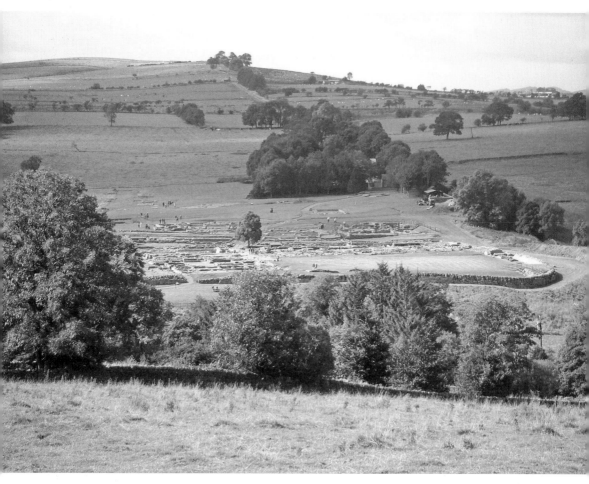

12. Vindolanda from the east in 2009.

by the Stanegate south of it, still traceable in the road that leads from Fourstones on the east, and to the north of the Vindolanda forts, although there is no evidence yet that it had a fort in the earliest period. What we can best appreciate today may be from high ground to the east, looking down on a visible complex of stone building bases, the latest in a series of occupations of the site.

Archaeologists always have a problem of what to display to the public on a site like this, and the more layers of occupation there are, the more difficult the decisions become. So the most important factor is the recording of every stage of excavation, and its publication. What makes Vindolanda so difficult and fascinating is the fact that it has what Robin Birley describes as 'a wooden underworld'. The Roman army, when abandoning a fort, used to demolish it and flatten the site before building a new fort on top. They did this so many times that the earliest remains are revealed in very deep, waterlogged trenches; a nightmare for the diggers, but a godsend for what they reveal.

The peculiar conditions that have led to the arrest of decay means that objects that normally rot away and disappear are preserved, so that in the museum there we can see more leather objects than anywhere on the rest of the Roman frontier. Hair, bones, plants in abundance provide a field day for those studying the past environment. The writing tablets, rightly named by the British Museum as a national treasure, give details about frontier life as never before. Interestingly, the excavations are entirely privately financed, and perhaps the most important on-going excavations in Britain. The Trust aims at sharing everything with the people who visit, and not just the remarkable finds of pottery, jewellery, tools, and hundreds of other accoutrements of life there, but also the diggers welcome and explain to visitors what is going on.

The occupation layers are sometimes confined to a small area, and the equal importance of what comes later may only allow a glimpse of an earlier period. Interpreting this is mind-boggling. Sometimes, at places like Coria, the evidence of filled-in ditches is visible in what remains to be seen: walls that dip erratically because there are ditches below.

During excavation here the whole process of levelling, sinking and rebuilding has been visible throughout. Wattle walls have appeared, gateways, and early roads, but the most exciting discoveries came from the third timber fort by the Ninth Cohort of Batavians, for it was here where most of the writing tablets were found. Their survival was miraculous, as they were supposed to be burned on a

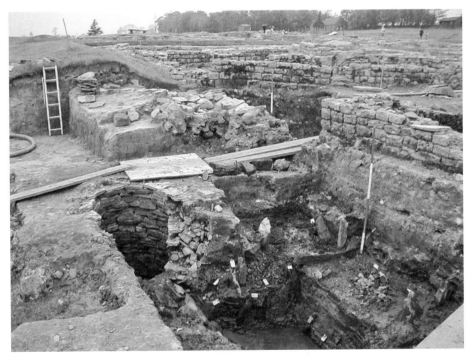

13. The depth of deposits, including preserved timber, at Vindolanda during excavation.

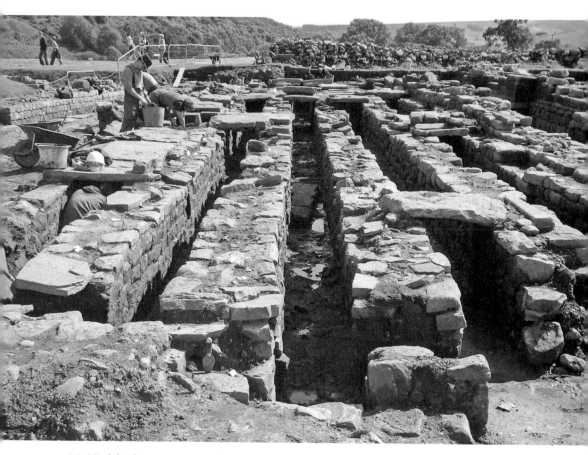

14. Vindolanda excavations in the south-west corner of the fort.

bonfire when that fort was abandoned when the troops were ordered to Dacia, but the fire went out! Perhaps it rained. The tools, textiles, pottery, and even a wig have survived. It was like Aladdin's cave, but much more interesting.

After that came timber forts numbers four and five, with more exciting finds, taking the history up to c. AD 128. So we see that this site was well-used long before the decision was made to build the Wall.

My life in archaeology (unpaid and uninstitutional) has been primarily in prehistory, but as I live within easy reach of Vindolanda I have been able to follow its progress, sometimes taking part. Unlike prehistoric sites, where one may excavate for weeks and find only structures, this excavation constantly produces finds that will maintain the keenness of diggers and spectators alike. In 2009 the north-west quarter of the latest fort was excavated, filled with barrack blocks, small roads, and a unique shrine.

This followed work on the south-west quarter, where two large storehouses, one a granary like those at Corbridge, were revealed, with hundreds of small bones beneath still to be analysed. This is so essential now to a fuller understanding of the

environment then, whereas in the past the emphasis was on chasing wall outlines and finding things for museums; this is the way archaeology has progressed, and is no criticism of early excavations. What we see now on the surface is the latest of Roman uses of that site. At one stage, it was thought that the settlement outside the fort walls was a *vicus*, ('extramural') for civilians, along with its bathhouse, but further work shows that some of the civilian-type houses are built on the Severan fort, which extends over a considerable area of the site.

Before the stone buildings, there were five timber forts, and much is known about them, but the history of the rest of the second century becomes vaguer with what are known as periods VIa and VIb up to about 205, the pre-Severan period which built in stone, the famous bath house to the west of the fort being one example. Much of what can be seen now is the Severan fort, even where the civilian buildings cap it. What used to be thought of as the *mansio*, or inn for travellers, proved to be built on the CO's residence, for example. A unique feature of this period was the discovery of what must have been about 200 round houses of the type that Iron Age and later 'Romano-British' people lived in – but not within Roman settlements.

There are several plausible reasons for what they were, but I leave these to others to explain. We do know that the Fourth Cohort of Gauls (from France) was garrisoned there, and that one of its prefects was Sulpicius Pudens. This is a good point on which to leave Vindolanda in my narrative, as I saw *in situ* the huge altar stone erected by

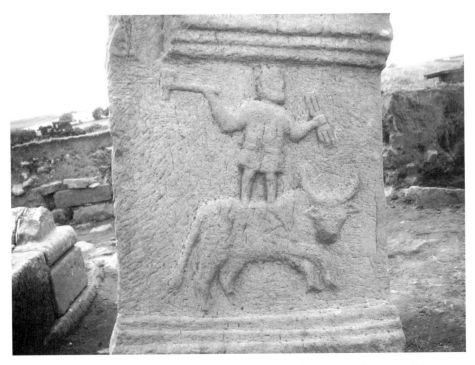

15. The 2009 discovery of the Vindolanda shrine by the north fort wall: Jupiter Dolichenus.

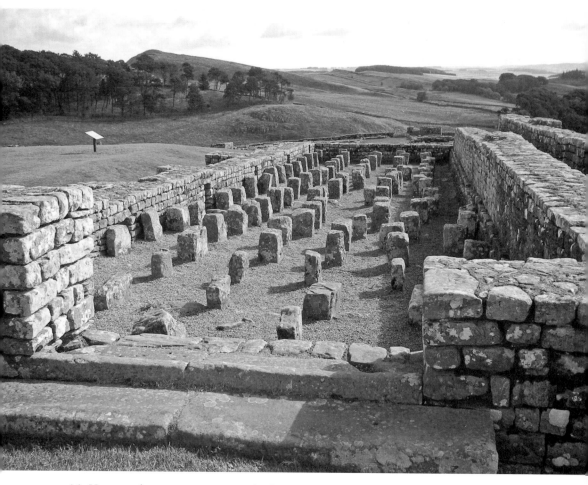

16. Housesteads: panorama east over the Granary.

him in a shrine cut into the north-west part of the fort wall. Facing south was a bull, sideways, but with its head towards us, with ears, bulging eyes, and a human standing on its back with an axe in one hand and thunderbolts in the other. The dedication in translation reads: *To Jupiter Best and Greatest of Doliche Sulpicius Pudens prefect of the Fourth Cohort of Gauls fulfilled his vows gladly and deservedly.*

There is a patera carving, showing the vessel used to make offerings, on another side of the altar. What we know, then, is that here was a god, Jupiter Dolichenus, of the cult of Baal in Asia Minor, growing in popularity among soldiers in the second century, emerging at the time of the emperor Severus in the third century. It was usual to import all kinds of gods, as we see with the officers' cult god Mithras (from Persia) at the temple at Carrawburgh, adjoining the fort there on the Wall east of Vindolanda. In the same shrine area at Vindolanda was another earlier altar dedicated to the prefect of the Second Cohort of the Nervians (from France/Belgium), who was later transferred to Whitley Castle Roman fort near

Alston. Sulpicius is also named on an altar which fell from a high point on the wall in a 1949 rebuild of the medieval walls of Staward pele, a defensive tower so typical of this region.

For all this latest information I am most grateful to Andrew Birley, who made me most welcome, as usual. Readers may see why I have dwelt on this site, for it illustrates the complexity of excavation and interpretation and poses the same problems that we are faced with on other sites too. Tourists and other visitors have a whole range of sites to explore, including that superbly–sited Housesteads fort with its sweep of landscape to the north.

Vindolanda is on a plateau, snug in a valley at the confluence of streams, lying behind the Wall in a back-up position which, I imagine, was more congenial, especially in the winter.

So what happened to the vast quantities of Roman building stone?

ARCHITECTURE

There is an abundance of stone in the Northumberland Tyne valley, but when people came to use it more extensively in preference to wood, what better place to find it than in old Roman remains? There may have been something awesome for the Saxon poet who felt uneasy at the sight of the work of giants crumbling, for it reminded him of the brevity of life. 'Where are they now?' becomes a dirge. Some later invaders, the Anglians, who became settlers, lived among the ruins, and used the roads that began to grow over and went unrepaired. They had no skill to build as the Romans did, or to understand their technology.

But as new generations grew up, the building-stone available in such quantities was literally a godsend to bishops like Wilfrid of Hexham, who plundered Coria to build at least the foundations of his monastic church in the seventh century. Since then there has been a steady raid on it, so that many buildings incorporate the giveaway sign of stones cut to Roman specification, of lewis holes for hoisting them, their distinctive tooling, and their decoration. Before the Norman invasion, the Anglians used this quarry to good effect: the western arch of Corbridge church tower was brought wholesale from Coria, the pillars of Chollerton church may be Roman, Warden church tower has Saxon 'long and short' work at its corners made from Roman stone, and the glorious Saxon tower of Bywell St Michael's, as well as the nearby St Peter's, go to the same source.

Further east, Ovingham church, named after Offa, likewise has Roman material visible. It is a very high proportion of reused stone that we find in the Corridor, for these churches are close to the river. Such things, too, as Roman millstones, quernstones, statues, altars, and decorated surfaces found their way into people's houses and gardens, some being built into walls. When 'heritage' became important, this activity was restricted and forbidden by law. Roman sites were excavated, and many walls were straightened up and levelled off to make them look good.

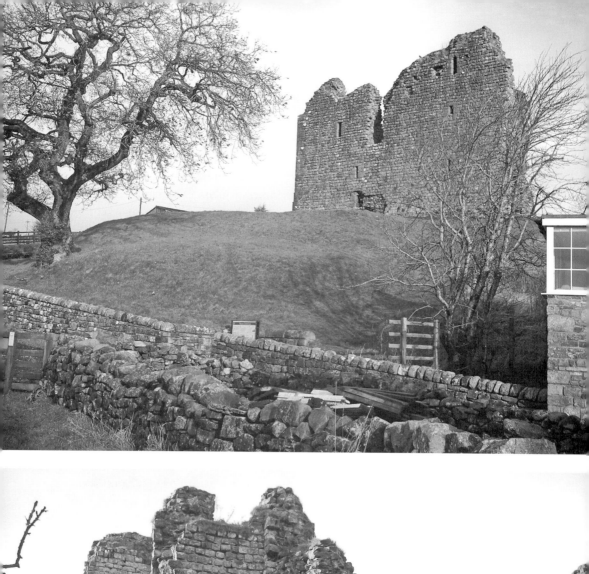

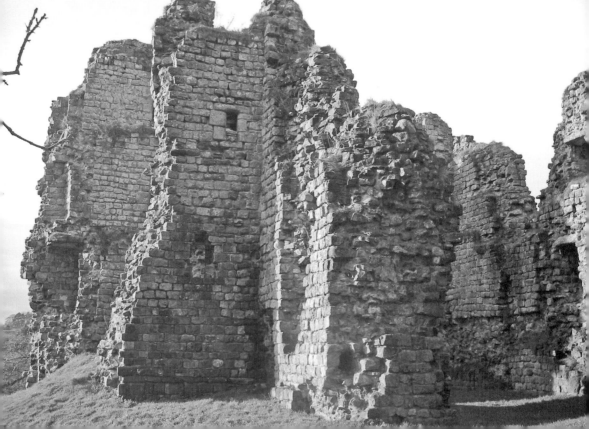

How much material went into Norman and later castle and tower building is difficult to quantify, but **Thirlwall 'castle'** is a good example of re-use of Roman stone, the Wall being very close. It is a hall-house, a rectangular block, recently restored and accessible, rather gloomy inside because of a lack of windows, and possibly dating to the early fourteenth century when Scottish raids began in earnest.

The Thirlwall family had become rich in overseas wars, and took their place there as landed gentry. A tower like this was necessary for defence, but it was also an outward and visible symbol of power, founded by John Thirlwall and kept by the family for the next 300 years. The site was a good one, as we can appreciate as we approach from the road, across the railway, for its natural mound is so obvious. Below is the Tipalt Burn, and the castle rises high above that. The large battlemented block had a staircase inside a wall, a spiral staircase, prison, cellars for storage, room to stable horses, quarters for servants on the first floor, and above that was a Great Hall for the family, bedrooms, chapel, and toilets. There is a good National Parks leaflet with illustrations by Mike Ritchie and Peter Ryder (from National Park Authority, Eastburn, South Park, Hexham, NE46 1BS).

It is not surprising that there are very few quality buildings of the 'Reiver' period, yet some churches managed to develop. Hexham Priory is a good example, although it did not escape raids and partial destruction. Medieval building is uncommon, and there is almost a total absence of decorated and Perpendicular building, whereas the Early English style of pointed or 'lancet' windows is much in evidence at Haltwhistle, Warden, Corbridge, Ovingham and the two Bywell churches. Heddon-on-the Wall shows how window tracery develops in the mid-thirteenth century.

SETTLEMENTS

Haltwhistle lies at the west end of the Northumberland Tyne valley, and what is visible there has an interesting story to tell, because it really was a frontier town where survival was a key issue.

HALTWHISTLE (*SEE* PLATES 1 AND 2)

Haltwhistle is one of the small towns in the valley that in the past was situated in the west of the Border – the more turbulent and poorer part. Its Anglian name means that it was situated on high ground overlooking the place where a stream

Thirlwall 'castle'.

Opposite, top: 17a. The approach.

Opposite, bottom: 17b. Detail of the surviving walls.

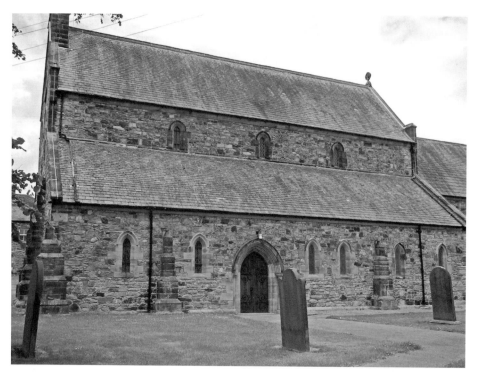

18. Haltwhistle church.

and the River Tyne joined – a good description. To the south is the fertile valley, now with small industries, and rail and road links from east to west. It lies south of the Roman Wall, rising to that frontier in ridges that are on the whole poor as arable land, but rich in minerals and stone. It is proudly thought of locally as 'the Heart of all England', which description finds its way onto one of the many inns along the street that runs through the town and small market place. Here are the oldest of the town's buildings, the almost disguised fortified 'bastle houses' typical of the Border, where security was what you could make it.

Before these fortified houses was the Church of the Holy Cross, which is below the level of the main street and faces south, with a commanding view across the river valley. It is remarkable in that, despite the usual changes centuries later, it has managed to retain much of its late twelfth-early thirteenth century character. It is the oldest building in the town, as many churches are, but speculation about what may have been there before Norman times is not useful, even though the name may pre-date the Norman Conquest. It is built of stone on a glacial boulder-clay terrace, its name first appearing in 1178, many years after the Norman Conquest. It came under the jurisdiction of Arbroath Benedictine Abbey in Scotland, and as a sign that this was a Border region where families had a foot in two national camps, William granted the monks lands in Haltwhistle towards the upkeep of their Abbey. Their masons built it, and it remained pretty intact on its original plan

until the addition of buttresses and a north vestry in the nineteenth century, for the almost square shape formed by nave and aisles is all of one period. It is quite sparse, as befits such a remote location, and has plenty of room inside. Churches were more than centres of worship, for they became the focus of all town life. Like other churches it had disputes about its ownership and use, going for example from Arbroath to Durham and Tynedale, until the great upheaval of 1553 when monasteries were dissolved and all the lands and buildings were at the mercy of Henry VIII and his men.

The rectory was built in the fifteenth century, and today it stands as 'The Old Vicarage', with few survivals of the original.

It is not easy to think of what life would have been like, except that at times it was enough just to survive, especially at the height of the troubles between England and Scotland. The Border was a buffer zone, passed through at times by armies, and at the same time a centre of conflict between the warring families of 'Names', the latter being the names adopted from the clan heads to show which side you were on, like Hall or Armstrong; local allegiances were often more important than your being Scottish or English.

There is one incredible story of what happened when people crossed the allegiance borders: the girl who was hanged in Haltwhistle market place in the late sixteenth century because she fell in love with a lad from the wrong family. I wrote the story for a local school which used it in one of its dramas. I let this represent what might have happened in such a town.

THE HANGING

They tell me useless things. The worst is, "Pull yourself together, man." Alright, we all know what death is around here. We've all had our fair share of raiding and killing. We had to, to survive. This vast open country is harsh in the uplands, it makes me feel small, frightens me sometimes, wondering where the next raid is coming from, wondering if my sheep and cattle will prosper or die, or be stolen. It's harsh, but Mary was lovely. I'd do anything for her; she was my only surviving child, and now the Wardens have hanged her. For what? Not blackmail, murder or reiving – oh no. Love! You can say that word to some people and it will embarrass them.

It's left me, an old man, to sit outside my hut, my dogs the only creatures left that mean anything to me, the smoke from the thatch spreading over my garden where the hens scratch at the remains of onions and peas. "Well, what did she do?" you ask. You, a stranger, with a voice from a different land.

I'll tell you. Perhaps telling it will get it off my chest. The Border's rotten. I'm told it's been worse. My dad told me about Flodden, about the thousands of English and Scots who slaughtered each other, while he and his kin stripped the dead on the battlefield afterwards. He told me he didn't give a damn about English and Scots, and that what matters is the name you had as a Borderer. It's the same still: the people

who matter most are the ones who stick by you. Not the Earls, not the ones in the big castles or the Wardens who are supposed to keep order. They'll shift with the wind. They look after themselves. They lay down the law, but we have laws of our own. Now Mary and Archie have paid the price for breaking the so-called rules.

The crime? They fell in love. People have got away with murder and crimes far worse than that when they have the right connections. So when one really GOOD thing happens – and the preachers have been telling us for years that we should love one another – it gets strangled on the end of a rope.

You want to know more? Who are you? Oh, it doesn't matter anyway. No one, nothing can hurt me any more.

Archie Graham was a young Scot. A lad we knew well. Outstanding – especially as he had this mop of red hair. Always larking about. A frequent visitor to our village, bringing cattle along the drove road south. A strong, well-armed lad, good to have on your side in a fight. But you should have seen his face when he looked at our Mary!

Mary was a real looker. Golden hair and incredibly dark eyes. I'd spend a lot of my time wandering around whenever the young lads came round, to keep my eye on things. But those two managed to give me the slip, and in the end I gave up wasting my energy. Perhaps I should have kept a tighter rein on her, but there's so much work to do looking after the beasts on the upland pastures and keeping the garden going, and me with no wife living, that it was impossible. I could see, though, that this was serious. Of course I was worried. What if he was just playing around, and Mary had to take the consequences? But it wasn't like that. She was a Fenwick and English, and he was a Scottish Graham. Not that it mattered to us round here. As I've said, we respect the family groups more than we do the differences between English and Scots. The Border hasn't been a barrier to love affairs, as the people here roam greater distances beyond their homes.

We all had some idea of what the law would let us do in many things, but most of us thought that the judges made up some of the laws as they went along, as it suited them, or when they hadn't a clue, so we didn't take them very seriously all the time.

We should have known better. My lass and Archie couldn't live without each other. When Mary realised that a bairn was on the way she told me everything. She told me that she and Archie would be married, that they would not have it any other way, and that she wanted him and the child more than anything else in the world.

What could I do? I scraped what little money I had together, and gave it to them with my blessing. It was nice to think of myself as a grandda' as all my other children had died before they were five.

Time passed. They came to see me sometimes at night, so I kept in touch with them. They were so happy. The blow fell shortly after the baby was born. The warden's guards arrested them in Scotland, dragged them off to court, and accused them of getting married without the Warden's permission.

In my life I have seen sights that have turned my stomach. I have seen crops fail, cattle and sheep die. I have seen farms abandoned when disease has struck or when men have not come back from raids. I have seen the landlord's men try to squeeze

the last drops out of the farmers. I have suffered the arrogance of rich people as they chased deer over my land. But never before have I wept so much as at the hanging. Imagine: two young people who have committed no crime except to love each other – love that knows no border, that crosses all the barriers that people try to build. I couldn't watch the final, disgusting act of the law. I have seen people's bodies twitch long after they have dropped and are suspended by a rope.

And what about the bairn? In my old age I have dreamed of a grandchild. I have made a little basket of thatched reeds like the one that Moses was found in. I have built a little hut. I have begun to make toys. Look. You can see them here.

Go now. My tears will embarrass you. Leave me under this vast sky where some day I hope to meet Archie and Mary, where there will be no Fenwicks, Grahams, English and Scots. That is all the hope I have left.

Go now. Don't linger with a broken old man.

I have tried in this to recreate what someone must have felt, without much evidence: it is not 'history', but it is about humanity.

When we come back to the town and how it has developed in history, we can read how it suffered from the Scottish invasions of 1296-7 under Wallace ('Braveheart') along with the rest of the valley, and from Edward I's retaliation, earning him the title, 'The Hammer of the Scots'. One recorded local event tells how the vicar of Haltwhistle was captured in 1314 by the Scots and ransomed by the Bishop of Durham. That was followed by the Black Death (1348), which killed off up to a half of the country's population, and in some parts drastically altered the balance of power between landlord and tenant farmer or serf. Perhaps changes were not so far-reaching when poor grain crops and animals were the staple products, with an emphasis on upland pasture.

Whatever effects these events had, there was certainly a great emphasis on building small strongholds in the form of thick-walled towers, usually with two storeys. There was little room for many animals on the lower floor, however, but what there were would have given some added warmth in the winter. Not only were there many bastles fringing the market square, but also in the surrounding area. Some of course have disappeared, others have been developed and some have survived particularly well. One characteristic is a stone stair to the upper storey which may have replaced an earlier ladder, and another is very small windows slit into the thick walls.

As the Border 'period' was a big one, it is unlikely that places were in a constant state of siege, but nevertheless raids were frequent especially in the west of the county, where much of the land's wealth was 'on the hoof'. It is unlikely that the earls of the north-eastern part, along the fertile coastal plain, would not have made agreements with their Scottish counterparts not to burn each other's corn, as all would have suffered. Neither was the land as lawless as some make it out to be: there were rules that were matters of convenience, to be administered locally, otherwise nothing would have been able to exist in such lawlessness.

Haltwhistle bastles.

Left: 19a. Steps and masonry of a bastle north of the main street.

Below: 19b. Another bastle opposite, built into a modern structure in the main street.

We have then a small town where the wealthier folk lived in their bastle houses, where the vicar had his glebelands and collected his tithes in return for the church services he offered, and where the others living and working in the area must have sought safety in times of war and raids, temporarily leaving their heather-thatched, defenceless cottages. The latter could perhaps have sought refuge in the church or in a defended three-storey tower to the east, the Musgrave tower that was demolished as recently as 1963. More of our history lost! In happier times the houses would have clustered around the church and market, where today their sites if not their remains can be seen built over.

The town was on an east-west valley routeway, so the main street attracted inns and shops. There would have been barns for hay, and the blacksmith's shop would have been a key building. When we leap forward in time and look at the new buildings, we see that the coaching inns became particularly important with the coming of the turnpike roads in the 1760s. Thus there were five in 1822 where the Newcastle-Carlisle stage passed through. The old bastles have been absorbed in later building, but they can be traced in the fabric.

Churchyards tell us something of the past, and the later the graves and inscriptions, the more information we are given. There must be thousands of burials deep down, as the height of the ground often betrays. There are sometime reused memorials of late medieval times and battered monuments like those in the church here, but the early eighteenth century especially saw a large number of quite elaborate gravestones appearing, mainly of local stone, and often made by local masons. Everywhere many have now been cleared away to make grass cutting easier, although in some Northumberland churches this has been resisted to leave 'traditional' cemeteries with crowded rows of graves. Haltwhistle's have been largely cleared, but those remaining tell their stories of trades, names, relationships, causes of death, and other stories. They sit in 'God's acre', where the church's main changes are the addition of buttresses and a vestry; there was not the wholesale cleaning up and changes usually characterising the Victorian era.

The coming of the railways has left a great legacy, and the station continues in use on the Newcastle-Carlisle line, a godsend to everyone living in this valley. Here the buildings are fine, with a spacious modern approach, the group of ticket office and waiting room, a wonderful cast-iron water tank, railway bridge and signal boxes have survived well and give the place character.

A long street leads from the market to station, passing a particularly fine building of 1900, The Mechanic's Institute. The main buildings are of the eighteenth century, and others that fit well are a century later, retaining the image of a pleasant market town, where old and new blend well together.

However, this is a small part of the picture, because in the Haltwhistle area there is a range of industries that are typical of the Wall corridor. From the Roman Wall at Cawfields a burn runs south to join the Tyne. At the Wall itself, a huge quarry cut away whinstone, and left the Wall high in the air above a lake created by the quarry. This stone was transported by a tubway beside the burn to the railway

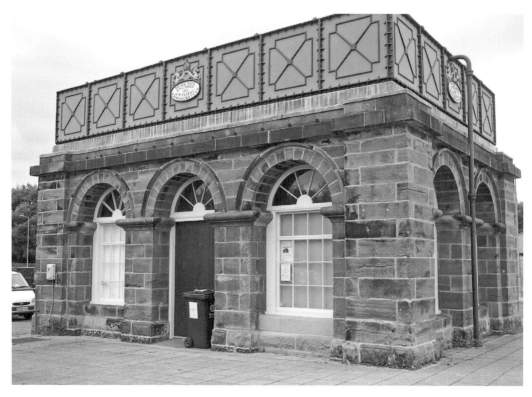

20. Haltwhistle station water tank.

1902-1952, and this incorporated existing lines bringing down coal and limestone. There were two woollen mills and a brickworks. We have a complex of buildings and mines that can still be traced, one of the latest being a fire-clay works that operated from *c.* 1940-60. Towns and villages like Hexham, Rothbury and Felton had their own gasworks in other parts of the county, and so did Haltwhistle. There was even a short-lived iron works that operated only for about four years, rather smaller than that at Hareshaw Linn, Bellingham. All the workers in these industries were housed, adding to the older domestic buildings. In many ways, Haltwhistle tells the same story as many other areas that had mineral resources, overtaken in scale by other parts of the county, especially on the coast.

The varied occupations of these communities, in addition to the main employment in agriculture, also led to an astonishing diversity of different kinds of churches at a time when evangelism was very strong, and people were looking for a religion to fit their particular needs. Again, Haltwhistle is not exceptional, with its Mission Halls, Presbyterians, Wesleyan Methodists, Roman Catholics, Salvation Army, and 'Primitive' churches. As in the rest of the country, not many of these have survived, especially as their recreational functions have been taken over by other organisations and television, leaving redundant buildings to be taken over for some other use.

WILLIMOTESWICK

There is some confusion about the spelling of this place on maps, but the spelling that I have given above is the generally accepted one. I mistakenly gave it as 'Willimontswyke' in an earlier work. An early spelling, *Willimoteswike* in 1279, makes its meaning 'Willimot's Farm', a French name.

This is a very rare fortified farm, built on a rectangular pattern in which walls and towers enclose a courtyard. A substantial fortified gateway and the remains of a thin tower lie on the eastern corners, the latter forming the corner of the house, but there is no obvious sign that this is repeated to the west, where farm byres and other farm buildings have covered up earlier work. The plan is very similar to that of the rectangular walled castles at Ford, Etal, and Chillingham, which we meet later in this book, but on a smaller scale. It is a working farm, with restricted access, off the beaten track, with the nearest small village being Beltingham. It lies on high ground just to the south of the River Tyne, at an outstanding viewpoint essential to such a small fortress, and there is no bridged crossing of that river. South lie Ridley and Plenmeller Commons, with extensive stretches of rather bleak moorland. The name Ridley is the family name of the people who lived there, among them the famous bishop who was burned at the stake in Oxford for refusing to renounce his faith. The Ridleys are one of the foremost Northumberland families.

The approach to the farm is an impressive fortified gateway, a structure once 'at risk' and recently made safe by English Heritage.

Although it is in a dangerous condition, it is almost intact, and appears to be late fifteenth to early sixteenth-century. From the outside, there is a large rounded-arched doorway, wide enough for farm traffic.

Above it is a niche, and to the north are windows, including two fine ones with mullions, set into a coursed stone wall that is based on some massive sandstones. It supports a parapet that protrudes with some battlements and a triple tapering course of rounded stones running below it. Inside the tower are two doorways that give access to all floors, and one of these leads directly to a spiral staircase.

This tower is echoed by another that is slender, and that forms the eastern part of the house which occupies the north side of the courtyard, so presumably the present range of farm buildings are on the line of the wall that once joined the towers. The house has double wings where the towers were, but as it was rebuilt in a Tudor style in around 1900 it is difficult to know exactly what might have been there. A Tudor-type doorway, sixteenth-century, of stone has been set as today's entrance and the walls have been pebble-dashed.

This would have been the main living accommodation. What happens on the south and west sides is, again, difficult to ascertain, as there are signs of so much rebuilding. One of the great interests for me is the variety of materials that we can see, such as different kinds of roofing tiles, and splendid thin stone slabs, all of different colours and periods. Everything speaks of a work-place, with barns and

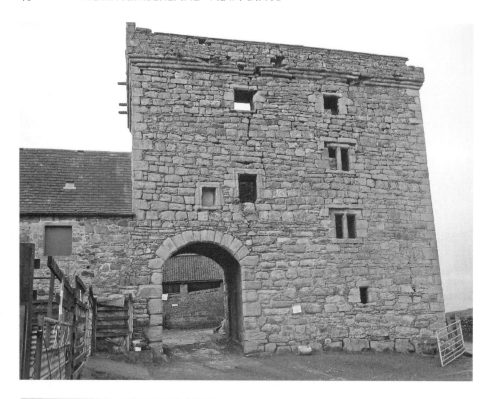

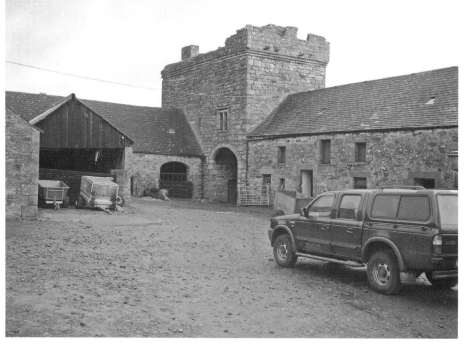

Willimoteswick.

Top: 21a. Willimoteswick gate-tower at the north-east corner.

Bottom: 21b. A working farm inside the courtyard.

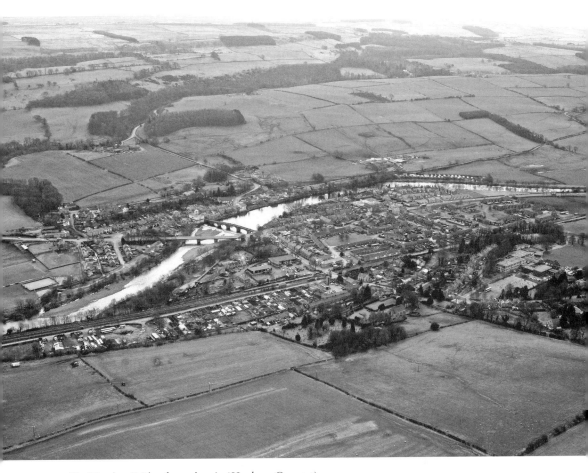

22. Haydon Bridge from the air. (*Hexham Courant*)

byres all around the courtyard. The walls on the north are old, and this confirms the original as well as the present complete enclosure.

When I last visited it, it was certainly a busy working farm and not a manicured historic building, and I was grateful to be invited there.

HAYDON BRIDGE

Often in the spelling of place names 'don' and 'den' are interchanged. Haydon should be 'Hayden', meaning a valley where hay was grown; yet Warden should be 'Wardon' as 'don' means a hill.

Haydon Bridge lies to the east of Haltwhistle on the same side of the river, its earliest known building being on higher ground to the north, where the church served as an outlying chapel for the community. Some of the stone from this church went to make the new church of St Cuthbert closer to the river, where

the present village lies. The village is different from other settlements on the Tyne because it actually lies on the flat alluvial land (haughs) rather than taking advantage of the terraces on either side, which suggest that the main reason for the village that we see today was its position at the bridge, which must have been an early structure more convenient to cross the fast-flowing river than a ford. It would have been an important communication, especially for the local landowner. Houses may have been built close to the bridge and along the roads, which gives the village its linear pattern today. A problem with assessing what form the early village took is that the land has been built over, but Charles Coombes detects some 'burgages', which are narrow strips of land facing a road, common to many Northumberland towns, that may have been covered. In 1323 there is a reference to Haydon Bridge as opposed to Haydon, but when we look at this date we see that it was a time of bitter warfare between England and Scotland, allowing little scope for development.

When the land was taken from the Derwentwater estates, it was administered for the crown by the Greenwich Hospital Commissioners, a story briefly covered under 'Dilston' further in the chapter. The Derwentwater family owned many estates in Northumberland, but after 1715, as result of their playing a leading role in the Jacobite rebellion, and after the execution of James Radcliffe, they were eventually confiscated. The results are seen in the eighteenth-century administrator's buildings, such as the Anchor Hotel, built as a Rent House on the south bank, Almshouses (Shaftoe Terrace), and the warden's house. The church was built by then, in 1796, and in 1869 a transept was added for the children from the Shaftoe Trust School. A monument from the old church is housed there, a damaged fourteenth-century effigy.

The old church is one that recently attracted local artists who made a special feature of such small churches. Its western end was demolished, but the twelfth-century and fourteenth-century chapel were saved in the late nineteenth century. Another link with an older past is a Roman altar re-used as a font – again not unusual in this valley.

An interesting clue to more recent activities comes from the cemetery to the east, where we see the appearance of locally-mined fireclay made into crosses which are stamped *The Langley Barony Coal and Fireclay* Co. *Sanitary Ware Manufacturers*. Clay and coal often occurred together, and the mining of fireclay began in the mid-eighteenth century, and reached a peak in the nineteenth. Firebricks for industry were made from this, and salt-glazed sanitary ware. At nearby Bardon Mill the fireclay works took over a woollen mill building and a pottery still operates there. The history of the Langley Barony has been researched by the late Charles Coombes, whose last appointment was as head of the Corbridge Middle School, and his work has been saved in manuscript and CD through the Shaftoe Trust and the Hexham Local History Society for public use.

A new by-pass has just been completed which takes the main Newcastle-Carlisle road away from the village to the south of the river, and has at last brought some

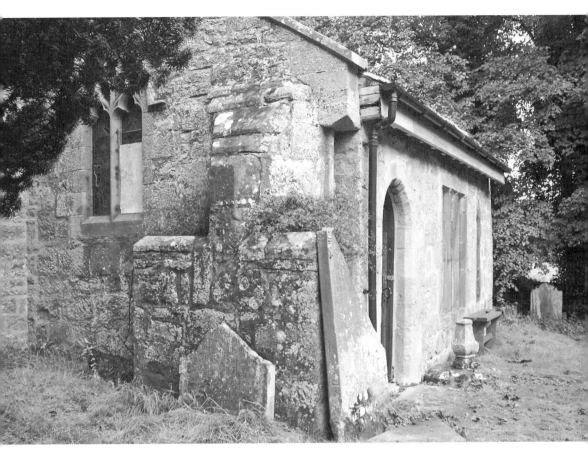

23. Haydon old church. (*Sonja Bailes*)

peace to the people who have suffered the constant heavy traffic on an inadequate road through the village. This will prove to be a significant event in its history, as it did at Haltwhistle. The village is linked to the south by a bridge which, since its first record in 1309, has suffered severe flooding, especially in the flood of 1771 which destroyed almost all the Tyne bridges. The present one dates to the 1820s, with an arch rebuilt in 1969. Like Haltwhistle, the village is connected to Carlisle and Newcastle by the earliest east-west railway in Britain.

Like Haltwhistle's, the position of Haydon Bridge within a border region has left a number of fortified towers. To the east, Alton Side is a bastle house with sixteenth-century extensions, but the largest cluster of these towers lies at Chesterwood, about three-quarters of a mile to the north west; the name incorporates the element 'chesters', which appears in some Roman survivals as a fortified place, but is often given to pre- and post-Roman sites. Here there is a small green enclosed by possibly six bastles, an arrangement which is echoed north-west of Bellingham at Greenhaugh. They point to the need to defend settlements from small-scale raids, but would not have withstood a large-scale assault.

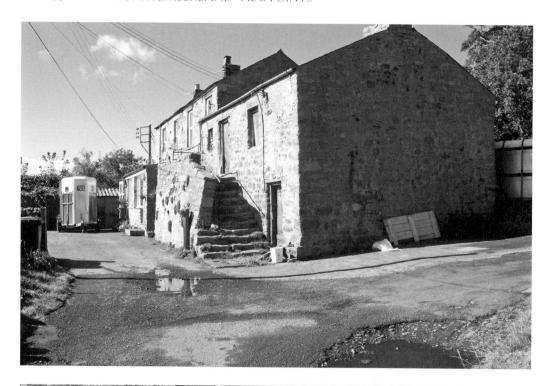

Chesterwood bastles.

Top: 24a. A bastle with its staircase. (*Sonja Bailes*)

Bottom: 24b. Detail of large stones incorporated in a 'recycled' wall. (*Sonja Bailes*)

As at Haltwhistle, there is an abandoned industry – this time the Langley Barony Leadmines which exploited galena veins inside the limestone, and were short-lived. The operation has been researched and published in easily accessible form by Susan Harley (*In the Bewick Vein*), and pieces together what can be seen on private land of the whole process of extracting, crushing, washing, and smelting the ore.

Groups have been able to negotiate visits to the addit (mine entrance), power house and crushing machinery and the circular 'buddles' where the ore was dressed. Here were many additional buildings to the Mines, such as a joiners' and blacksmiths' shops, and binsteads (where lead ore was brought in and weighed). This operation was unique because it lasted only about twenty years, from 1873-1893, yet was highly successful. It struck rich. Usually smaller operations were financed by the large ones, and many failed. It used steam power instead of water power, making it noisy and smoky. Although it was profitable at first it hit a recession when lead prices fell, and like so many of these small industries, went into liquidation. Stone was plundered from the site, but it was not levelled. This makes it a fascinating place to visit.

25. Lead working at the Joicey Shaft, Haydon Bridge.

The Barony was established in the thirteenth century, with Langley castle at its centre – a large tower-house restored splendidly in the 1890s, after it had been in ruins since 1405. On this south side of the river there was another lead mining operation, some of its remains still visible, and well-recorded. There was a coal mine at what is now Stublick farm, exploited since 1700 with bell-pits and deep mining. The engine house, boiler house, and chimney are still there, dramatic buildings in a dramatic setting.

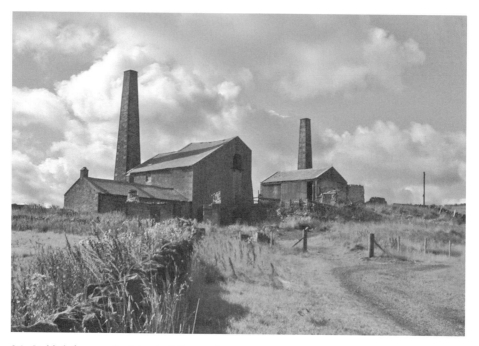

26. Stublick farm coal mining buildings today.

Alongside the coalfield was a small lead smelt mill, now dismantled, and the site of a sawmill, with reservoirs, but the most dramatic survival is the flue which is built as a stone tunnel, at one point crossing the now-abandoned railway line, and travelling on to a preserved massive chimney that dominates the skyline.

The reason for these buildings was to take the poisonous lead fumes away from the smelter where they were less harmful. The abandoned railway line, the old station (now a garden and cultural centre), and the stone bridges all combine to make this an area of extraordinary interest and unique scenery.

Already we have moved from the deep past to the present, with so many visible parts of history telling the story of how it is determined by the use to which people put a landscape in order to make a living.

Charles Coombes analysed the kinds of occupation found in the Langley Barony in the mid-nineteenth century, and worked out that in 1851 27 per cent were

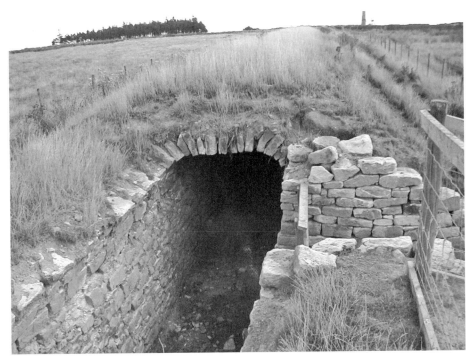

27. Langley flues and
chimney.

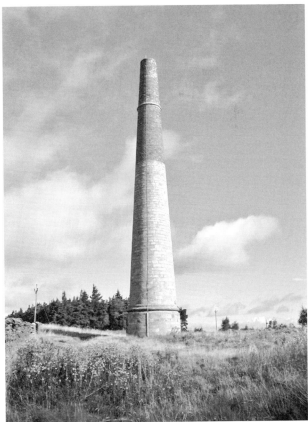

employed on the land, 14 per cent in domestic work (house servants), 14 per cent in crafts (dressmakers, stone masons, cordwainers, shoemakers, metalworkers, blacksmiths, whitesmiths, millwrights, iron moulders, iron founders, fitters and turners). There were 11 per cent labourers, and about 5 per cent each in transport, metal working, lead trades, ironstone miners, coal miners, and retail traders. These villages were therefore quite self-contained.

At Chesterwood, where there were forty-four adults and twenty-four children, nine were agricultural labourers, seven ironstone miners, and there were singles in lead mining, a joiner and cartwright, labourer, house servant, dressmaker, a landed proprietor, housekeeper a farmer, agricultural servant, and two apprentices to the joiner and carpenter.

The Langley Smelt Mill, with forty-six adults and fourteen children, had fourteen lead miners, two lead and silver separators, and one each of: smelt mill labourer, brick maker, brickmaker's labourer, dressmaker, grocer, retired grocer, agricultural labourer, a joiner and three charwomen.

By 1886 the village was self-supporting, with many businesses. This happens in many village communities throughout the county. Interestingly, there were six inns to serve the population and travellers.

SETTLINGSTONES WITHERITE

It took me some years to realise that a mineral known as witherite (natural Barium Carbonate) was mined almost exclusively in the Tyne valley at two main places: Fallowfield and Settlingstones. Both mines are now closed; both were also associated with lead mining, as witherite occurs in the same limestone as galena. There is also an even rarer mineral at Fallowfield called barytocalcite, which is still to be found there in a protected area, a Site of Special Scientific Importance. In the lead-mining area there is also zinc, iron, fluorspar and barytes. We have already seen that the region of Haltwhistle and Haydon Bridge has mined lead, although it is on the fringes of the main orefield of the North Pennines, but the discovery of witherite was an outstanding addition to what could be exploited.

The mineral, Barium Carbonate, is named after Dr W. Withering who, in 1784, recognised that it was chemically different from Barytes (sulphate of Barium) when he examined minerals from an old mine on Alston Moor. Barytes is found in the fault fissures of rocks formed in different geological ages; in its highest grade form, Barium Carbonate is restricted to the north of England. The Settlingstones mine is to the west of the lead where the Witherite seam replaces that of galena. It occurs vertically in the strata, varying in width from 1.22 m to 3.66 m (4 feet x 12 feet), and was worked mainly where the vein passed through the Whin Sill.

Settlingstones lies close to the Roman Wall, where we have seen that the landscape is determined by faults and by the intrusion of volcanic basalt (dolerite, whinstone). The vein that includes Witherite runs from Fourstones through Settlingstones. At

28. Settlingstones witherite mine: the site of the waggonway as a raised field boundary from mine to mill.

Fourstones were the famous Prudham Stone quarries, and there was a coal mine where new houses are now built. An article in the Newcastle *Weekly Chronicle* of December 1873 says that it was not very important as a colliery village, the mine employing thirty to forty men, with an output of about 100 tonnes a day. Much of the coal was burned in the limekilns locally, much of the lime being sent to Whitehaven and Maryport in Cumbria for iron-smelting there. Stone was sent to Scotland and to large northern towns for building. It was a different story for Settlingstones.

Settlingstones is now a small terrace of houses, with gardens and extensions, and although the mine has been virtually destroyed, there are still traces of it. One notable sign is the field boundary and roadway where the industrial tramway used to run, but there are other mining survivals elsewhere, particularly to the east where there was a lead-mining operation. The earliest-known workings at Settlingstones were for lead extraction, as early as 1690. In 1872 it ceased to mine galena, but Witherite was mined afterwards, until quite recently when its resources began to run out. In a report of 1968 in *Mining and Minerals Engineering* it was reported that although there were many shafts in the area, only two were then in use: the Ellen and Frederick shafts. The former is the more easterly, and the latter lies closest to Settlingstones, its filled-in shaft visible from the Stanegate. There are still people living in the area who worked there. The distance between the

Ellen and Frederick shafts is one mile on a north-east to south-west axis. Further along this axis to the south-west are the Langley Barony mines. Elsewhere, many old shafts and disused quarries are dotted around. The ore was mined from 190 m – 408 m (400 feet – 880 feet) deep, in pockets, with the use of air drills, rods with carbide bits, and explosives. Ponies dragged the filled ore tubs to the shaft bottom. At a deeper level the ore was hauled up by winch. In this way about thirty-six tonnes a day were brought to the surface. When the tubs reached the surface, they were hauled along by endless rope 915 m (3,000 feet) long to the mill at the Ellen shaft, where the processing was quite unsophisticated, but effective. The route of this is clearly visible today on a field boundary, going gently downhill to the processing plant, near the Stonecroft mine, the brick engine house and remains of a boiler house still visible. Everywhere that mining took place, there are spoil heaps and directed water sources.

When it arrived at the mill, the ore was fed through a hopper onto a belt where the stone, sulphate and large pieces of ore were removed. The ore was crushed, and then graded through sieves, each grade being treated differently. The gravel and witherite were stored, and the products sent by road to their destination, or to the bagging plant if users preferred it in that way. Seven men were employed in the mill. A small laboratory checked on the product, and graded it. Some of the $BaCO_2$ was very pure, some was sold in crude form, and some gravel was also sold. The water for the processing flowed by aqueduct from a dam nearby.

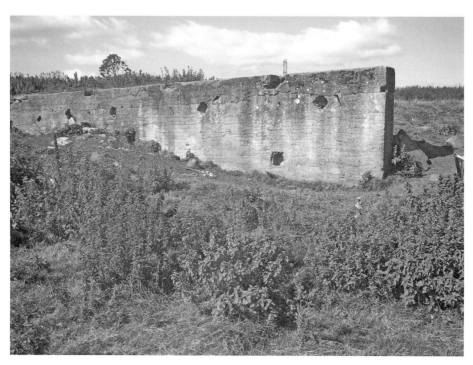

29. The site of the Frederick shaft.

The power used was at first steam, and National Grid electricity. Air compressors were established on the surface of the Frederick shaft for underground use.

An earlier account of these processes is given in The Transactions of the North English Institute of Mining Engineers, vol. 27, 1877-73: *A visit to the Stonecroft and Greyside Lead Mines, the Prudham Quarries and the Settlingstones Lead Mines*. One hundred members took part. They visited the quarry, mentioned that there were also nine lime kilns turning out 150 tonnes of lime a day, and that Fourstones Colliery had fifty to sixty men and boys working there. The author borrowed a description of the geology of the area from C. A. Lebour, stressing the north-east to south-west direction of the mineral veins, where faults throw up seams 'rich in Carbonate and Sulphate of Barytes'. The lead-mining area lies in a hollow filled up with boulder clay, which is good in patches for clay for tile-making. The Stonecroft and Greyside lead mines receive attention before he passes on to Settlingstones, which the party visited.

He notes that the mine began work in 1770, was abandoned, and began working again in 1833. The processes of crushing, separating, and preparing ores for market are like everywhere else, and 'do not require special description'. He says that between 2,000 – 3,000 tonnes of barytes, chiefly in the form of carbonate, were produced annually and 'shipped principally to France and Germany. A little goes to America, and some is used in England for glassmaking and other industrial arts.' He adds that 'Almost the entire product (of barytes) of the British Islands is, in fact, within a few miles of this place'.

He ended with: 'The weather throughout the day was exceedingly fine, and the excursion was greatly enjoyed.'

There are photographs of this large industrial enterprise at Settlingstones at work, and local people remember its all being there up to about 1960. The name Settlingstones was in existence in 1255 as *Sadelingstan*, meaning a place where people mounted their horses.

So why is the mineral so valuable?

The mineral is not very common in nature, and occurs in a white, yellowish-white, or light grey colour. Softer than fluorspar, harder than calcite or gypsum, it is found in crystal form (hexagonal, orthorhombic or botryoidal) or as fibres, quite brittle. It is more expensive than natural Barytes, but has qualities that make its extraction well worth it.

It has a very wide industrial use, depending on its treatment. As precipitated Barium Sulphate ($Ba\,SO_4$), large quantities were used to make highly-glazed coated papers, used for example in photography. It was also used to a less extent in making ink or colour.

It was also used as a filler in the rubber, oilcloth, linoleum, and paper industries. A pure grade is used as part of a 'barium meal' before X-rays are taken. In its smallest form it was put into a wooden vat of hydrochloric acid and stirred slowly, mechanically outside the building because so much carbon dioxide was given off. The product was called 'blanc fixe', and one good use for it was in brilliant colours. Other uses were for printing-inks, dyeing, and printing textiles.

If Witherite is dissolved in dilute nitric acid, a decanted solution is formed after it has settled, and it crystallises. This barium nitrate was used for the manufacture of military explosives, green flares and signal lights, blasting powders, and in ceramic glazes.

The addition of sulphuric acid and cold water, the production of a precipitate to which phosphoric acid was added and decanted produced hydrogen peroxide, famous for turning hair blonde. It was used to remove excess of chlorine from bleached fabrics, and used to restore discoloured oil paintings.

Barium oxide and hydroxide (Ba $(OH)_2$) was produced by furnacing Witherite with carbon. The hydroxide was extensively used in the chemical industry, and in the tanning industry it was used to remove hair from animal skins. It was used for paints, polishes, linoleum, insecticides, cellulose lacquers, and water-resistant materials. However, its most important use was to extract sugar from uncrystallisable molasses.

In the brick and tile industries it was used to counter the white scum that forms on bricks when they dry out after wet weather, caused by calcium sulphate ('Plaster of Paris') added to the cement. If air-floated Witherite is thoroughly mixed with the mortar, it renders the calcium sulphate inert with insoluble barium sulphate.

It was used to purify brine, to soften water for boiler feed and other industrial purposes, important in laundries, paper mills, tanneries and dye houses.

Other uses were for case-hardening steel and wrought iron, important to ships and armour-plating. It is also important in optical glass, when the dispersion of light is eliminated. As white lead is poisonous, it provided a non-toxic white pigment for paints. On the other hand, it was used in rat poison.

I am fascinated by this list of uses, and when we think of how important the mine was internationally, it is difficult to see how the world's largest witherite mine should have come to this. However, we have seen that the area is littered with defunct industries. Nature takes over when the levellers have removed the workings, and we are left with a slight rise to the south of the Stanegate where the main shaft used to be, a long pipe sticking out to allow gas to escape, and some large chunks of concrete. The mineral rights belonged to the Duke of Northumberland and the Greenwich Hospital Estates, which must have benefited financially from this. The operation also provided work in the area, and there are still people around who worked there. The *Hexham Courant* newspaper of 4 April 1969 reported the last working shift at the mine thus:

> Settlingstones mine, the world's only source of commercially mined witherite, worked its last shift on Friday … On the last shift the men sent up to the surface 37½ tons of witherite.

Despite that respectable quantity on the last shift, it seems that no one thinks that there is any prospect of reviving the industry, even though no new sources have been found anywhere else. We have only to look in the landscape for other

30. Beamwham lime kiln, east of the house.

signs of deserted industries to see how focus shifts with worked-out seams and new discoveries. A good example is the lime industry; at one time, the kilns were essential to agriculture, and to the production of limewash. There is a good example at Crindledykes, where an impressive kiln with quarries around it and waggonways has been preserved for us to see. Another smaller, off-road site is at Beamwham, west of Settlingstones, which may mean a tree in a marshy hollow.

Among the industries of this valley is paper-making: at **Fourstones** the paper mill is still operating, and there are the remains of another at **Haughton.** The latter is more renowned for its 'castle', but on the same bank of the river, William Smith, who owned the castle, set up an impressive mill, which was completed in 1788, to make paper with linen (old shirts: rags to riches). The mill became famous during the French Revolution, when a plot was hatched to undermine the revolutionary government's currency by flooding France with forged *assignats* – French banknotes. It might have succeeded had it not become a political issue in England, some protesting that the whole operation was distasteful, so in 1795 printing stopped. This did not stop the mill continuing to be successful, producing seven tonnes of paper a week, using machinery installed by the famous engineer George Stevenson. Today, part of the building remains, and is let as flats.

Any paper-making is now left to the Fourstones paper mill, established at about the same time, in 1763; today the oldest surviving parts of the building are nineteenth-century. Inside, it has Britain's oldest paper-making machine, dated to 1860.

Major settlements in the valley include Hexham and Corbridge, but as these have received a big share of my time and writing I shall merely point out a few ways of looking at them.

HEXHAM

Sharing with Ripon the oldest Saxon crypt in the country, Hexham has developed from one of the most important early monastic sites to the centre of a flourishing modern town, where its history, both secular and religious, is there for all to see. The street pattern, like many others in Northumberland, shows how the houses fronting them had strips of land running away from the street to include gardens, outhouses, workshops, pigsties, and numerous other uses, the strips still visible in some places but generally built over in larger developments. The streets focus on the Market Place, around which the Priory, Moothall, Old Gaol, and other civil administrative buildings were sited. It had a market – a condition of status and growth, and until quite recently cattle would be driven into town to be sold. What catches the eye are the Abbey Grounds and Sele parklands, but emphasis has been placed recently on preserving Hexham's industrial past, for it was in the tanneries and their subsidiaries that most people found work. It also prospered because of its good rail connections.

31. Hexham from the air.

32. Cockshaw: the site of part of the tanning industry.

Because it is so well preserved, it has attracted good quality housing, making it a very desirable place to live, and its schools and cultural life reflect this. It has also attracted one of the largest industrial operations in the valley, for the Egger's factory at the east entrance to the town processes chipboard, its material coming from the many forests that have been planted in Northumberland on otherwise poor land.

CORBRIDGE (*SEE* PLATE 6)

Corbridge was not only one of the largest Roman settlements in the county, lying at a point on the river where it was crossed by a magnificent bridge, but also it developed as an important medieval town. Today it is scaled down from what it used to be.

Like Hexham, it has become an attractive place to live in but, like so many other places, its traffic is difficult to contain on streets not geared to such volume and frequency. It was also a large and important medieval and later settlement. Its Roman site continues to attract many visitors, and some of the architecture in its centre is fascinating to many, so it is a tourist centre, with the added attraction of easy access to the Wall.

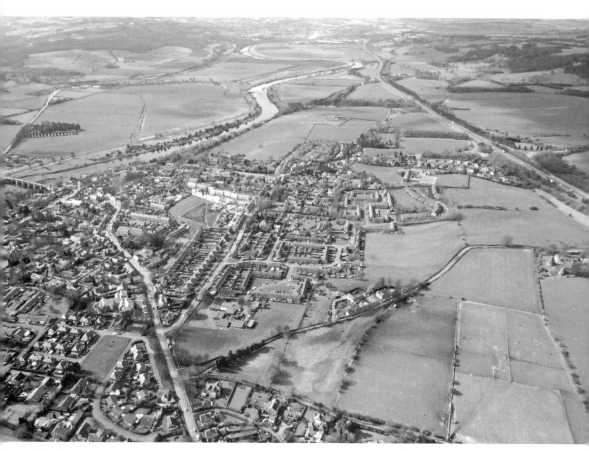

33. Corbridge from the air. The River Tyne is to the south (left) and the A69 to the north (right). The Roman settlement lies between the road and river at the top. (*Hexham Courant*)

DILSTON

Dilston is one of the success stories of the region, for the castle has received funding, thanks to the efforts of enthusiasts, to excavate the remains of a succession of buildings from early medieval times to the eighteenth century, when the last hall was deliberately demolished following the acquisition of the place by the Commissioners of Greenwich Hospital. Excavation has pushed the date of the first building further back than the tower-house that was incorporated in the Radcliffe's (later Earl of Derwentwater's) grand house of the 1620s, which was itself incorporated in a remodelling of 1711-15. Unfortunately for the family, their commitment to the Jacobites, as a Catholic family in the 1715 rebellion, cost James Radcliffe his life and eventually his descendants lost the estates, to be passed to crown administration. Their landholdings across Northumberland extended to areas as far north as Scremerston, near Berwick, and we have seen that their lands in the Haydon Bridge area were administered in the same way. Many of the Tyne valley farms once belonged to them. The story and the results

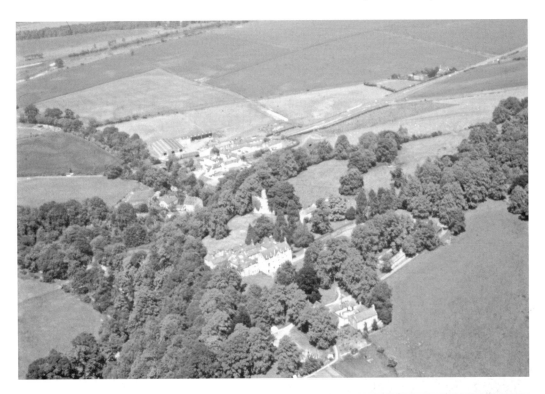

Top: 34a. Dilston to the Tyne valley.
Bottom: 34b. Dilston 'castle' and church.

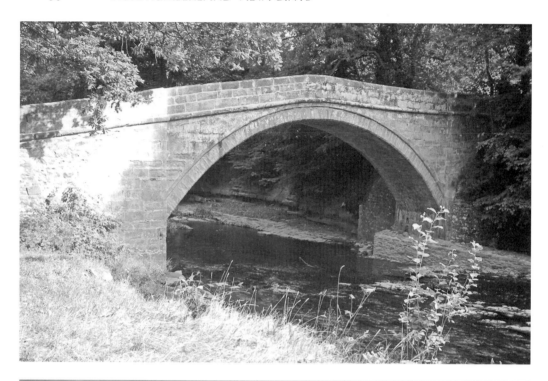

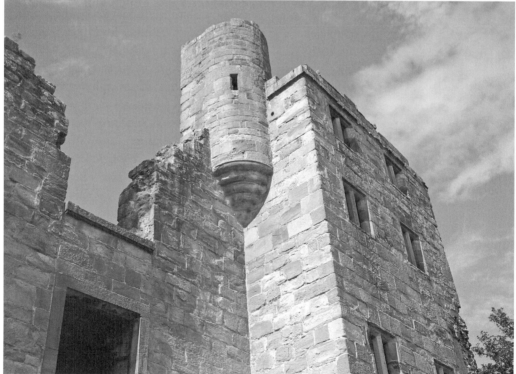

Top: 34c. Dilston bridge.

Bottom: 34d. Dilston 'castle'. For both, *see also* Plate 7.

of recent excavations are well told in the early seventeenth-century chapel which stands south of the castle, close to the gateway with a segmented arch dated 1616, which was central to the approach to the Jacobean house. So thorough was the demolition that almost all the stone was removed.

A combination of air photographs and pictures at ground level offer many viewpoints of this interesting landscape. As we fly in from the west, from Hexham, with the Tyne to the north, we see the Devil's Water, a tributary of the Tyne, crossed by a lovely bridge built *c.* 1620, leading up to the castle by a way that has been recently excavated and restored.

The river banks were landscaped as a pleasure garden, and water power was used to drive mills. To the west are the remains of a brick and tile works built with red brick. The name Devil's Water was *Divelis* in 1233, and comes from the British *dubo*, meaning black, and Old Welsh *gleis*, a stream.

Somewhere to the east, in the same field as the castle, lies the deserted village, one of hundreds that are known in the county. There are sufficient signs in the field to locate it, and this may become part of a future excavation programme to shed more light on how ordinary people would have lived.

Currently the modern Dilston Hall, built away from the old structure but still close, houses one of the few MENCAP colleges in the country. Originally built in 1835, the large house has been added to and altered considerably.

BYWELL (*SEE* COLOUR PLATES 8 AND 9)

Further to the east, Bywell at first appears deserted. The original village was removed, and that area is now a large grass field. The population was housed across the river at Stocksfield. To the east of the field is the 'castle' – a fifteenth-century rectangular tower, and the nineteenth-century Castle House. An eighteenth-century hall lies to the north, but the most fascinating buildings are two churches, built so close together that one wonders what on earth was going on. They both have Saxon foundations and other features. The reason is that they were established by two different Religious Orders that co-existed.

The church still in use is St Peter's, the north nave and west chancel side-walls of which appear to be of the eighth century, with four round-headed windows. It has been modified and changed since then, of course.

The other church, St Andrew's, now 'redundant', is more interesting in some ways, especially because it has such a remarkable Saxon tower, built with some 'long and short' quoins, with the upper parts of the tower a little later. The effect is beautiful. Inside this church is a fine collection of medieval grave slabs, both male and female, and some obviously commemorating important burials. Once they were displayed built into the outside walls, but most of them are now inside for their preservation. There are similarities between this tower and that at St Mary's Ovingham, which is late Saxon, tall, with no buttresses.

St Andrew's church.

Left: 35a. From the west.

Below: 35b. Detail of the upper masonry.

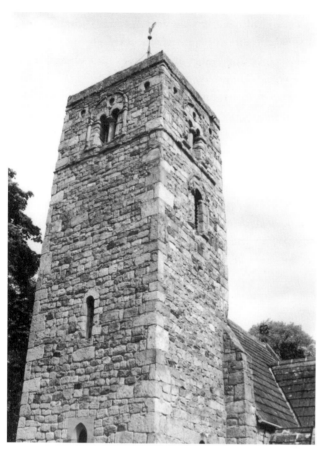

These Saxon survivals are remarkable, bearing in mind the tumult of the Border, but the Tyne valley churches exhibit many examples of the history of early church architecture, despite the nineteenth-century zest for cleaning everything up and destroying many fine early features. There is also a good selection of coloured glass, with some emphasis on guesswork about what the early saints looked like, coupled with the adoption of the symbols associated with them by artists from time immemorial. Really, we have little, if any, idea of what they looked like, and the tendency was to dress them up so richly that they stretch our credulity. They are to be viewed as works of imagination and skill, although the faces of some are so wishy-washy that it does not do their memory any favours.

From Bywell and Stocksfield the river widens as it moves towards the sea and to the built-up industrial complex of Newcastle. My general survey of the Northumberland part of this valley and its signs of a varied and interesting past ends at Prudhoe and Wylam, where modern industry and reminders of the great engineering past (the birthplace of George Stephenson at Wylam for example) intensify.

PRUDHOE

The sight of Prudhoe from the railway gives only a glimpse of the castle that was the oldest major building there. There is evidence of prehistoric activity in the discovery, for example, of polished stone axes, and the castle itself had a prehistoric carved stone incorporated in its structure, but the general appearance is of a modern town and industries surrounding what looks like a medieval oasis.

36a. Prudhoe from the air: the castle at the centre.

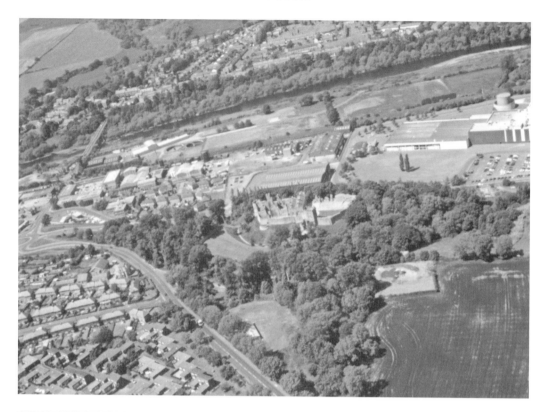

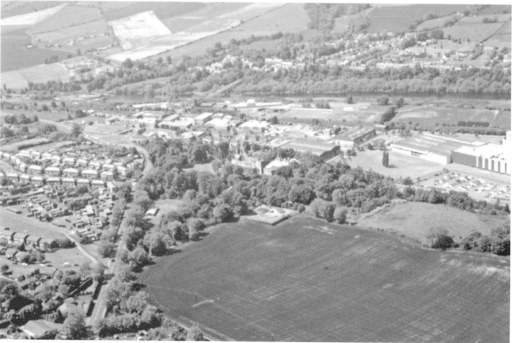

Top: 36b. Prudhoe to Ovingham.
Bottom: 36c. Prudhoe and Ovingham. *See also* Plate 9.

It is sited on high ground overlooking the river, approached through an impressive gatehouse and barbican that are reached over a deep moat. The ridge of outcrop is followed by a wall that encloses a free-standing keep and barbican. The outer bailey has a well-preserved wall and encloses an excavated hall of the thirteenth or early fourteenth century. The keep is now separated from this outer bailey by a late Georgian gothic house. The early castle belonged to the Umfravilles, and in the fourteenth century came into the hands of the Percys. It is now in the care of English Heritage, and open to the public.

The town lies to the south of the castle, and industries follow the valley and the railway.

WYLAM

Today Wylam is known internationally as the birthplace of George Stephenson, one of the great engineers of all time. It is appropriate that the railway is still in use, and that we have followed it (or it has followed us) the whole length of this valley. It is a symbol of the predominance of the North East's role in the Industrial Revolution, and of the adoption of its products and science all over the world. Its closed branch lines and abandoned industries are evidence in a shift in the balance of economic power, and the need to use skills differently. The Metro Centre, a vast shopping complex, in some ways emphasises that, despite the loss of manufacturing industries, the region has found a way of being able to re-cycle money on a much flimsier basis.

NAMES

The map that covers this area is, of course, covered with names, prompting us to speculate on what they mean, who gave the names, and when. Their origins vary considerably, some being recent, and others reach back several hundred years. The latter are, in a way, understandable more if they are well documented from their earliest spellings, and through the changes that archives show us. The major towns and well-established villages tend to be the oldest.

The area is also covered with fields, which appear only on estate and farm maps, a reminder that every field has had, or has, a name. These names change more rapidly than settlement names, as deeds may be lost or ignored when a farm changes hands, or people choose to name them differently. Whatever happens, at the root of field names is the urge to personalise the landscape, to pick out landscape features, what grows there, what animals may be found, who owns the land, and what events may have taken place. When all the names, whatever their origins, are read together, they are like a poetic landscape, a Breughel in words. If a farmer wants a field to be ploughed, a name makes it clear to which one he is referring.

River names are generally very old, going back in some cases to pre-Roman times, some of their meanings obscure. They, like hills and other prominent places, provide a clear reference point to people moving about the area, and their names tend to endure, passed on by word of mouth. The River Tyne means to dissolve, or flow. Like Allendale, the name is pre-Roman; so is the Erringburn, which means 'silver' or 'bright'. Bywell is a spring at the river bend; Devil's Water is a black stream. The word 'burn' is used for streams here, rather than 'beck' as it is in Cumbria.

Names are given to mark landscape features: Chollerton (a gorge), Colwell (a cold spring), Dipton (deep valley), Haltwhistle (a hill above a fork in the river), Haughton (low-lying river land), Plenmeller (a bare hill), Sandhoe (sandy ridge), Slayley (muddy), and Steel (steep).

When we look in a name for what might have been growing there, we find oak trees at Acomb and Oakwood, alders at Allerwash, hay at Aydon, barley at Bardon Mill, a grove at Barrasford, broom at Broomhaugh and Broomley, and elders at Elrington. Haydon Bridge may be named either from hay or an enclosure; Fallowfield was fallow or newly-planted, Langley a long wood or clearing, Thornborough had thorns and Yarrow had yarrow grass. The small settlement at Ryal, which means that it specialised in the growth of rye, retains fossilised ancient field systems of rig and furrow, extensively used for arable farming.

The land had wild game birds at Cocklaw, horses at Horsley, lambs at Lambley, and swine at Swinburn.

We can imagine early settlers from northern Europe after the collapse of Rome reaching the coast first, then penetrating inland along the rivers and other accessible routes, perhaps abandoning plunder for settlement, carrying with them their tribal or family name, naming their settlements after it. If it were not for place names, we would know little or nothing of these names. Egelwin gave a name to Anick, Babba to Bavington, Bynn to Bingfield, Blenkin to Blenkinsopp, and Ceola to Chollerton. Others include Collan (Coanwood), Dot (a Danish or Swedish name at Dotland), Gunware (an Old Norse name at Gunnerton), Hun (Humshaugh), Ing (Ingoe), Cena (Keenlyside), Mata (Matfen), Ulfkell or Wulf (Ouston), Ofa (Ovingham and Ovington), Sigwine (Sewing Shields), Sigemund (Simonburn), Hwita (Whittington), and the French name Willimot at Willimotswick.

When these names have '-ington' and '–ingham' included, this is an indication that a personal name is referred to. *Ham, ton,* and *wick* all mean a farm or settlement.

Hainings are enclosures, a Newbiggin is a new building, Staward is a stone enclosure, and Stelling an animal enclosure. French influences are very few, for although the Normans recorded local names they seldom added any of their own, but we do have Beaufront (beautiful brow), Beaumont (a fine hill), and Blanchland (imported, meaning a white glade).

A strong Roman presence, with the Wall and its accompanying forts, milecastles and turrets, and its roads, has left very little direct evidence in names. The word 'wall' occurs, for obvious reasons, in Wall itself, and in Wallwick (a farm on the wall).

The Stanegate, the early Roman frontier, means a stone road. Chesters can refer to Roman or earlier fortifications, and the name sometimes appears too as 'castle'. We do know that Halton was once *Onnum*, Chesters was *Cilurnum*, Carrawburgh *Brocolitia*, Housesteads *Vercovicum*, Great Chesters *Aescia*, Carvoran *Magna*, and Corbridge *Coria*. Vindolanda, carrying the element 'white', is one of the rare names to be confirmed in the writing tablets found there; 'Vindos' is derived from British, meaning white, and 'landa' is a lawn or enclosure.

Other names along the Roman corridor, though not old, are fun to think about, such as Goodwife Hot, the Goodwife's holt or wood. There is a Grandy's Knowe (hill), Crindledykes, Beggerbog, Bonnyrigg, Swallow Crags, Saughy Rigg, Fozy Moss, and many more to equal them in interesting sounds and meanings.

Glimpses of other peoples and practices come to the surface in names. Fourstones may be the kind of four-poster of stones arranged around a prehistoric burial similar to that at Goatstones. Hallington was holy, Newborough was a new fort, and the Portgate is where the Roman road passed through the wall. More recently, a Riding is a clearing, Settlingstones may have been where horses were mounted (saddling rather than settling), Stocksfield belonged to a monastery, Threepwood had disputed ownership, and Unthank was probably occupied by squatters, without leave. Wharmley ('quernstones') was a mill clearing, and Whittonstall had a quickset hedge.

The further back some names were established, and their changes can be traced in documents, the better the chance of learning what they meant originally. More recent names may suggest instantly understood meanings, and speculation about this can be delightful, but we have to be careful, as we can be wrong when we learn more about them. This is particularly true of field names, for every field has had, and has, a name. Why? It shows the intimate relationship between the land and those who work it; the names personalise it, reveal sometimes a sense of humour, frustration with difficult land, rejoice in fertility, comment on what grew there, what kind of animals and birds were at home on it, wild and tame. Corbies are crows, a tod is a fox, a whaa is a curlew, and a laverock a skylark, for example. There are many 'shields', temporary herds' huts built so that they could look after the animals on the summer upland pastures. Sillywrea was named after the willow, salix. Was a house called Humbleton named after a bare-headed hill in the Cheviots? Muckle Moss is big, Whinnetley Moor probably included gorse, as whin provided shelter for sheep.

We can find field names as long ago as the fifteenth century at Chollerton, but other sources of names are much more recent. One such source is the Greenwich Hospital surveys in the eighteenth century and later; the lands of the executed Jacobite, the earl of Derwentwater, based at Dilston, were administered by them. This resulted in very accurate accounts of all that he had lost, in acres, roods and perches, with every field named. The Earl of Northumberland's' surveyors also kept very good records of their landholdings, many much earlier than those of Greenwich Hospital, so we do have a lot to work on in this area.

FIELDS

The Tyne Valley has excellent maps available of the Greenwich Hospital estates, which include detailed field maps with names. I discovered one of these after I had given a talk in Corbridge, given to me by a lady who had kept it for over twenty years. This map, with farms stretching from Hexham to Haydon Bridge in different colours, now in the County Archives with a copy at the Moothall, Hexham, was accompanied by a sale catalogue which listed all the names on each farm. It is an example of what might still be undiscovered. The thoroughness of Greenwich Hospital means that from the early nineteenth century we have a record of considerable detail of land measurements, ownership and names.

It is impossible for me to work through all these old and new names here, so I will take just two examples, one buried in documents without maps, and the other a late nineteenth-century map of Fourstones village.

In 1479, a 'Terrier', a land-list, from Chollerton on the North Tyne gives us some of the earliest field-names in the area:

Kilneflate, Horselawpule, Schothalghbankys, Overshotlaubankes, Blaklaw, le Lons, Bronslauemedoue, Bronslawflate, Canonflatte, Canonbutts, Canondike, lez hevedlandes de Brouneslawflatte, Maynflatt, le Crosse, Holmersbank, Harlawhop, le Messeway, le lonynghed, Aldchestre, le Stobithorn, Morelaw, Dueldrigge, Smythehopside, Craustrige, Westraustrige, Estraustrige, Fartirmerethorne, Faltemere, lez Merlepottes, Waynrigg, Brereryg, Hudesrodes, Korhilles, Milnrig, Fulrig, Swynburne-feld.

Many of the elements are frequently present in other similar lists:

Flat, shott, butts, land, rigg, field

All these indicate the way the great medieval fields were split and apportioned.

If we can trust the sound of the words to approximate to something that we recognise, a piece of level land in the common field had a limekiln on it; a mill rig had a mill. Merlepots had clay.

A shott was a furlong, which included a 'haugh', land by the river. There are flats of land named Brown and Canon; there were rigs named as being foul, Dueld (dualled?), Crow's, west, east, wagon's, barley, Maynard's. One was a plough headland. Hud had some roods, the Swynburnes had a field, there was a black hill, a Brownshill meadow and a Brownshill flat. Some of the ground was wet, with a mire and a horsehill pool.

There was a road (lonnen), a road head, Messeways (path through boggy ground). Being close to the Roman Wall, there was an old fort. There was a hollow bank on a river or stream, brushwood, and some wasteland on a hill.

The next example is much more recent, a plan of Fourstones East Farm around 1820, by the Greenwich Hospital surveyors. It extended over about 351 acres, and the acres, roods and perches are marked in, as well as the name of the field.

Colliery Farm

Low Red Lands

Red Lands

East Red Lands

Dog Holes

Old Kiln Close

Gowkstone Field

Well Close

Buckley Wellfields

High Long Flatt

Low Long Flatt

Middle Long Flatt

Lee Hill

Hallbank

St Helen's Field

Peter's Haugh

Horse Flatt

Inner Hot Bank

Huxton Brow

Saint Foin Haugh

South Horse Flatt

Outer Hot Bank

Lancelot's Haugh

Errington's Haugh

Hot Wood

Peasecod Close

River South Tyne

Leach Poll Haugh

37. Fourstones East Farm drawn from a Greenwich Hospital map.

It is immediately obvious that we are not dealing with very ancient field units, as they are all 'enclosed' with straight edges, particularly where the turnpike road cuts straight through. The fields adjoining the river include three 'haughs' which means the flat alluvial land. Leach Pool indicates that it has a slow-moving drain running through it, but Lancelot's Haugh is a fanciful name, Saint Foin is a leguminous plant used on limestone soils as an improver (in French it means 'healthy hay'). Errington is a local landowner and place. Buckley Wellfield may mean that water springs up there rather than the field having a well in it. There seems to have been some religious impulse in naming fields after Peter and St Helen. 'Flatt' is an indication of something older, because although it may mean level ground, it is more likely to refer to a strip in the common field, normally a furlong. By this time such units had been split up into something smaller, but the name was retained for new fields within the old division: Horse, South Horse, Low-Middle-High Flatte. Other names to the east have the element 'Hot' in them, which means a holt, or small wood. Two still retain the wood connection: Hot Wood and East Hot Wood. 'Gowkstone Field' refers to a cuckoo, although in local dialect a gowk is also an apple core and an idiot. 'Lee Hill' can be the sheltered side or simply a field. To the north the element 'holes' is applied to diggings, and next to it is an enclosure (Close) with an old kiln. Then we are on to Colliery farm. Three fields with Red lands incorporated again refers to a division of the old unenclosed field of an earlier system of land-sharing, and 'red' may mean reeds or literally the colour of iron.

These examples will serve, however inadequately, to give a taste of what can be discovered from a considerable amount of material awaiting further work. It is another part of the richness that is the history of this valley.

THE ALN VALLEY

The Aln valley offers another cross-section of the county; part of the river's course was the subject of David Dippie Dixon's work, a local historian who lived in Rothbury, but was born in Whittingham, noted particularly for 'Upper Coquetdale' and 'Whittingham Vale.' The former has recently been up-dated by Paul Frodsham; the second will provide some of the material for this chapter, as his connection with, and love of, the region at the end of the nineteenth century and his research give an extra dimension to how we see the valley. He considered only the Vale of Whittingham, which in his study runs from the river's source at Alnham to Bolton, and I shall continue to search for other viewpoints from here to Alnmouth on the coast.

The valley has very fertile soil for the growth of crops, pasture, and trees, but is flanked by higher ground, some of which is moorland, and planted forest such as that on Thrunton Crag. It shares with the Tyne Valley a spread of prehistoric sites, signs of early inhabitants, some locations highly visible and others hidden. There is a Roman presence, too, in this area lying north of Hadrian's Wall, particularly of a road which crosses from south to north (the Devil's Causeway), running into Scotland, and by an east to west road from High Rochester (*Bremenium*) via Holystone, Trewitt, Lorbottle, Callaly, and Whittingham which joins it at Learchild, where there are the badly-eroded remains of a Roman fort. The region was only partly controlled by Rome, but there are Romano-British farmsteads at Canada (Millstone Burn), Longframlington, and Learchild along the Causeway. In the hills there are many Romano-British settlements which continued to cultivate lands farmed by prehistoric people for centuries.

A more recently-abandoned line of communication is the Alnwick-Cornhill railway, still visible in places, with some of its stations surviving by being used for other purposes. The main road still follows its way north from Longframlington, and although some of the original stagecoach road from Framlington Gate to Whittingham has been replaced, the old road is still visible as a substantial track as it runs via Newmoor crossroads (Rimside), Rough Castles (where there are two low-profile Iron-Age enclosures and some prehistoric rock-art) east of Thrunton Forest overlooking the Swarland brickworks, and so on to Whittingham.

The Vale is still a relatively quiet place, with local roads following the ridges that have always provided routes for tracks and roads from east to west; this is

38. Alnham from the Salters' Way: in the dip to the left is the church.

an area devoted still primarily to the cultivation of the land, and of low-density population. I shall select some examples of these.

The River Aln is narrow in its upper course, and at Whittingham it meanders considerably, widening when it reaches Bolton on course for Alnwick and the sea, flanked by woodland and high moorland.

I begin with **Alnham,** now a small survivor of what was once a much larger village on the fringe of the Cheviot Hills. It means simply a settlement on the River Aln, and in Dixon's time was often called *Yeldom*. The oldest spelling was *Alneham* in 1228, and it has changed little since then. There is now a re-used vicarage, a church, a redundant school, and a few houses standing in the 'tofts and crofts' once allocated for a garden and somewhere to keep an animal or two. A deep hollow way runs in from the north, known as The Salters' Road, coming from the southern part of the hills, and extending far beyond this area. The source of the river is here. The defensive tower, church, and traces of a castle mound with attached enclosures testify to a greater importance than the village has today, but these are not the oldest remains, as there are prehistoric enclosures on the nearby hills.

There is a particularly impressive 'hillfort' that shows signs of being used in Roman times too, and a settlement at High Knowes which forms an earlier settlement higher in the land. There are two palisaded sites (i.e. surrounded by

Top: 39. Alnham to the north.
Bottom: 40. Alnham Castle Hill.

a strong fence), but the recent aerial survey suggests that around them is an enclosure that may be a medieval deer park. Another sign of activity, this time over 4,000 years ago, is the presence at Scrainwood of prehistoric rock-art and burial cairns, on lower ground.

Whereas the High Knowes site has been excavated fairly recently, the Castle Hill site has not been, but the latter has been extensively surveyed, so I shall use this to show how light has been cast upon some of these hilltop enclosures. There has been an intensive investigation of Cheviot 'hillforts' from the air and ground, with an emphasis not just on the enclosures, but also on the wider landscape; after all, they were there to serve a community, and not to be just an enclosure against attacks. Those investigated have improved our understanding of their function, especially the 'Discovering Our Hillfort Heritage' project within the Northumberland National Park of all forty-two hillforts from the air, and eleven in detail from the ground. Among them was Alnham.

The equipment used for the survey, especially GPS, using satellites, is far more sophisticated than was available in the past. Not all hillforts have been examined archaeologically, but the new survey has enabled a more detailed sequence of events to be proposed without digging. However, it is sites that have been dug using modern methods, such as Wether Hill, near Ingram, that show most clearly a development from an unenclosed settlement of wooden round houses to a palisaded enclosure (surrounded by a big wooden fence), and then to an earthen rampart enclosing a large near-circular area, and finally to the building of a stone rampart to supplement the earthen one. As the defences spread further out, ring-groove houses were built over the earlier defences.

Hillforts were in many ways an advertisement for the power and wealth of the community which lived in or near them. Although some were built for defence, with thick, high walls of stone (such as Brough Law or Yeavering Bell), others had something more like terraces thrown up from ditches. The gateways were particularly important, reminding those who approached them of the power of the people within. At Alnham Castle Hill there is more than one entrance, and the sections of ramparts look out over different parts of the surrounding area.

Modern survey suggests that there was an early rampart in the centre, then two ramparts were added concentrically, with one and possibly two gateways facing north-east and south-east, with two round huts inside. The next changes were the highlighting of outer ramparts to the north-west and south-east. Finally, in the Romano-British period (or Roman Iron Age as it is now called) the ramparts were disused, and enclosures containing stone-based round houses were built, mainly to the east. Trackways led into the settlement from the west and east.

So the hillfort is like a defended 'village', although such a term is not accurate for something that would have been the homesteads of extended families, with the ramparts conferring some status on the group as an outward and visible sign of this.

In this late Iron Age-early Roman period, just over two thousand years ago, one big change is in building the houses out of stone instead of all wood, as we can see from excavations elsewhere; there is now evidence of a gap on some sites between the two periods of use, so we must not think of continuous occupation.

At Castle Hill it seems that the ramparts were no longer necessary as an enclosure, and that any boundaries within the perimeter were more for keeping cattle in than for keeping enemies out.

Why, then, did people choose to live in some places that had been abandoned long ago? It does seem odd to occupy a windy hilltop, even though the work of building some enclosures had already been done for them. Perhaps the place was still regarded as an ancestral home – 'our place'. We must see the sites in an agricultural landscape, where in prehistoric times grain would have been grown on the terraces and lynchets (obscured by later medieval ones, which continued to use the land for arable crops). Since prehistoric times the land has changed, and although the preservation of these ancient sites is widespread, later agriculture has built over them. For example, ramparts could have been turned into convenient animal pens or used as shielings, where herdsmen would build a temporary shelter to stay in when they looked after the grazing animals in the summer. There is so much highly-visible medieval rig and furrow ploughing, now grassed over, in the hills which cuts across terraces in a different direction, to show how many systems of ploughing have been used. This covers early 'cord rig' – about one metre across, which was one of the earliest forms of ploughing, but came back hundreds of years later as narrow rig and furrow. What is interesting to me is what the local people living to the far north of the Wall did with their surplus grain; perhaps they had an arrangement with the Roman garrisons to send it there in exchange for things that the locals did not have. The Romans may have drawn their frontier at the Tyne valley, but they did not ignore what was happening to the north of it. Many of the farm plans of this period, although not in the areas ruled directly by Rome, followed the pattern of what we call 'Romano-British', with arrangements of stone-based houses inside a stone-walled enclosure. We see these at Beanley Moor, and at Jenny's Lantern, for example, but we also see them incongruously inside Vindolanda.

Scrainwood (still pronounced Screnwood) was *Scravenwod* in 1242, and it has two meanings: Old English *screawena-wudu* is the wood of the shrewmice or villains (more likely); *screafen-wudu* is wood in a hollow place. It has several rock-art panels and boulders, and there have been discoveries of prehistoric burials there.

Another occurrence of rock-art, this time of simple cups, is on a volcanic block in Alnham Northfield – a rare case when the art is not on sandstone.

To return to the village: St Michael's church has an odd-looking north wall, as the aisle arches are visible on the outside; because the population shrank, the aisle was removed and the arches were filled in with stone. A major rebuilding took place in 1870, leaving some original features such as Saxon quoins on the north-east and south-east corners of the nave, some twelfth-, fifteenth-, sixteenth- and seventeenth-century features, all of which reflect periods of growth, change, ruination and restoration.

Inside, there used to be six thirteenth-century grave slabs, including one with shears (a woman's grave), four surviving on the choir floor, and there are others built into the nave wall. One tombstone that catches the eye is later – that of George Alder in 1611. Here, with some modernisation, is what is written on it:

> Here lies George Adder of Prendwick son of Robert Adder gent died riding thrown in the water at Kelso the ford called Hemrseid ford in Tweed casted away and found beneath the at Sharpit Low and dying on the 15 February 1611. All laud and praise be to the Lord and so forth.

As at Ford, Corbridge, and Whittingham, there is a strong defensive tower of the fifteenth or sixteenth century, known as The Vicarage in 1541, and it continues to be inhabited, but not by priests. It has been restored since 1844, and retains its tunnel-vault.

A green mound south-east of the church is mentioned as a castle in 1405, and was probably burnt in a Scottish raid in 1532, and thereafter began to decay until there is little left to see. However, there are lumps and bumps around it in the field which show its position, and of its outliers.

Like so many other Border settlements, Alnham was the victim of raids, especially in the reign of Henry VIII when events were building up to a major showdown at the battle of Flodden (1513) and after. We know from State Papers that great damage was done; it was reported that corn, hay, household goods, and a woman were burnt in a raid by 300 Scots, then a larger raid in 1532 brought 3,000 attackers to a wide area of the Middle March. The Flodden campaign, for all the bloodshed, had not stopped Border raids. Both the castle and the vicar's tower suffered – to say nothing of the people.

There is a survey in Alnwick Castle (Stockdale's) which has this to say in 1586:

> Alnham. The Lord hath there a fair strong tower of ancient time builded and strongly vaulted over, and the gates and doors be all of great strong iron bars and a good demesne adjoining thereto, the house is now ruinous and in some decay, by reason the farmer used to carry his sheep up the stairs and to lay them in the chambers which rotteth the vaults, and will in short time be the utter decay of the same house if reformation be not had.

(I have partly modernised this. 'Demesne lands' belong to the Lord, and often appear as 'Mains' in local names of villages and fields)
An earlier survey of 1541 has this to say:

> At Alnham be two little towers whereof the one is the mansion of the vicarage and the other of the inheritance of the 'king's matie p'cell' of the late Earl of Northumberland's lands being scarcely in good reparations.

Mr Dixon is eager to record local customs, and one in particular: after a wedding at the church, there was often a footrace to get to the place where the party was being held, when the men peeled off their jackets as they ran, fell into bogs and drains, ran across heather, and arrived 'breathless, coatless, hatless and mud-spattered' among barking dogs, squealing pigs, and peoples' shouts. This time it occurred in a race from Alnham to Ewartly Shank, after which there was a feast and dance, ending with the singing of 'God Save the Queen', after which the revellers 'dispersed to their several homes, amid the lonely valleys of the Cheviots.'

The life of such people was indeed hard work and lonely at times, difficult for us to imagine in our 4x4 and television age, so their parties were exuberant and very happy – apart from the hangovers.

At the nearby village of **Prendwick**, he records another such party. Prendwick itself, north-east of Alnham, along the base of the hills, was spelt *Prendewick*, *Prendwyk* in 1242, and means that it was Prenda's farm. It was famous for its lamb sale, an annual event, and for the Prendwick Kirn Dance which took place after the harvest had been gathered in. Invitation to the supper went out by word of mouth, fiddlers were employed, and the granary prepared for the occasion. People arrived on horseback, in carts, or on foot. After greetings, there was tea and spiced cake; in some cakes were a ring, a sixpence and a button, the latter meaning that if you chanced upon it you would not marry, whereas the ring meant that you would. The sixpence promised wealth, but not love, so the youngsters in particular were apprehensive when they took their cakes.

The upper floor of the granary was decorated with corn stalks and ribbons, home-made candles and a huge lantern. The Keel Row dance was begun with a lady visitor and one of the farmer's sons. After that it was fast and furious. If the fiddler 'squeaked the fiddle' by running his finger down the first string, it was a signal for a kiss. At some point, 'Bessie and Jimmie' entered – two young men disguised as an old man and woman – the floor was cleared, and they danced a difficult hornpipe. There were sandwiches and beer, and a corner where the old people could sit, smoke and chat.

At the end of the evening came 'The Cushion Dance' which was not restricted to this area.

When I came to write a novel for young people called 'Unquiet Grave' I used the sources that I had found of the ritual and made it a meeting point for two of the characters. The wording of the ritual is formal, and the rest made up.

THE CUSHION DANCE

The candles in the old barn had nearly burnt away.

"The Cushion Dance" everyone yelled, and the fiddler turned to his friends with a nod. As they tuned up, someone brought in a cushion.

"Who's going to start then?"

"Give it to John Bolam," came the hoarse voices of a gang of men who had drunk enough beer and cider to guarantee very sore heads the next day. They were envious of John that night, for he had been made farm manager, but they bore him no ill-will. He was one of them. So they pushed John before them, and he held the cushion close to his body.

"Take your partners."

To the fiddles, flute and small pipes, those who were still sober began to dance; John danced around with the cushion until the music stopped.

Mary waited, seated, alive with excitement. Attractive, beautiful to some, with her red gold hair that shone in the candlelight, accentuating her white skin, she'd had plenty of boyfriends in her short life. She wanted John, who was older than her, handsome after his fashion, and now a real catch. He had told her the news as they brought in the last of the harvest: he was to be farm manager.

There was thick tobacco smoke through which the candles wavered, and a strong smell of sweat and hay. John was surrounded by silence.

Mary's inner voice pleaded:

Please John, choose me.

I have watched you all night. I want you.

Everyone knew the words, the ritual.

"This dance it will no further go," John began.

"I pray, you good sir, why say you so?" Mary had been chosen.

"Because Joan Sanderson will not come to."

"She must come, whether she will or no."

Mary took the cushion that John held out to her and knelt on it at his feet as a hundred raucous voices shouted;

"The best bed, the feather bed,

The best bed of a';

The best bed in 'wor hoose

Is clean pea straw."

John raised Mary from the cushion and followed the tradition to the end.

"Welcome, Joan Sanderson," he said, and kissed her.

"We shall get married now," he added, quietly in her ear. The ribaldry around them grew worse, but they were oblivious. The band played its final number and, with the exception of some snoring youths that were better left where they were, the dancers eventually found their way home.

RYLE

Great Ryle, Little Ryle and Ryle Mill formed an estate, the earliest spelling of which means Rye Hill, just the same as Ryal close to the Tyne.

Great Ryle, *Rihul* in 1177, was owned by the Umfraville family of Harbottle, descended from those who had been rewarded for services to William the Conqueror.

It eventually passed to the Collingwood family, and then to Lord Ravensworth, in the parish of Whittingham. There is a record of 'two pele towers' in 1541 at Great Ryle and Prendwick, newly built, but nothing remains today. These fortified towers join a long list of about 1,000, of similar recorded structures throughout the Borders.

Mr Dixon recalls for us that in the mid-nineteenth century, the hamlet of Great Ryle had long, low-roofed thatched houses made of oak beams that were carried down to earth instead of resting on the walls. A party wall divided them, with a doorway from the part where a cow was kept in the winter to the place where the family ate and slept. There was only one entrance from outside, and this went through the cow quarters. Accommodation was sparse, with box beds and a 'kist' for keeping clothes in, the heat coming from a fireplace with an open chimney. There would have been little light. There are official reports on accommodation for farm workers which show that those who moved to another house after the 'hirings' would take window glass with them and other fixtures. As agriculture was labour-intensive, especially at harvest time, and there was competition for the best workers at the annual hirings, landowners and farmers began to realise the importance of offering hired people better accommodation. Such reports praised farmers like John Charles Langlands of Old Bewick, for example, for building decent housing, and keeping his workers and training his managers locally. The labour force was supplemented by itinerant workers, and by the women Bondagers, both groups being necessary, but seen by some as a threat to good morals.

One little anecdote about this area is a curious one, which shows how an event that did not take place there was claimed: the story of the Queen and the Robber. This belongs to the Hexham area where, during the Wars of the Roses, the defeat of a small Lancastrian army (a skirmish rather than a battle) led the queen and her son to flee to the forest, where their lives were threatened by an outlaw. The queen pleaded with him, telling the truth about who she was, and he relented and led her to safety. There was even an opera written about it, performed in London and Hartlepool. (For more details, see my book on Hexham).

Little Ryle (*Ryle Parva*) is at the bottom of the valley on the south side of the river, and the farm incorporates the ruins of a bastle house in which the Collingwoods may have lived. Ryle Mill completes this small grouping.

ESLINGTON PARK

I was lent a coloured map of Eslington when I arrived to talk to the Local History Society at Whittingham on place names and field names. Dating to the latter half of the eighteenth century, this was one of many that seldom sees the light of day, and I was asked to comment on the meanings. Fortunately

this was not too hard, although, of course, there were some that I could not explain. As I chose Whittingham Vale as one of my viewpoint areas, and knowing Mr. Dixon's interest in the field names of the farms there, I shall use this as an opportunity to look at some field-names that I have not covered elsewhere. First, though, the place itself. It was first recorded in 1163, and means that the settlement was named after an Anglian called Esla. At the time of Mr. Dixon's writing it was the country seat of Lord Ravensworth, the latest in a line of owners that included Hesilriggs (or Hazelriggs), Herons and Collingwoods based at the manor house. The house was castellated in the 1330s, but there is nothing left to see of that. How the Ravensworths came to own it was because another Northumberland 'worthy' was in the same boat as Lord Derwentwater of Dilston; George Collingwood was executed for his part in the 1715 Jacobite rebellion, and the family that became the Earls of Ravensworth, which at the time was headed by Sir Henry Liddell, bought it and built the present mansion in c. 1720. The mansion was added to in 1797; in the most recent Pevsner it is described as 'very simple but very dignified.' It was the first Baron Ravensworth who added the stables and offices to the west in 1858, and gates, walls and bridges leading up to the house. The bridge, called the Lady's Bridge, became well-known because the engraver, Thomas Bewick, made a woodcut of it.

Although the present park has no traces of the position that it held at the time of Border problems, documents tell the story of the Collingwoods in Border warfare helping the Warden of the Marches to keep order. The estate was rich agricultural land, and would have been tempting to Scots raiders, so militancy was necessary to protect it. The fall of the Collingwoods came when George joined Radcliffe at Warkworth and went with him to Preston, where they were defeated and captured. In the second rising in 1745 the passion had not died, and Thomas Collingwood was accused of high treason at Morpeth, from which town he escaped, and had a high price on his head. In the offer of a reward he was described as 'a person of middle stature, about 25 years of age, has a round face, and a short nose, and wore, when he escaped, a light-coloured wig, a dark-coloured coat, and silk handkerchief about his neck.'

He was caught, tried at Carlisle in 1746, but was released when nothing could be proved against him. Today the name lives on in many branches in a widely-scattered area.

By the time the estate had been sold in 1718, the deeds included 'a large stone house, sash'd, with coach house, stables, etc. A garden well-walled and planted with an orchard and other conveniences, fit for a gentleman.'

The Liddell family who bought it were later raised to the peerage. A son, Henry Thomas Liddell, became a MP in 1826, and his campaign and election give a viewpoint of the way people were elected before the great Reform Bill of 1832 was made law. The poll was over fifteen days, with candidates wearing different colours, and even having different tunes for their campaigns. Voting was

open, (not secret), there were processions, feasting, drinking and revelry – all of which cost the candidates a lot of money, and brightened up life for some of the population. The election was held at Alnwick, so candidates arranged for voters to travel there.

> After being feasted and refreshed at the expense of each party alternately, they voted for their man on the very last day of the poll, with feelings of regret that the glorious campaign had come to an end. When Mr. Liddle, after the election, went to Rothbury to thank his supporters there, a great crowd met him at the west end of Beggar Bog, took the horses out of his carriage, and dragged the successful candidate in triumph into the village. In doing so two men were unfortunately run over – one, John Mackay, was killed on the spot; the other, William Storey, was seriously injured.' (Dixon)

We also hear that the election was accompanied by some amusing songs and rhymes, so all in all it was a very robust and, for some, a dangerous affair.

The MP became a lord in 1855 on the death of his father, and left the Commons. In 1874 he was created Earl of Ravensworth and Baron Eslington, but died four years later.

FIELD NAMES

This has been one way of looking at the some aspects of life of the community, and now I will put the spotlight on Eslington to show another part of life: its fields. Dippie Dixon, throughout his book, names fields as he goes along, farm by farm and estate by estate. I share this interest, but have not before looked closely at this area, apart from the Alnham Northfield field-names. They tell us so much about the farms, and although it is likely that they were named from the very beginning, many or most must have been changed, so what we have when we discover a field-name map or list is a window into that process at that time – but the principles of naming are the same in any period. I took up the challenge by the Local History Society with a map that is interesting, though not so old as some of the estate maps that I have studied, like the hand-painted maps of the 1620s of the Earl of Northumberland's extensive estates.

This is what I wrote for the Society's annual publication:

ESLINGTON ESTATE IN 1746

The map of the estate (spelt *Esslington*), belonging to Sir Henry Liddle, has all its fields named, and is a good snapshot of the process of naming places. Eslington itself is documented in 1163, meaning Esla's named settlement.

Many of the field names have obvious origins and meanings, but some are more difficult. Some of the most common give directions, although it is not clear, for example, what a field is north of. There are over twenty of these 'directional' names, including North East Close and West North Bank. East Field is capitalised, and may therefore be a remnant of a major division of farm land in medieval times into 'Great Fields' and their subdivisions. 'East Field' lies north-east of the village.

Some fields are named according to their use: Mill Close for the miller, Spittle belonging to a hospital, Nine Wells probably the source of many springs, Pedlar Close set aside for the pedlar. Lime Kiln refers to one of the most useful agricultural buildings of the day, with lime for fields and such things as whitewash and disinfectant. Peat Pots is interesting; not only could it have been a source of peat for burning, but may also have provided clay for pottery (there is a Dirt Pots near Elsdon). There are Easter (eastern) and Wester (western) Turf Moors. Clover Lands and Clover Field appear sometimes as 'Clavering' on other maps. Ox Close reminds us that oxen were the main source of pulling power, and here they were enclosed. Coney Warren was deliberately created for a source of rabbit meat and fur. There is a Duck Field, Hare Park, Brown Cow and Raven Cragg. The Carlings are possibly places where peas grew well. Glebe Haugh (land by water) and Glebe belonged to the church.

There are indications of what was growing. Eshott would have been a slight ridge with ash trees (like the one near Felton). The Reeds is self-explanatory, and Whitefield, of which there are many in Northumberland, may be named after grass that turns white, an element also in White Leazes, where a 'lea' or 'ley' was pasture or meadow, and Leazes its plural. Other fields may be named 'meadow' as in How Meadow – a meadow in a hollow. West Thorny Bush is clear. Ellen Steads is a steading with elder trees or bushes.

Crook Bank is a bank beside a curving stream (as in Crookham). Mearburn Close is near water. Stob bank, on a burn, had tree stumps. Hopesburn is in a valley.

One has to be careful not to associate all *riggs* with ridges. In medieval farming the large fields were divided into strips, the largest of which was a furlong, but *riggs* were also land allocations for tenants within the large common fields, along with *dales*. *Butts* were bits left over. *Lands* were also divisions, so Eshott Lands fall into that category.

Later divisions could be named after people, as in Wades Piece.

An interesting name is Threep Moor, as this comes from Old English *threpian*, and Middle English *threpen*, meaning that its ownership was disputed (there is a Threepwood near Haydon Bridge). Jockeys Field is also Dike Nook, a walled area. Kellets (Close) is a surname. A 'Rawlidge' may be a ridge with a row of small buildings on it.

As Mile and Whittingham are places nearby, there is a Mile Pasture, West Mile, East Mile, Whittingham West and Whittin Lea. 'Payne' gives a name to a rectangular strip.

So far these names are fairly straight-forward to interpret, but others present problems, either from changes in spelling or obscure origins. The 'peth' at Rumpeth is a path, but why 'rum'? Was it 'rim'? Sprittle Doles may be a mis-copying of 'spittle', a name we have seen already, and 'doles' are either dales or a day's work. 'Howbanth Field' could be a bank by a hollow. Sirenkle Bank is obscure, but 'le' at the end of a name often refers to a hill (Toddle, for example, being fox hill). Catt Callow may be named after a wild cat (a nickname too), and gallow is not necessarily a place where someone was hanged: Old English *galga* as *galla* means barren, wet land.

What is Cumber Croft? *Cumber* in Cumberland means Welsh, and *Cumbra* is a personal name. Wanless Crook is a bend in a steam or river with a surname that is still in use. Is Pasture Deveridge a personal name of ownership? Wellywise Field sounds fascinating, but is it derived from 'springs'?

There are two Camp Fields, and the word 'camp' must always remind us that that it is a name often given to a fortification of any age. *Campus* is also a field.

Finally there is a Saint ... tian Field, which is obscure.

One further puzzle on this map is the type of script used for different fields: block capitals and 'Gothicized' italics, for example. One asks why in West Thorny Banks the middle word should be in gothic script, and the rest in capitals. However, the great virtue of this map is that the names are readable.

SIGNIFICANCE OF THE FIELD PATTERNS

The shape and size of the fields is very much of the 'improvement' period, when rectangular fields were imposed on earlier systems, varying in size. These could, of course, follow the old rig and furrow allocations so evident in the county, but that would need older maps and documents to check, if they exist. The settlement of Eslington, at the centre of the field system, has small plots of land attached to each cottage, with roads radiating from it. It lies in the bank of the River Aln, here a small watercourse.

It is a tightly-patterned series of holdings. To the north it is bordered by Clinch Grounds, then, clockwise, by Branton, Glanton, Shawdon, Bolton, Broompark, Learchild ('Larchild'), Edlingham, Callaly ('Callela'), and to the west by Great Ryle. Such place-names have a documented history, whereas Field Names are far more transitory, changing when fields are split up, when land ownership changes and maps are lost, and for other reasons.

OTHER FARM NAMES BETWEEN ALNHAM AND ESLINGTON IN THE LATE NINETEENTH CENTURY

Dippie Dixon took trouble to gather these names together under the various farms.

ALNHAM

The earliest records seem to be those of 1615, when the fields were named thus: Kirkbank (church), Whitchester (camp with white grass), St Andrew's Wells (springs), Penny Laws (Rent?), Cuthbert's Flatts (divisions in the old field system), Abbot Acres, Nyne lands, Vicar Cross Flat, Kipple Deales, (hill where land is split into stints?), Huckes Laws, Grayes Meadow, Coatt Wendes (?), Chapel Dene (valley), Pill Moore (pool), and Guild Acres.

The fields recorded by Mr Dixon are: The Camp Hill Pasture, The Millers Field, The Mill Ridge, The Millers Close, The Castle Middle Field, The Dyer's Field, Buddle's Upper, Middle, Low Field, Tulley's Close, Carter Knowle Field, Hogden, Cobden and Hogspethfield.

So there were millers, cloth dyers, fields with hogs (in a valley and on a path); some fields lay in the old castle grounds, and Tulley and Buddle gave their names to some (but note that a 'buddle' is also used in lead washing). The parish itself included Prendwick, Scrainwood and Unthank – the latter, like that near Haydon bridge, meaning that the land was occupied without leave, by squatters.

I add to this the Tithe map of the same Northfield which is part of the Duke of Northumberland's estate, which shows a difference from those given by Mr Dixon at a later date.

The common land was divided and allotted in 1776, which accounts for the small parcels and for the straight boundaries.

The Northfield includes here farms called Northfield Head, Penny Laws, Part of West Unthank Farm, The Castle Farm, Alnham Home Farm and Hestleton Ridge Farm.

The fields are named (with my comments in brackets) West and east Willow Field, Little Castle Field, The Long Bank, Great Bankey (on the slope), Hestleton Ridge Moor (hazel grew there), Black Chester High Field (a bleak fortification), Middle Field, West and East Castle Field, The Castle SW Close, Penny Laws (a 'law' is a Hill and 'penny' may be to do with rent), Near, Middle and Far Fields, Alnham Moor (once waste), The Middle Castle, SE Close, Alnham North East Field, The Church Field, Alnham South East Field, Home Pasture, Alnham Middle Field, House Pasture, Alnham West Field, The Castle Hill Pasture, The Lea Field, New Field, Camp Hill Pasture, Plantation Field, Black Chesters cow field, The Quarry Close, Alnham Glebe lands (belonging to the church), The Millers Close, Ormonds Close (N,S,E,W, Mid), Unthank West Wood, Cobden Pastures, Carter Knowle (hill), Penny Laws Near Field.

41. Map of the Alnham Northfield in 1843.

The tenants named are: Storey, Tulley, Marshall, Green, Fettis, Hindmarsh, Awburn, Atkinson, and Chrisp – many of these are familiar names in this area today.

PRENDWICK

The fields were named as: W., E., and Middle Floats (named after 'float grass' which grew on swampy ground), Willow Tree, Dove Cote, Mill-Dam, Church Fields. Others less obvious are: March Gutters, (March being on the edge), Black Middens (a waste heap?), Maylies (where it could have been 'leas' – meaning fields), Among the hills are Hart Law (deer hill), Crow Plantation, Old Stell (shieling), Craw-Crook Well (a 'craw' being a crow, 'crook' meaning bend, and 'well' being a spring), and Gairs Syke ('gair' being a grassy place and 'sike' being a watercourse).

RYLE

Middle West Horsden Hill (horse hill or valley), Low-High Cow, The Croft, Whinney (gorse), Middle Mere Burn ('mere' being a boundary in this case), Front, Little. Closes: Ox, Cow, Curry's.
Lands: Railey, West Railey (rye fields).

LITTLE RYLE

Night Fold (where beasts were enclosed at night), Kiln Field, The Seven Acres, Fanny's Burn, Beans Close, Bought Knowles (hills with a sheepfold), Horse Close, Quarry Field, High Hopes Close and Low Hopes Close ('hope' usually being a blind valley), The Half Moon (its shape), The Middle, The Four Acres, The Ten Acres, West Intake (taken in from waste), The Haugh (alluvial land), The West and East Flowers.

RYLE MILL

The Haugh, Kiln Field, Middle, Stackyard, North Back, North Broom, Low and High Leazes ('fields'), Mere and Low Mere Burnside (boundary).

UNTHANK

Ormond's North and Hill, Waterside Close, Ruff, Cart Close, Well Close, Coldside, North Red Meadows (reed).

CALLALY

Mr Dixon selects these names from Yetlington Lane Farm, Callaly High House and Cross-Hill Farm: Big-Hops Close, Low Floats, West, High, Low Charters, Tongues, Haver Acres (oats) Ox Close, Snowden's East Close (surname), High and Low Thornlees, Gills' Well, Nesbitt's Close (surname), Four Nicked Close, High Folly, Mare Meadows, East Cow Hill, East and West Pea Law (hill), Box-Hill Field, High and Low Camps (prehistoric) and Ewe Layers.

LORBOTTLE

In 1724 the names were listed with various crofts and closes, and these: Watter Leys (fields), Long Faugh (fallow land). The word *flatt*, which was a division of the great fields in the medieval system of land allocation, appears in Great Field Flatt and South Flatt. One that is difficult to interpret is Prumpley, although the *ley* in it means a field.

WHITTINGHAM

Mr Dixon picks names from these farms that he finds particularly interesting:

West Rothill: Tod's headlands ('Tod' a personal name but is also a fox, and the headland is where the plough turned), Hawklemass (hawk hill), Ellen Steads (name or elder tree), Tile Kilns, Bradford (the broad ford), Turf Moor.

East Rothill: North Camp Field, North Rumpeth (?), Pasture Davridge, Broomy Stobs (stumpy ground covered with broom).

High Barton: Green Side, Night Folds, North Duck Field, North Eshet Lands, East Raveledge (raven ?), South How meadow (hollow)

East Lane Head: Middle Close, West Close, East Mill Close, Aller field (alders), Spire Leazes (? fields).

South Whitton Lea: North Tire Carlings (Peas), South Tire Carlings, Wester Bank, Lime Kiln Field, Middle Intake, West Intake, East Whitton Lea.

Whittingham Inn Farm: Crook bank (winding), West Pedlar Close, South Middleton, Camp Field (also The Shay Field, where the Postchaise sometimes stood), Easter Bank (eastern).

Middle Whitton Lea: Nine Wells, Gourleys (?), West Wood head, West New Close (also White Knowe – hill), South Spittle Dowes (hospital)

He also lists the Eslington estate names, which I have used in this account from the earlier map. Some of the above are also duplicated in that map.

There is still so much more material to be examined, including names of fields today – a fine and useful project for Local History Societies and for university departments. With that brief spotlight on names, I will return to the settlements in the valley.

Following the course of the river to the sea, we encounter **Callaly**, to the south of the Aln on a tributary, which from its earliest Old English spelling in 1161 was *Calluelea*, pasture for calves. It came into the ownership of another well-known family, the Claverings, whose old family name was de Burgh. Like other local families, they were mixed up in national and Border politics, and their fortunes varied. For example, they supported the king in the English Civil War, the losing side. They were linked with the Duke of Newcastle's 'Whitecoats' and were defeated with the rest at Marston Moor, and for their loyalty to Charles I they lost some of their estates, but retained Callaly. Like so many others, they also backed the wrong horse by joining the Jacobites, when William and his brother John were captured at Preston and taken to London. We hear that Lady Cowper, beautiful Mary Clavering of Chopwell and married to the High Steward of England, managed to get clemency for them, so some estates remained theirs. The Claverings owned Callaly for six centuries until, in 1877, it was sold to Alexander Henry Browne. Mr Dixon saw this event in this way:

> And those who have the weal of their county at heart, must admit that the change in ownership has been a happy one, for a wealthy and resident landlord is beneficial to all classes.

In Pevsner, the writer on Callaly Castle calls it: 'One of the most interesting and varied houses in Northumberland. It would deserve a monograph all by itself.' Although it is multi-period, most of what can be seen, but not often open to the public, is from 1675-1890. It is very large, irregular in plan, and the south part incorporates a medieval tower.

The road that leads to Whittingham passes the rising ground on which Castle Hill is so-named because it has a large hillfort of pre-Roman times with some rock-cut ditches forming its enclosure. It is difficult to interpret what can be seen there, but well worth the climb through some lovely woods to reach it. When my children were small the wood was a place of great fascination for them, as there is an abundance of different kinds of fungi, and the beech trees that grow there are so beautiful at all seasons. Within the enclosure are the remains of two rectangular buildings which are thought to be remnants of Old Callaly, a castle documented in 1415, with commanding views. As no excavation has taken place, it is impossible to say more.

Mr Dixon is very interested in family trees and details of architecture, but he also likes legends, and one that he cites concerns the fact that there were two castles at different levels. Apparently George Tate, a notable local historian, has it that when the lord of Callaly was erecting a castle on the hill, his wife preferred something lower down. She got one of her servants to dress up as a boar and he went up the hill to pull down what had been built during the day, relying on an old superstition. So the lord sent his men to keep watch, but when they saw the 'boar' come out of the wood and pull down the work they were scared stiff and fled. The lord gave way, and built his castle below! Believe that if you wish.

LORBOTTLE

Luuerbotl in 1178, the *botl* is Old English, as in Shilbottle and Harbottle, meaning a building, and the person from whom it was named was Leofwaru.

In 1724 it had sixteen farms. The 'big house' or hall was built at the turn of the eighteenth century for Adam Atkinson, after which the estate was bought by A. Browne of Callaly Castle. What happened to the small village, or 'township,' is not known, but we do know that in the Civil War sixty men were taken by the Roundheads as they lodged there, asleep.

From Lorbottle to Thrunton there are sandstone crags, forming the boundary of the Vale of Whittingham, to the east mainly covered with coniferous forest.

They have ousted what might have been there – beech and birch trees and many heath plants which still grow elsewhere to the west. One notable feature of Callaly Crag is 'Macartney's cave', said to be carved out of the hillside for a retreat for the named man, who was chaplain at Callaly Castle, and a cave called 'Wedderburn's Hole', named after a cattle rustler.

42. From Thrunton Crag north to the Vale of Whittingham.

The crags are steep and spectacular, with splendid views over the vale and to the east, with one overlooking an industry that has taken advantage of a thick deposit of glacial clay – Swarland Brickworks – that still flourishes.

Where there is forestry, care has been taken to keep the crags open to walkers, with well-defined footpaths and cleared viewpoints. To the west, along the same ridge, where the moorland is still open, there are many prehistoric burial cairns and sites of settlements.

WHITTINGHAM AND GLANTON

Two of the most substantial settlements in the valley are Whittingham and Glanton, both just off the main road today, and therefore affording some peace from modern traffic. It has not always been so, because the old stagecoach route from Newcastle running north went through them. The Roman road, the Devil's Causeway, running in from the south-east, joins the modern road at Powburn, after which it runs parallel to the old Alnmouth to Cornhill railway line, the latter taking advantage of a narrow gorge left behind by melting ice, which breaks through the high ground on either side, where, to the north-east, is an open landscape of moorland on which are many prehistoric sites, some of the finest in Britain. I shall say more of these later.

Whittingham is now the largest village in this part of the valley, its position owing much to the routes that passed through it. The stagecoach road crossed the Aln in the village by a ford until a stone bridge was built at the beginning of the nineteenth century. In 1846 the present main road was constructed, and in 1889 the Alnwick-Cornhill railway opened.

It is a large 'township' historically. At its centre is a 'pant' (spring), which was rebuilt as a drinking fountain in 1874 as a memorial to the Revd Goodenough's wife, Elizabeth Ann.

It has a church that shows its great Anglian antiquity, and a surviving fortified tower. There was another tower which became a vicarage, just west of the church. In the nineteenth century this was extended into a long narrow building along the road, but it was demolished by the Rev. Goodenough, who rebuilt a new one on the site off the road.

The church is a reflection on what amounts to the insensitivity and vandalism of some Victorians to the past, for the oldest Saxon church tower in the county was almost totally pulled down by the same local vicar and replaced by a gothicized one. Today the story is shameful. St Bartholomew's was a manorial church erected by its owners, showing alterations and additions from early Anglian times through the Norman and medieval periods, surrounded by a large cemetery, on the river bank. We know that in 1090 its tithes were given to the monks of Tynemouth, eventually becoming the gift of the Dean and Chapter of Carlisle Cathedral. The priest lived in a rectory, until in 1307 his title changed to vicar. It went through the changes of the Reformation and the Civil War, but survived as a building at the centre of the community.

The awful fate of the Anglo-Saxon (or Anglian) building came in 1840, when the new vicar, Rev. Goodenough, had the tower dismantled and replaced by the present one. The old one was built on a 'long and short' work design, where different-sized quoins (corners) alternated. Other churches of this period, such as Warden and Bywell, had massive sandstone quoins, but not like this, which are unique and the best in the county – even though only the lower courses survive. They are linked to survivals in the west wall of the Saxon nave.

The History of Northumberland, edited by Madeleine Hope Dodds in 1933, a standard work, has this to say of the vicar, quoting Hodgson:

> ... a Yorkshireman who understood neither Northumbrian dialect nor Northumbrian architecture, he yet contrived to make himself very popular in his parish.

It is amusing to read that this man who caused so much annoyance to antiquaries was himself of an extremely sensitive, irritable temperament.

Gunpowder was used to demolish the tower; the survival of its base was because it would have endangered the new north arcade.

The architect was also responsible for pulling down some fine Norman work that formed the round piers and arches of the north arcade of the nave, like that

left on the south, and replacing it with imitation thirteenth-century work. There is original Early English (Gothic) work visible, but why he should have destroyed a Norman arcade like that is incredible.

In 1841, the Archdeacon Singleton visited the church and deplored the removal of the pillars. He said of the vicar; 'He is proud of his work and has fitted up for himself a most aristocratic pew', long before the present pews were made. There is a sketch of the outside of the church before the 'restoration' took place.

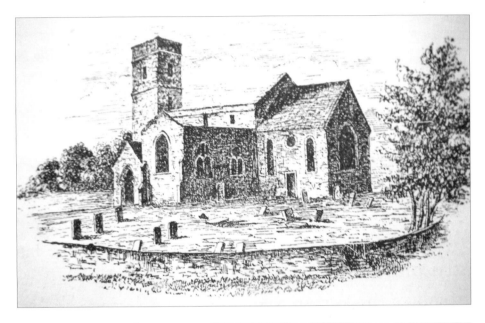

Above: 43a. Drawing of Whittingham church before restoration, included in Mr Dixon's book.

Right: 43b. The tower today, showing the splendid Saxon long-and-short quoins below the rebuilt section of the upper tower.

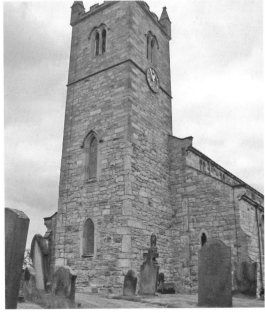

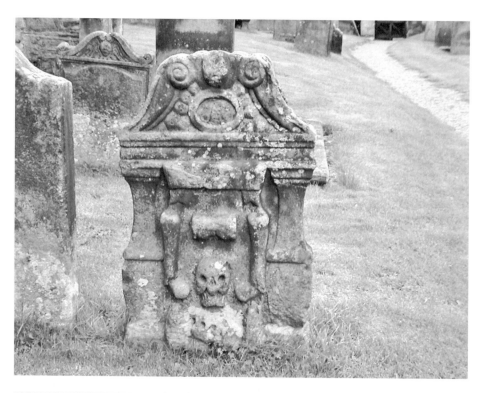

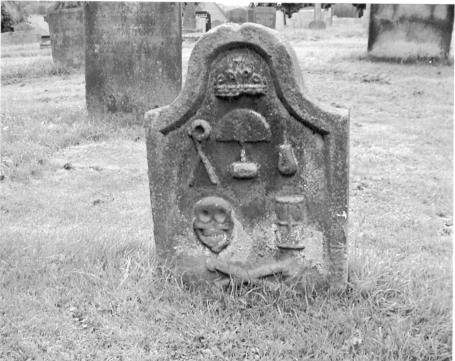

44. Two gravestones in Whittingham churchyard, both with symbols of death, and one with tradesman's tools.

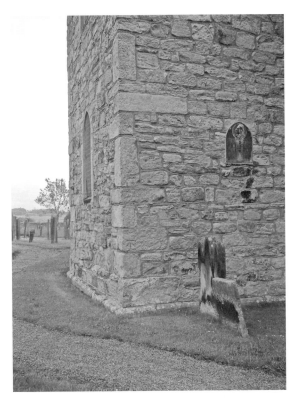

45a. Whittingham: Saxon quoins.

45b. Saxon corner.

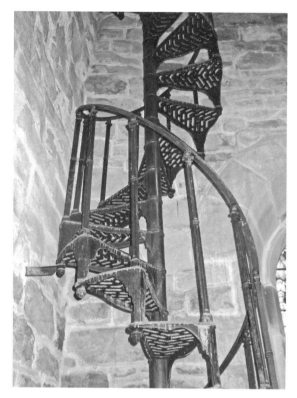

Left: 45c. Modern spiral stair in the Saxon tower.

Below: 45d. Latin cross.

The chancel was restored, and the east widow is in memory of the architecturally-insensitive vicar, in 1880. There is also a sad tribute to his son, who was killed in the Crimean War, mourning his 'early promise' and 'his untimely death'.

The porch, Early English, has a sundial on the gable. It leads in from a very interesting churchyard which, from the drawing, looks large and circular. Near to the east stile (one of two) is a Latin stone cross, found in the north wall of the churchyard and re-erected.

The gravestones are an interesting collection, many obviously carved by local masons, and all telling their stories of human life and death. The oldest are early eighteenth-century, like those, for example, at Hartburn church, but not so sophisticated. There are the symbols of death, such as an hour-glass, skull, and crossbones, and there are symbols of the trade of people buried there, such as a saddler's knife, a bradawl and compasses. There are the sad tales of many children dying early, and the sentiments expressed about mortality and the afterlife. On one grave, that of Ralph Ruttledge, is recorded the death of '9 small children,' and his son at forty-five. His wife died at thirty-five, and he at sixty. What on earth lies behind that in terms of human suffering?

Thousands more buried there have no memorial, and this is the story of such churchyards. There are many examples of the land around the church, 'God's Acre', being considerably higher than the church base with the sheer volume of burials.

THE TOWER

The tunnel-vaulted defensive tower that is another prominent monument in the village was the focus of local Press stories in 2009 when the refurbished tower, owned by someone who lived far away from the village, had to be broken into when a caravan beside it burst into flames. Firemen traced the problem to an electric cable leading from caravan to tower, and when they broke in they found cannabis growing there. There had been concern about the refurbishment of this tower by local people, who thought some ancient structures were being removed from a graded building.

The tower is likely to be from the fourteenth century, the period when the wars with Scotland were hotting up, and the rest may be sixteenth- or seventeenth-century (Pevsner). It became ruinous, so Lady Ravensworth took matters in hand, and had it repaired in 1854. Here is the inscription:

> By the munificence and piety of Lady Ravensworth this ancient tower which was formerly used by the village as a place of refuge in time of rapine and insecurity was repaired and otherwise embellished for the use and benefit of the deserving poor.

The valley, in a survey of 1734, was considered 'large and populous.' In 1811 we are given the facts that people belonging to the district of Whittingham included a

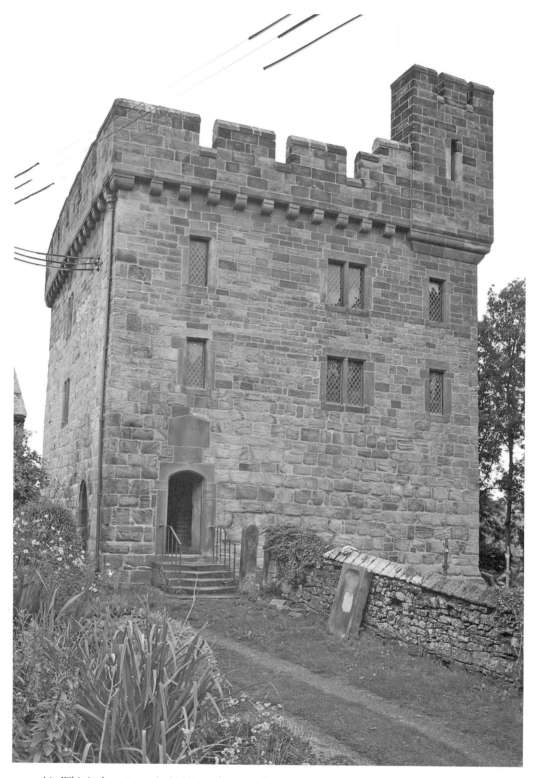

46. Whittingham tower in 2009, much restored.

schoolmaster, millwright, painter, butcher and innkeeper. Between 1821 and 1855, Mr. Dixon has given us more details of occupations:

North side of the Aln: farmer, woodmen, labourer, joiner, quarryman, foreman drainer, two millwrights, schoolmaster, draper and glover, three carriers, stonemason, grocer, shoemaker kilnman, head forester, and three tailors. He also lists two who had 'disappeared'.

South side of the Aln: blacksmith, cooper and grocer, carter, two shoemakers, stable workers, four occupants of almshouses in the tower, two people in the post office, blacksmith, butcher, five labourers, one in the 'killing shop', a farmer and overseer, draper and grocer, grocer, saddler, and an innkeeper.

Each time we look at occupations within Northumberland villages before recent changes, we can see how self-sufficient the people were. It is very different from today when schools have closed, Post Offices have either closed or are threatened, and village shops are a thing of the past in many places. Houses have been taken over as second or retirement homes, and local people can no longer buy houses in the face of outside economic affluence. This also stems from the way in which agriculture has been intensively mechanised.

The area was famous for Roman Catholics who defied the Church of England authorities, and openly rebelled to re-establish Catholic kings. They were the big landowners, the Claverings and the Collingwoods. They had a chapel built in 1750, but it was not consecrated. A resident chaplain was appointed. The church closed in 1877 when the estate was sold, and the money was transferred to St Mary's on the Eslington estate, completed in 1881.

Dissenters had their own ideas about worship too; in 1702, a house in Glanton was licensed for worship, but the church congregation split, apparently between farmers and shepherds, and another church was built there in 1783.

GLANTON

The name comes from Old English *glente*, which means a look-out place. This fits the location of its outstanding small hills that lie to the north of the present village. The village has nothing ancient in its buildings such as we find in Whittingham, but there are some elegant buildings dating from the eighteenth century, and an even earlier dovecote attached to Glanton House – the birds kept there were used as a winter food supplement.

I choose again to focus on the number of trades in the village, including Powburn, this time in 1827: cooper, milliner, baker, slater, draper, blacksmith, three grocers, four joiners, shoemaker, two masons, butcher, six farmers, surgeon, three innkeepers, a schoolmaster, and a Presbyterian Minister.

When Mr Dixon was writing, he says that it had developed into a popular health resort, the opening of the railway bringing in visitors who were also interested in exploring further afield. It had a famous well called the 'Keppin Well',

where the story has it that parents took weakly children there in the summer to be strengthened, wrapped in blankets and placed under the spout. The name meant that the water was kept or 'kepped' in pails or jugs. The village had its own poet, one Thomas Donaldson, a weaver.

I leave, with gratitude to him, the work of Dippie Dixon to take a broader view of the landscape, especially from the air, as a viewpoint as the Aln winds its way towards Alnwick and the sea.

A good starting point is one of my favourite pictures – of the glacial deposits at Powburn, where the melting ice lay, and the meltwaters cut the gorge that is now followed by the road and discontinued railway. It is still exploited commercially for gravel, and this extraction extends north-eastwards towards Beanley Moor. If I draw a line south-east of this as the microlight flies, it crosses Titlington Pike, with its large hillfort and reaches a parallel outcrop of sandstone separated by the Titlington Burn known as Jenny's Lantern.

There is a strong prehistoric presence here, with house sites and fortified enclosures, and at ground level there is a panel of prehistoric rock-art at Midstead,

47. Powburn gravel deposits.

all north-east of the hill called Jenny's Lantern Hill, but on the same ridge. One of my memories of this was that when my friends and I were walking the ridge and recording, we came across a sheep that was lying on its side and couldn't get up. If it had been left it might have died, so two of us took it by the horns and yanked it to its feet. It raced off to join the rest of the flock, and we were happy. This is not the first time that I have faced this situation.

The site is a reminder of how numerous prehistoric sites are in Northumberland, and mostly unexcavated. These are probably Iron Age, extending into the Romano-British period, but the rock-art panel is over two thousand years earlier.

Here, then, are some photographs to look at.

We are flying south, with the large outcrop of sandstone, an extension of Beanley Moor, to the fore. This is high moorland, rising to 233 metres, forested on its southern slope. Beyond that, the valley formed by the Titlington Burn runs across the picture from side to side (south-west – north-east), where the flat fields of that valley then rise to a number of ridges, many with tree cover and to the valley of the River Aln.

48. Air photo over the top of Titlington Pike.

49. Jenny's Lantern settlement.

We pick up these fields to the left in the picture, in the Titlington Burn valley looking south-west to north-east, where the land rises to form regularly-enclosed fields to become moorland. A prehistoric enclosure, seen as a circle, lies in a field bounded by planted woodland, the first of many such features along this ridge that runs from top to bottom of the picture, Much of the moorland has been turned into pasture in the large, regular fields to the right. These continue to slope down to the Aln river valley off the picture.

50. Jenny's Lantern farm and prehistoric site.

Jenny's Lantern farm area lies to the east of the above settlement, at a slightly lower level. Forming another ridge of thin soil that supports only enough grass to provide pasture for sheep and cattle, the area was favoured not only for defensive circular earthworks of pre-Roman type, but also what must have been a more congenial environment for scattered round houses, marked as 'settlements' and 'homestead', that stretch almost as far as the wood at the top left of the picture. Below the wood, running across the picture, is a faint field boundary near the road and open fields, where there is the site of prehistoric rock-art; this pre-dates the enclosures by 2,000 years at least, and indicates that the ridge was used extensively throughout prehistory. No modern excavation has taken place here, so it is not possible to say more. A light patch at the centre of the picture is the ruined farmhouse.

If we change the focus, and get closer on the ground, these illustrations help to clarify the general picture.

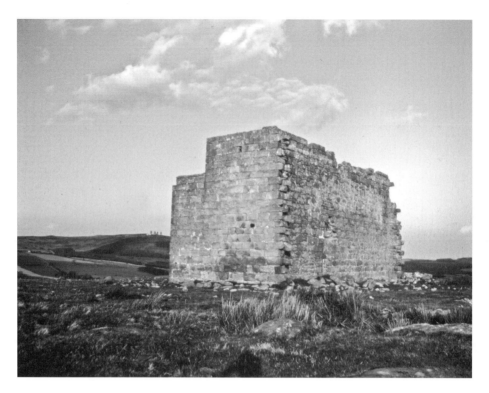

Top: 51. Jenny's Lantern farm.

Bottom: 52. Midstead: view from the prehistoric sites to Brizlee, with the 'golf ball' radar on the horizon.

53. Alnwick and the moorland to the west.

We see another ridge to the south, with Abberwick Mill on the river, and the site of a deserted village at Abberwick further south – one of many in Northumberland. After that, we are on to the turnpike road from Hexham to Alnwick, which I have written about elsewhere.

Still flanked by high moorland, the river runs through wooded valleys to Catheugh (cliff), with the RAF 'golf ball' radar scanner on a rocky ridge to the south, and so on to Hulne Park, part of the Alnwick estate, where Brizlee Tower is another prominent, but more peaceful, landmark. The turnpike road has meanwhile cut its straight route over the moor, and descends to the town of Alnwick, where we will pause awhile.

Alnwick is a major town, having a long association with the Earls/Dukes of Northumberland, playing a significant part in Anglo-Scottish and English politics, for they were powerful people. The town has always figured highly on the visitor list, but even more so now that the Duchess has developed the extraordinary Alnwick Gardens, with its Water Gardens and Tree House especially adding to the attractions of a visit to the castle itself. One sign of the power of the family is the number of estates that they control in the county. The use of the duke's 'spur' motif is common on many buildings, and the Percy lion is also evident.

Castle and town have a symbiotic relationship; the strong position on the banks of the Aln, controlling vital crossing places, led to the early establishment of a castle in Norman times that developed continuously on its keep and two-

baileys plan, a sign of its success in a way being that generations have reused it, rebuilt it, and made it fit the needs of an age. So, much of it is quite modern: like Bamburgh, it has thrived because people continue to use it. Useless ones fall down, and what is left has to be preserved as 'heritage', and the Duchess in particular has gone further than most in attracting people to things that are novel grafted onto something ancient. It has also been used, because of its dramatic structures and location, for many films, which bring income to the area and encourages the curiosity of people to visit the site. Harry Potter is a recent example.

The town hangs onto its skirts, for a castle offered protection in time of war and raids, and brought employment. So the people lived in a walled town with guarded gateways, their houses facing on to the main streets, the direction of which was determined by main routes, each with a strip of land for garden, pig, a cow, and perhaps room for a workshop – a pattern of 'burgages' that can still be traced in the layout of the town today. The streets led to a central market place, for the key to being a successful town was trade. Within the ancient settlement there were further developments, but expansion naturally took place outside the historic centre as population and aspiration increased.

The A1 used to run through the town, and I remember, when I worked there, the complete snarling up of traffic on ridiculously narrow roads, although it is now by-passed. It had a railway link, with the train running from Alnmouth to the grand 'ducal' station that is now Barter Books, then on its winding way to Cornhill, marked by some very attractive stations and signal boxes, viaducts, cuttings, and embankments, some of which remain though the tracks and sleepers have been taken up. The line suffered, like so many others, the curse of market forces, but their being encroached upon by vegetation has brought magnificence in decay.

I spent eleven years training teachers in Alnwick Castle until the college closed in 1977, so I had plenty of time to observe the town too. Since then, there have been great changes and developments, with some rebuilding inside the once-walled town area, where the predominant material is sandstone, and with the usual increase in supermarket and other provision outside. One curious fact at the time of writing this is that the town has only one petrol station.

We have then a mixture of old and new, but to the north-west, well outside the town, but in the Duke's Park, is one of the best-preserved friaries in Britain. It is enclosed in a fifteenth-century wall, over three metres high all round, containing a big range of ruined buildings, including a tower of 1486, cloister, church, and buildings such as a chapter house, refectory and infirmary, and pierced by a gatehouse. The site chosen by the Carmelites in 1242 was at the end of a spur above the Aln. There is also an Abbey close to the castle, of which only the fifteenth-century gatehouse survived, but the excavated foundations were marked out in the late nineteenth century. It was founded by Premonstratensian canons in 1147.

The ruins of St Leonard's Hospital lie to the west of the road that crosses the Lion Bridge on its way to join the modern A1.

How, then, do we view this town, with all its rich variety? A view from the air is a good beginning.

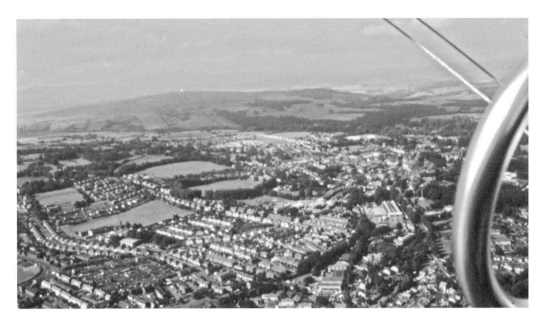

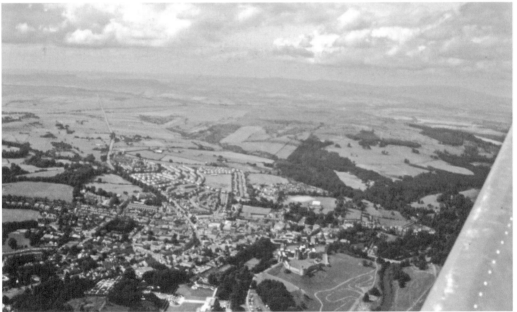

Alnwick from the air.

Top: 54a. From the south. To the left of the curved strut is the rectangular roof of the old station and the Tenantry Column.

Bottom: 54b. The castle is bottom right and the Water Gardens bottom left of centre.

54c. Alnwick, with the Alnwick Gardens (bottom of the picture).

The air photographs, taken mainly as the aircraft approaches from the south, skirting the town to the east, place the greatest emphasis on modern developments outside the walled town, with rows of houses and blocks of estates mingling with small factories, supermarkets, schools, and leisure facilities. Although the railway is no longer used, the roof of the railway station – a building befitting a ducal town – is a rectangular, prominent one, opposite the Tenantry Column erected by tenants who were grateful to their lessee.

The line itself ran south out of the town, then made a course to the south-west planned on a series of loops before turning north-west, with the spectacular viaduct at Edlingham marking its course towards Scotland roughly parallel to the main road. No doubt the main landowner had a big say in where it went. Although the rails have been removed, the line is still traceable for all its course; its early route out of Alnwick can be seen from the air by a line of hedges, for example, and the convoluted course approaching Edlingham is seen as deep cuttings and embankments. Its course to Alnmouth is also still traceable, and there has been talk of rebuilding that part of the line.

It is fortunate that the Great North Road by-passes the town to the east, with the road from Alnmouth bridging it; the other B road still crosses the river on its way north via the site of the Abbey, marked by a very long stone-built wall on its way to Chillingham and Chatton. The road to the south-west, on its way to

Rothbury and Hexham, is known as the Corn Road, and as a toll road it cuts some sharp lines through the country on what used to be unenclosed moorland – a very clear feature on the map, and from the air.

Development of the town continues, mainly on the periphery, although some renovation has taken place within the town wall on the old stone buildings. The arrival of the Water Garden, which uses a considerable flow of water, meant that the roads had to be dug up for new mains to be installed. Although the town has been declared one of the best places to live in England, it was like many other towns in the nineteenth century in being filthy and disease-ridden. A key document on the condition of towns was a government report in the 1850s, when arrangements were being made for direct government intervention through the Public Health Act. Because the Act was supported by the Duke, and by notables like Earl Grey, objections on the grounds of expense and other self-interests were overruled. The research that preceded the application of the Act makes grim reading.

We tend to think of country towns and villages as being attractive and healthy places, but this is far from the truth, so that in the nineteenth century they were often no cleaner than the big industrial towns. With the rapid growth of the North's industry, new communities came into being without a great deal of attention to domestic comfort – the idea was to build houses as quickly as possible within the smallest space, and to fill them with as many people as possible. This kind of overcrowding happened in villages and small towns too. There was a large mobile working force, for example, for the building of roads, railways, and other projects, that had to be housed, often temporarily in shanty camps, or in lodging houses. The agricultural industry had years of coping with a need for seasonal labour, especially at harvest-time. What was new was the sheer scale of building in the large towns. Alnwick was no exception to overcrowded accommodation and its consequences; it is only recently that some of the more dismal areas of the town have been improved.

The state of Alnwick in the 1850s is the subject of a detailed report, a Board of Health enquiry, and it makes depressing reading. Today we see an open Market Place with roads leading into it, and good quality stone-built houses leading to a river that is dominated by a fine castle looking onto a Capability Brown landscape, but our reading gives us another viewpoint.

The report was the result of State intervention, provoked by the horrendous diseases that periodically swept the land, including cholera. Human nature does not seem to change, and the response to this threat varied between those who were unwilling to spend money to help alleviate the appalling conditions in which disease revelled, and the kindly and liberal-minded who were determined to help the sufferers. There were people who made a lot of money out of the exploitation of the poor, and who were determined to hang on to it, and make more money. Often, local employees in the towns were incapable of dealing with such problems, either by inclination or lack of skill, and the solution could only lie in state intervention. Unbridled capitalism destroyed lives and debased

people, had to be checked then, and still must today. We cannot for a moment look at the past and feel smug that we have 'progressed' when the fat cats grow fatter, and people are exploited on a global scale by new massive Corporations. The future of our planet is now in doubt because of ignorance and corporate greed. It is a matter of scale.

So what picture can a government report give us of Alnwick in 1850? The report on Alnwick and Canongate did not dwell much on the lovely part of the castle above the river, but got down to the causes of disease. It included reports and 'memorials' by many people, made comparisons with other parts of the country, and even allowed a curious inclusion on weather observations, especially on the occurrence of thunder and lightning, which some regarded as having a bearing upon the spread of disease. The conclusions were that Alnwick was filthy, and that if something were not done to clean it up by improving drainage, sewage disposal, water supply, housing, and roads, it would get worse. Not only in Alnwick, but also in the Union of sixty-one townships and parishes attached to it.

People throughout history have distrusted bureaucracy, and still do; many see it as a nasty way of taking away their cash, and of imposing rules that will prevent them from exploiting others with impunity. The author of the report, Robert Rawlinson, had seen it all, and he and his assistants took great pains throughout this report to point out that what was being proposed would not just cost them money in rates, but save the money because people who were healthy would be less of a burden on the rates. A new 'establishment' could not be formed out of thin air, but by using talent and experience already there, and by spreading it more widely, this would lead to greater efficiency; where the skills to implement changes were not there, they could be brought in. Rate payers would openly be able to see estimates, and what was being spent.

What was the alternative? Rawlinson spells it out:

> Neglect of sanitary arrangements produces disease and misery, which result in pauperism; crowded cottages, room-tenements and common lodging houses are filled with degradation, immorality and misery, they foster crime, which acts and re-enacts upon the whole framework of society; vice is strengthened by contact with vice.

Some compulsion was needed to make sure that action was taken:

> One class of owners of property would willingly pay their proportion of the expense, but any single objector can stop the whole proceeding; and there are men who have a morbid feeling of vanity which finds a species of gratification even in mischievous obstinacy of this description.

People were given their say in the proposals, but the fact that the Duke, the Earl Grey and the vicar of Shilbottle were in favour of the proposals outweighed the opposition.

So what were the problems? An example: the report carried a detailed survey of 'Tenements in Moore's Yard, or the Tunnel, the Pant Hall and Premises.' The plan of Alnwick town centre still shows that the fronts of houses face on to the roads, with land behind them following the old 'burgage strips', a long back yard. Entries and little lanes would develop between some of these strips for access. There were plenty of nooks and crannies where people could dump their rubbish of all kinds and leave it there to rot for a long time.

At the head of Moore's Yard there were sixty-nine people living there at the time of the survey, with another 169 who were said to reside there at night. All lived in rooms which varied between 'dirty' and 'dirty in the extreme'. Patrick Conolly, an occupier of one of these rooms, had seven people in it at the time of survey and twenty at night. The beds on the floor were dirty – and this was typical of the situation. This part of the report was made by John Davison, Surgeon, who also provided a more general report on the town. He was fully aware of the link between overcrowding, poverty, filth, and disease, especially in his profession, but so were others in the town who would visit the sick and remove the dead, at risk to themselves and their families. Filth was generated in middens, as liquid waste ran directly onto streets, by filthy cellars even in quite smart houses, by the lack of clean water, pig sties, and slaughter houses ('animal and vegetable matter of all descriptions thrown out of dwellings into the open channels and there, owing to the want of a descent of the open channel, it is allowed to remain until this putrefractive process commences, when gasses of the most noxious qualities are produced.') In the same submission, he goes through the town to pick up the really nasty bits. As a doctor he would have seen it all. The Bondgate Tower, a prominent proud landmark today, where the old town wall was breached by a gate, opens up to Bondgate Within (i.e. within the city wall), and harboured an area where 'A collection of putridity may always be found', with the worst part being the sewers opening up from private houses into the street, where 'the stench is occasionally intolerable.'

Bailiffgate-street, the approach to the magnificent castle barbican, was 'where the descent of the open channel is not sufficiently great to carry off the liquid filth which flows openly through the gateway (*not the barbican's*) from the square into the street.'

Public alleys, courts and yards were always sources of trouble, and the worst were in new Bondgate. He wanted slaughter houses, dunghills, and pigsties to be removed from King's Arms-yard, and White Hart Inn-yard was even worse: 'Great filth of every description may always be found, and it has long been noticed as much subjected to fever. An open sewer carrying all sorts of putridity, which is seldom or is never cleansed, runs from the Green Batt so far down the yard and, where it becomes covered, its place is supplied by a large midden, into which all the blood and offal from the slaughterhouses are thrown, and frequently for a considerable time to remain.'

Davison saw that it was in the yards of private property, sub-let, where the greatest 'nuisances' were to be found. In despair, he comes to 'Moore's Yard'

or 'The Tunnel', already mentioned in my account, which he says 'cannot be described', but has a go:

> A long, dark passage, badly flagged, with the irregularities filled in with putrid urine, leads into the yard, which is a perfect nursery for sickness. The yard is narrow, and contains pig-sties, open privies, and ashpits with a filthy sewer, the Bow-burn, all in immediate position with the dwellings of the inhabitants, who appear not to have the slightest idea of cleanliness, and may almost be said to be worse than lower animals, which in many cases seem desirous of hiding their ordure, whilst here it is deposited in all directions without such inclination.

This, and much more, he wrote on 19 November 1847 to the Board of Guardians, who then forwarded it to the General Board of Health.

Alnwick has a particularly attractive church, St Michael's, built largely in the Perpendicular style, at the end of Bailiffgate, on a rise. This church, too, has some part to play in Public Health considerations, as graveyards throughout Northumberland were often a health hazard. At a time of low population the graveyards could cope to some extent, although the height of the ground lay above that of the lower courses of the church masonry, showing how many burials had taken place. Water used for drinking might percolate through such grounds, and although the song 'On Ilkley Moor Ba'tat' amusingly depicts the cycle of a dead body through worms and ducks, with the conclusion that when we eat the ducks we shall have 'eaten thee', the problem of polluted drinking water was no laughing matter. Any sudden increase in population meant that more burials were made than the graveyard could safely take. There had been some movement away from the custom of wealthy people being buried under church floors or in the walls, but it was still regarded by some as a family right. By the time of the Public Health enquiries, it had been clear that new graveyards were needed. Sometimes, as at Hexham, there were cases of recently-buried bodies being disturbed to make way for new ones. The 'right' to be buried in God's Acre was considered by some crucial, especially when the idea of resurrection involved the whole body going on to another dimension. Cremation was not accepted by some, especially Roman Catholics, and the current preference for that was a long way into the future.

A report on interments in Alnwick was drawn up, with the number of burials from 1842-5 detailed; there were 1,064, sub-divided into Gentry and Professional Persons, Tradesmen and Shopkeepers, Mechanics and Labourers, and (139) Paupers. So much for Death the Leveller.

The report recommended that no more burials should take place, and that five acres of Alnwick Moor should be bought for use as a graveyard, with separate areas and plots for other denominations. There was, however, reference to 'preservation of existing rights' in the town churchyard where high-profile families had always been buried.

The report also includes much discussion on building materials such as hollow bricks for houses, and the benefits of different kinds of baked tiles and pipes for draining. Street lighting was thought important too; a gas company had been in existence since 1825. Good street lighting was 'of the first importance – whether considered in a moral or a social point of view. It saved our policing, reassured inhabitants, and prevents much mischief and immorality.'

Roads were inspected, and although the Great North Road was in remarkably good order, the east to west road was not. It seems that there were many officials responsible for different sections of road, whether the 'surveyors' as they were called, liked the job or not. There is a telling sentence in the report:

> Some are appointed because the party having power to nominate him has a grudge
> against the man he names.

Throughout the report, we are aware of a mixture of self-interest, human misery, and of a great urge to reform. People who lived at the sharp end of life appear as names in lists, many of which names can be seen in today's population, such as Thompson, Jobson, Kelly, Mavin, Philips, Young, Baron, M'Fall, Campbell, Robson, and Foster. One of the main catalysts for reform was the scourge of cholera. In a table of deaths, Clayport Street had many of all ages from two to seventy-eight years. Altogether, the same area had fifty-six deaths. The total deaths in Alnwick each day went like this:

> September 23: 12; 24: 6; 25: 2; 26: 12; 27: 5; 28: 13; 29: 17; 30: 13.

By 30 October, 136 people had died.

It was not surprising that disease travelled so quickly or fatally in the light of the enquiry into sanitation, and the resistance of some ratepayers to supply clean water, to provide proper drainage, sewage disposal, and street cleaning either meant that their eyes were closed, or that they gripped their wallets more firmly-or both.

Today these abuses have been dealt with, and the new estates that have developed since it was no longer the town centre that housed most of the population did so on a different plan, outside the old town boundaries. The process continued into the era of council housing estates that we see today. The town centre, therefore, became used more for shops than residence, with both of course being combined in some buildings. At the centre is still the Market Place, triangular in shape because of the way that Market Street, Bondgate, and Fenkle Street (meaning 'at an angle') encompass it. The Town Hall in Fenkle Street was built in 1731, its square tower projecting into the Market Place. It has an external stair to a first-floor door, covered by a later porch. Across the Market Place is a larger building of 1826, the Northumberland Hall, paid for by the third Duke. It is classical in pattern, and underneath is an open arcade that now houses shops and

the public toilets. The hall provides a large space for all kinds of public gathering, but the open market is also a great space for events, such as an International Folk festival and the Alnwick Fair, though the latter's future is in doubt. There have been many processions leading to and from it, with a large overseas input, such as the Bryne band, and local people and organisations have joined in, costumed. My school drama cast from Rothbury came in with their Spindlestone Dragon, for example, and there was an impressive procession of many Northumberland schools representing various episodes in Northumberland's history from the castle, and through streets and Market Place, ending up in the castle grounds. When we produced the Warkworth Pageant in 1977, the cast of this mingled with the crowds in the Market Place for the Alnwick Fair, and a deliberate minor riot led to one of them ending up in the ducking stool.

The success of events like this, so beloved of tourists, involves a considerable amount of voluntary work. When Alnwick College of Education was in existence, we produced some fine musical and dramatic entertainment in the castle Guest Hall, and in the town. For example, we anthologised an Elizabethan Evening from documents of the age, and the spoken word was supplemented with music of the same period, performed in a room of 'The White Swan', the Olympic Room, where the timbers taken from the Titanic's sister ship gave the evening a feeling of the timbered rooms of another age. The presence of many young people with various talents, to say nothing of a dedicated staff, produced a healthy cooperation

55. Alnwick Fair crowds in 1977 watching the ducking-stool in the Market Place.

between college and town. Another point about such a presence was that, until 1977, there were many students who were training to be teachers who lived within the Alnwick and district community. Another fruitful addition was that the College of Education developed a Nursery Nurses Course, which again led to close ties with the children, parents, and students of college and town. Just before the college closed, an arrangement was made to take students from America, so that people from St Cloud University, Minnesota, lived in the castle for part of their course.

The urban architecture is largely eighteenth-and nineteenth-century. There are some interesting survivals of the deeper past, not always shouting their presence. For example, a street called Walkergate just off the Peth ('path') road that leads to the Lion Bridge, takes its name from a fulling industry; built into one wall is a mixture of styles and materials that turns out to be the remains of St Mary's chantry chapel (a chantry originally being a place where prayers were said for the souls of the dead). It was probably built in 1449, and became the first school in the town.

The same road loops round to pass the Church of St Michael, already mentioned for the problems arising from its graveyard in 1850. From the outside it looks completely Perpendicular in style, which is very unusual because at that time (fourteenth to fifteenth century) there was so much emphasis on war that there was little to spare for fine building. It shows, too, the power of the earls of Northumberland, and suggests that not all the Border was in chaos all the time. It is a very attractive church, well-maintained. Henry VI, in 1464, gave money for its repair, it was 'gothicised' in the late eighteenth century, and then restructured in 1863 by Salvin.

The older phases can be seen inside the church: Norman work for example. Excavation has shown that an early building was a narrow nave and apse, with no side aisles. Of particular interest is the late fifteenth-century work in the chapels, and there is a considerable amount of early decoration, including the 'Hotspur' capital. The nave roof is of the late fifteenth century, too. Sculpture, a chest, fragments of stained glass and interesting medieval grave slabs inside and outside the building are still there.

Other town churches are much more recent. On the road from St Michael's to the barbican, we pass St Mary RC church, (1836) now the town museum.

Further away, and not far from the old railway a station, is St Paul's (1846), recently changed from Anglican to RC, built by the third Duke, whose effigy (1847) lies dressed in the robes of the garter. As with many towns, the branches of the Christian church have made their impact: a disused Anglican Mission Hall (1886), with its soup kitchen; St James United Reform Church, Pottergate (once Presbyterian) built in 1894; a United Presbyterian church of 1846, in Clayport Street, now Sheraton House; the Methodist Church (1786, restored in 1886); and Sion Meeting House (1815), now a warehouse.

Schools are today still arranged on a three-tier system, which many of us directly concerned with education have long supported: First, Middle and High.

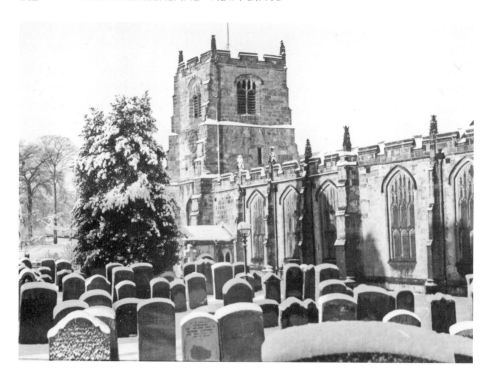

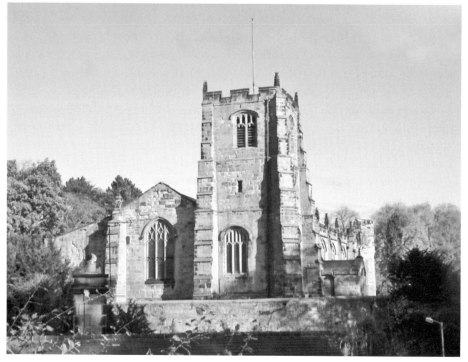

St Michael's church, Alnwick.

Top: 56a. From the south-east.

Bottom: 56b. From the west.

When the two-tier system was changed, some schools retained names such as 'Duchess' and 'Duke's'. The old Duke's school, long before that, became the town library at Green Batt.

It is not within the scope of this book to examine every building or development, but I will single out one which I find particularly interesting: the buildings around Howick Street, which in the 1830s concentrated on a high class residential suburb at the time when people were becoming very angry about the filthy state of the town. The styles of the houses varied, but all used fine ashlar sandstones and slate roofs. A good example is Grove House in Howick Street, which surprisingly has a walled garden. One interesting piece of social history is represented by the Mechanics Institute (1831-2), opposite St Paul's church, with a classical style beloved in that period for something special. The area of green Batt and Prudhoe Street, lying on the outskirts of the walled town, is of a different order from the older buildings.

Names of streets are interesting: Prudhoe castle was another major holding of the Dukes of Northumberland, Howick is a local village. Green Batt is possibly where people used to practise compulsory archery at the butts. There are many 'gates' and 'ports' within the old town, and they would literally have been where the road went through the wall. Elsewhere, 'gate' can mean a road. One building's name deserves a mention: Dorothy Forster's House, for her story ties in with the Jacobite risings that I have drawn attention to in other parts of this book. John Forster, her brother, played a flamboyant, though ineffective part in the rebellion, often pictured in military uniform on a white horse. He, like so many others, was taken prisoner at Preston, and gaoled in London. Dorothy undertook to save him, first of all by riding all the way to London from Northumberland. Imagine that! It was an extraordinary act of courage, at the end of which she managed to arrange John's escape to France. He was lucky, as many of the other rebels were executed.

Narrowgate, running past her house, reaches Bailiffgate only a few metres away, and here we turn in to the barbican of the castle.

The Normans devastated the North, which is one reason why we have no Domesday Book for this region. Part of their strategy developed into widespread castle building, the outward and visible signs to the locals of who was the boss. Gradually the Anglo-Saxon families who had ruled for so long were squeezed out of power, Norman French became the language of government, and the Church underwent a period of re-building that showed also who the spiritual leaders were. All over Northumberland, motte and bailey castles were established as the local focus of power of those knights who had been William's army, and many decided to stay. Originally, some of the castles were wooden buildings on a mound created from the digging of huge circular ditches, with the addition of a bailey. In Alnwick, 'Bailiffgate' means 'bailey gate'. Some castles, like that at Elsdon, did not develop beyond that, but others gradually replaced the wooden walls and fences with stone. The centre of the structure was the keep, sitting on top of a mound (motte),

57. Alnwick Castle. (*Gordon Tinsley*)

surrounded by a ditch. This was the main residence of the lord and his followers. Gradually there was a switch in emphasis from defence being centred on the keep, although that was the last resort during attack, to reliance on fortified walls that were a little distance away from the keep.

The site of Alnwick castle is well-chosen, taking advantage of the steep valley of the Aln to the north, and the steep sides of the Bow Burn. However it might have started, we know that by 1157, when it belonged to Eustace Fitz-John, it was walled in stone. Although much of what we see today is quite modern, the base of these walls and some other features shows its early period, especially where the stone courses follow the ground slope. The enclosing walls are roughly shaped like a triangle to fit the natural site, the base being the wall pierced by the barbican, and the apex being the Constable Tower (he who was in charge of the garrison). There were changes, particularly when the castle was bought by Henry de Percy, whose name lives on. When the keep was built of stone,

it was constructed as a shell on a platform on the motte, with bailey on two sides, east and west. Some square towers were replaced by semi-circular ones, as these could not be so easily undermined. The towers were placed at intervals along the walls, where they remain today, and they also formed an enclosure around the small courtyard at the centre of the keep. All these towers have been considerably changed.

The main entrance today is through the barbican – a fortified gateway that here is like a castle in its own right, and an outstanding example of its kind nationally. The statues that stand on top of it today are not old, and stories that they were put there to intimidate the Scots shows a poor opinion of the latter's intelligence. We enter a tunnel with steep sides, and if we were attackers we would have been subject to missiles from above. To add to our discomfort, a great drawbridge had been raised to cover the next obstacles of deep ditch, portcullis, and massive gates. Today we enter a large lawned area, with walls on either side of us, some with a walkway. At the north corner is the Abbot's Tower, a reminder of the religious establishments outside the castle, and from there, via the Falconer's Tower, we reach a long stretch of wall erected as a gun platform in the mid-eighteenth and nineteenth century, the wall turning sharply south at its end to proceed to the Postern Tower (now the museum), Constable Tower and Record Tower. From there, the wall reaches Salvin's gate, and a corridor of rooms in the wall via the Auditor's tower to the Clock Tower. This part has been used as students' accommodation, and for castle administration. The Clock Tower, formerly the Water Tower, has some medieval masonry at its base, and it opens into a large modern courtyard built by Salvin as a stable block, with the Riding School attached.

My time as a tutor at Alnwick saw much of this as college accommodation, including the Auditor's tower where I had my office, and we used the Guest Hall extensively for classes, and for entertainments of many kinds. The visits of film companies were memorable events, and the hiding of some modern features was intriguing. Many of the students, like the townspeople, took part in some films as extras.

The main part of the castle, the keep, is where the treasures of the family lie; the approach is under a Norman arch that is one of few ancient survivals. Despite renovation and rebuilding, the castle has managed to keep its medieval appearance, and the fact that it is lived in and used is much to its credit. Inside, Italian Renaissance decoration is much in vogue.

What has changed most since my time there has been the addition to the grounds, with the Duchess' enthusiasm and drive, for the Water Gardens and other attractions have added considerably to the number of visitors to the town. Each generation has contributed to some new building or repair, and some have neglected it, but today it is very popular as a prime visitor spot, for many different reasons, and to cater for many different interests. A major feather in its cap is the way that whole families visit it.

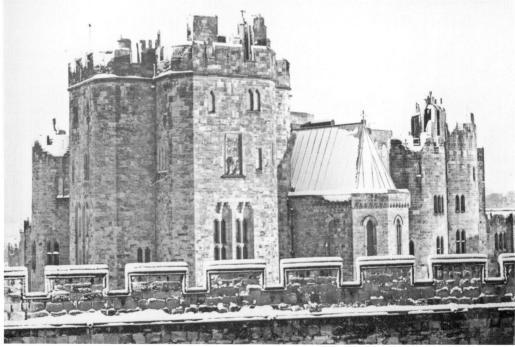

Top: 58a. The Water Gardens.
Bottom: 58b. The Castle keep in winter.

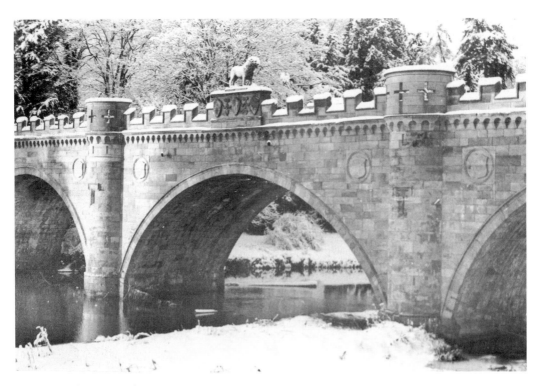

58c. The Lion Bridge.

I have always found the castle area visually fascinating over the years and seasons, and I offer some of these views. Quite recently, when I walked out one evening along the river bank, a Jools Holland concert was in progress close enough for me to enjoy it as I walked, at about the place where Black Adder begins his ride!

I have many memories of this town, and I am pleased that my daughter now lives there, but it is time to follow the river once more towards the sea.

TOWARDS THE COAST

The river meanders south-east through a landscape established by Capability Brown, and at first the main road out of Alnwick and the old railway follow its course. We are on the coastal plain here, where the land is good for crops. Many of the fields and their names appear on ducal maps, some of the best in the early 1600s, hand-painted, and in colour. I choose one of these, to give an insight into the area then: that of **Lesbury**.

The approach to Lesbury has one of the ugliest bridges designed in modern times, something quite out of keeping with the area. To press on: Lesbury has little that is visibly ancient, although the much-restored St Mary's church has many

parts that date from the twelfth century onwards. The settlement in 1189 was *Lechesbiri*, from Old English *laec-burg*, the leech's or physician's manor. As part of the Northumberland estates it has been well documented; in the seventeenth century, the hand-painted maps of the Earl of Northumberland reveal not only the layout of the field systems, but also their names. In my research into field-names, these maps have been invaluable.

There are also earlier references to fields, and these (with their possible meanings in brackets) offer a good picture of what the land was like.

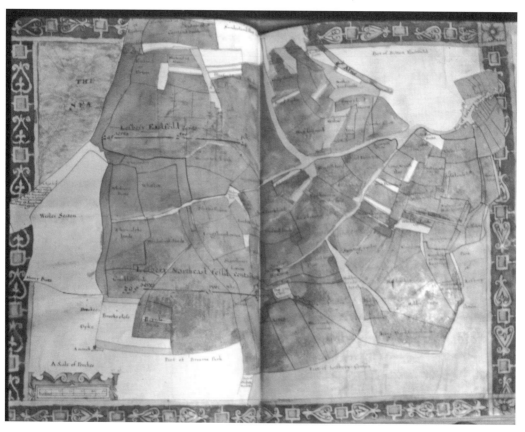

59. Lesbury in 1624: general.

The parish of Lesbury included the townships of Lesbury, Hawkhill, Bilton, Alnmouth and Wooden, in which Lesbury township was 1,646 acres. When combined with Bilton, its earliest names appear in 1498 as Grysgarth, Rawthornolech (a row of thorn bushes or trees along the slow-moving stream), Blackforthland (part of the big field where the ford was black or bleak), Redleflat (where there were reeds), Middiham flat (settlement in the middle?) and Sunderlande (land separated).

The next set is more detailed.

1567: Swinelee, or Shield-dykes (swine pasture, wall by a shieling), A dyke called Bustone Goate (water outlet to the sea), Doushawe dyke (by a small wood), Rimpeth dyke (the edge of the path), Houghton Besty-forde lande dyke, South flatte dyke, Cottyeards dyke (belonging to the cottars' yards), Chirchakre dyke (church land boundary wall), brocke dyke (brook), Chanley Flatte (later Chanell Flatt on the Aln Estuary), Scanley Flatte, husbandsmans letche, Mere letch (boundary land), Herker Snipes (OE *snaep* is marshy land), Snabs leses (projecting meadow land), Carterdean, Elders Hawghe (elder trees), Broome parke, Calledge Park (crow), Grayst well heade (Grysgarth in 1498, it could be a grass enclosure or paddock at the spring, or more likely a boundary, for 'graye stones' are mentioned as markers), hepstrother hilles (an overgrown marsh, including rosehips), Retche-hewghe (ridge or bank), Hyrde Hill, Sayning banke braye, East and North Seton (coastal settlement), Rose medowe, West noke, Conygarth (rabbit warren), north west lee rigg, Morysshe buttes (cultivated land by the marsh), abbaye land, Hungere crofte (infertile, needing manure).

The 1567 document shows clearly how many boundary stones were scattered around. A stone stood on the '*marche* hill', another stood outside the Snabes leses dyke, and further east were two 'great graye stones'. There were 'thre marche stones sett in the letche beside Rimpeth dyke.'

Another word for boundary was 'reane':

then right doune the north reane of the north west lee rigg ...

We are shown a detailed picture of problems, for the tenants were poor and the system of strip farming was inefficient:

'every tenant and cottager have in some part of there crofte riggs lyenge amongst ther neighbours', and the reporter wanted them exchanged and the crofts enclosed, but the distribution of fertile ground was too uneven for this.

There was not much stone for building, and natural resources had to be looked after carefully. The reporter mentions 'a good spring of youge allers, yf the same be cheryeshed and hayned and not suffered to be cut down', then there would be enough in a few years to repair the houses. 'Springe, allers and haynings' appear in field names. After touching on other matters, the writer made the recommendation that the people of Lesbury could improve their lot if they followed a Long Houghton custom: there, the tenants were grouped into *ploughe-daylles*, each of which provided a crew for a fishing coble. These tenants had their land 'lyenge rigge and rigge together.' In Lesbury the tenants held their land 'lyeing rigge by rigge and not in flats nor yet in parcels of grounde by yt selfe.'

As it was thought that no improvement could be made until the system was changed, a *Terrier* was made in 1614 to examine the system in detail. The 'big' fields are recorded as being split into 'parcels' for allocation to tenants.

NAMES OF THE WESTFIELD PARCELS

West and East bridge Haugh, Hether Side, Halley Well butts (holy well), Pootes wayst and Pootes lands (poots are unfledged birds, and a pullet is a powt, but in dialect 'poot' also means little, insignificant).

Broad deales, Cross land butts, Cross land hawuerse, Agnes acres, Durte poote butts, Burn knowle hawyers, Burn knowle roodes (on a hillock by the burn), Earsland roods, Earsland hauers (*ears*=rounded hills, buttocks). In the last name, 'ears' was a common Teutonic name, pronounced 'arse'; thus the Wheatear bird, originally pronounced 'whitearse', suited to the colour of its rump, was changed by a more fastidious people.

NORTH-EAST FIELD

Long Morrifur lands, Hodden heads letch, Hodden Tippett common meadow, Little Hodden flat, Hodden buttes, Heldon buttes, Heldon hawuers ('havers' are oats), Tongue buttes (projecting), Hame of Heddons (home), Sweeting roods (pleasant, fertile), Hawuers, West deare sides, East deare sides, Long Weasell Flatte, Griffin buttes, Cross buttes, Hawuers dikes, Hudletch meadowe, Castle close doore, Howle Hungerups (hollow, infertile), Wingyegg lands (windy edge lands), Hanging bauke Hawuers (on a steep slope), Hudletch lands, Cross land flat, Hall knowle roodes, East Hall knowle hawuers, Bancke riggs, Lyme pitt butts, Dungell hoopes, Pinder hill (OE *pundere*, land allocated to the keeper of the parish pound), Pilchesse lands (barked ash), Foure lands, East hawuers, Ruskie hawuers (rushy?), Blinde well lands (hidden spring), Crummy hawuers ('crum' means plump, in good condition, when used of crops. It can also mean a cow with crumpled horns).

THE 1624 MAP ALSO INCLUDES:
Lesbury North Common, Laine butts, Under hill, East Havers, Long Havers, Broom Close, Longfloor haver, Havers Head Law, Short flatt havers, Moores Crooke Roods, Havers Chick-acres, Coathills, Brookes Close, Brook butts, Crookit roodes (on the bends of the stream), Thorney dyke lands, Thorney dyke meadow.

ON THE SAME MAP THE EAST FIELD INCLUDES:
Burn Butts, Westerton Bank, East-bank, West Reans (boundaries), Wha flat (curlew), Wha meadow, Coney Garth (rabbits), Sunderland Havers, Sunderland

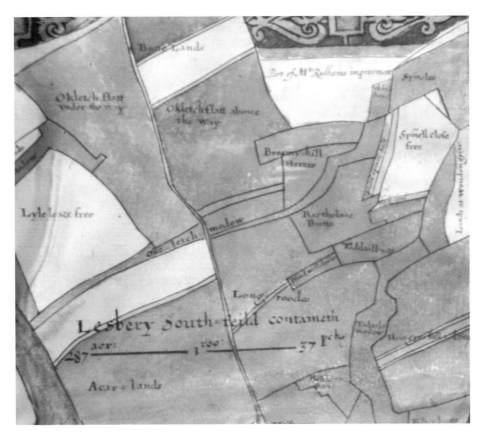

60. Ducal map of Lesbury South Field 1624.

flatlands, Long Seaheugh, Coatland roods, Alnmouth sides, Wester Seaton, East Seaton, Shellythorns, Crook, Brerland, Keenes acres, Bleasur lands, South floorehavers, Hepies way roods.

LESBURY SOUTH FIELD – SEVENTEENTH-CENTURY MAP

The names taken from this map have been arranged to show what they describe. Okletch flatte, Under the Way and Above the Way (oak?), Breamy Hill Havers (*bree* is the breast of the hill or bank; *bremel* is bramble), Spineles (spinney?), Wylie lands (willow), Pan close and leaze (a depression), Water close, Rea close and acres, Cheshill close (gravel), Haugh meadow pasture, Haugh leaze, Littlehaugh leaze, Thorntree lands, Long Sharplaw (steep), Shortsharplaw, long and Short Mirriches (marshes), Long roodes, Half acres, halfacre butts, hungerfull lases, Okletch Head, Hedland Meadow, Bilton butts, Okletch medow, Acar lands, Todaile medow (fox), Shipsburn (sheep), Lesbury Oxpasture, Delf lands (dug, a quarry), Headlands, Coatland rood, Toddaill butts, Crawlaw (Wester, East, Middle,

Greene-), Howlekiln water, Coaly Way, Armorers and Armorer Flatt (surname), Lyle Leaze free (surname), Friskett Roods and Havers (there is a George Fressell and a Francis Freswell). Botte lands (either butts or a building), Bartholme Butts, Holemeadow and lands, Goodly Crawlaw.

Not all of these names have been explained, as some meanings are unclear. There is a considerable amount of detail here, making it yet another deep source of local field-names. To people living there, these names would have been known to all, personalising the landscape in a way that no numbered system could possibly equal. We have lost much of this picture of the past, but the above shows how much valuable detail still remains.

ALNMOUTH

Alnmouth marks the end of our journey from the Cheviot Hills to the coast, a journey which has touched upon many ways of seeing our landscapes. It also marks the end of 'The Corn Road' from Hexham via Rothbury (1752-66), an early turnpike road which varies, as it twists around established field systems before going in straight lines across enclosed moorland.

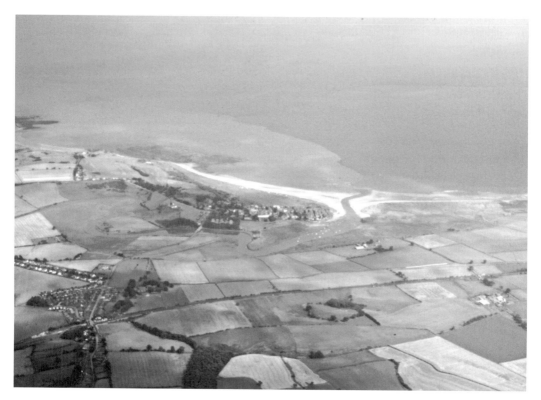

61a. Alnmouth, from the south-west to the sea.

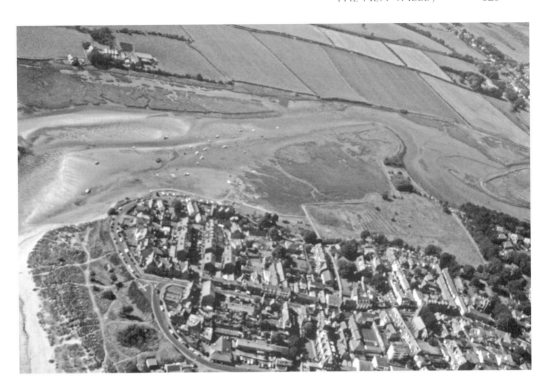

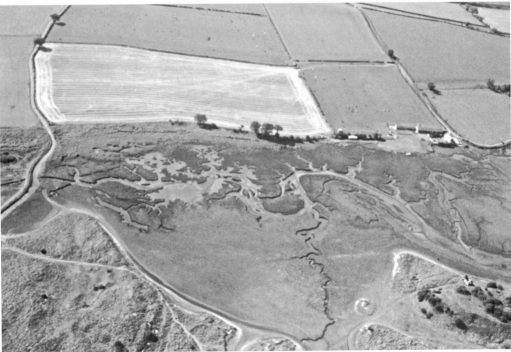

Alnmouth.

Top: 61b. The village and estuary.

Bottom: 61c. The old course of the river.

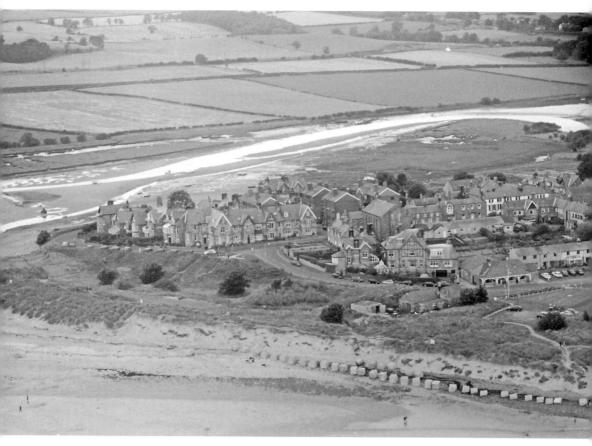

62. Alnmouth from the sea. (*Gordon Tinsley*)

Although today Alnmouth is a pleasant holiday village, it used to be a flourishing port, planned as such in medieval times. In 1806 a violent storm changed the course of the river, and the harbour silted up, allowing limited access, but with a flourishing fishing industry until the late nineteenth century.

The plan of the village follows what we see on the seventeenth-century maps, with regular strips of land like the burgages in Alnwick, visible on either side of Northumberland Street. As a reminder of the corn exporting business there is an eighteenth-century granary, converted to a row of houses, and another one converted into a vicarage. Another granary is now Hindmarsh Hall, and yet another called The Grange

The old course of the river is still visible, and a hill with a modern cross on it marks the place where a church used to be, and where Saxon stonework was found (now in Newcastle). The old harbour wall is to the west, and the harbour master's office is now the Old Watch Tower.

Today we see that eighteenth-century buildings have been re-jigged to fit new tastes, and perhaps one of the most attractive rows of houses that can be seen from

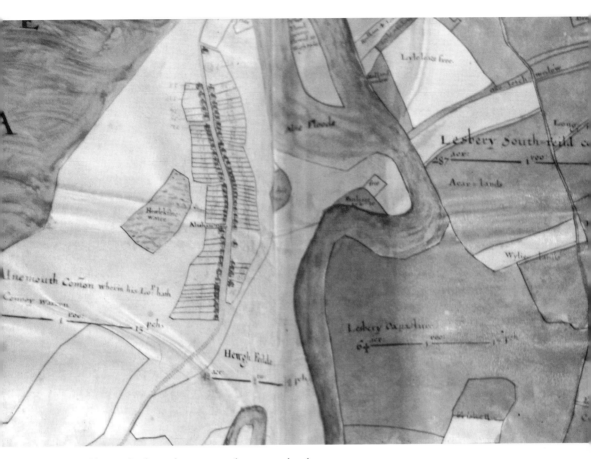

63. Alnmouth: the early seventeenth-century ducal map.

the railway to the west is Lovaine Terrace, where my family and I lived for a short while when we returned to England after two years in Malta. The terrace was built around 1860, made of concrete blocks, experimental at the time, rendered and painted different colours.

The beach attracts holiday-makers; one prominent piece of recent history is the row of concrete blocks put there in case of invasion, now used to pile towels and clothing on. For some reason, one block has found its way up Bracken Hill, on which someone has painted spots of a dice on its faces. There are wooden groynes along the beach, which in places gives way to rock outcrop and interesting pools. The northern rock outcrops are called Marden Rocks. A golf course, one of the oldest, is well established, with the club-house situated behind the dunes. Visitors approaching the beach by road are warned of flying golf balls. There is much more of the golf course to the north.

Within the town is a Franciscan Friary, formerly a large 1902-16 house on the hillside overlooking the sea. I remember one event connected with that: I was walking along the beach one winter when I saw a stranded young seal on the sand,

some distance away from the sea. I arrived at the same time as one of the friars, and we debated what to do about it, as the seal was distressed. Any approach resulted in its turning its head fiercely towards us, so we picked up long strands of seaweed and smacked its backside, until by jerks and convulsions it found its way back to the water. The brother and I watched with satisfaction as it swam to safety. That seems to me a good way to end this section: disappearing into the sea.

3

ESTATES WITH CASTLES

The rich and successful throughout history have regarded land as the real sign of wealth. Those who may have made their money through industry, trade, piracy, slavery, and other commercial activities then buy up estates to show that they have 'arrived'. Many such estates are ancient, some are newly-created, and others may originally have belonged to ancient families whose finances collapsed and they were forced to sell. There has always been a high status attached to owning land and what is on it, and a tendency for the landed gentry to look down on the nouveau riche, attitudes explored in many works of fiction.

I choose three 'estates' in the county, each with a castle.

CHILLINGHAM

Chillingham covers an area at the foot of the prominent sandstone scarpland that runs roughly from north to south, between the coastal plain and the western interior. The soils are mainly glacial, left behind by melting ice, and are on the whole fertile. To the west is the River Till, making its way northwards before changing direction west, then north again as it cuts through an outlier of the scarpland at Weetwood Bridge, turns north across the Milfield Plain, and reaches the Tweed, which then flows east to the sea.

Documents record a visit by Edward 1 in 1298, but we do not know what kind of place it was then, as the earliest part of the castle is a fourteenth-century building, like Ford, with corner towers linked by walls – different in design from the Norman structures that we see at Alnwick or Prudhoe. Sir Thomas de Hetton, who was given royal permission to 'crenellate' the building, was responsible for much of what we see now. Since then there have been alterations and rebuildings, but the departure from a medieval castle design came in the seventeenth century, when the castle was given a grand entrance facing north inside the courtyard, with three storeys and columns.

When I first saw the castle many years ago, the interior was a mess; since a change of ownership in the 1980s, when Sir Humphry Wakefield bought it, it has been transformed, after many centuries of neglect when it lost many original features. Outside, the grounds were laid out mainly in 1827-8, with walls and terraces, and the gardens are a splendid feature today.

Chillingham.

Top: 64a. Chillingham castle (bottom right).

Bottom: 64b. Chillingham estate, with the Hepburn-Old Bewick scarp in the background.

1. Haltwhistle: the Tyne is at the top right corner. Industries and a caravan park lie on the 'haugh' and the town on a terrace. The main street, market place and church lie to the left of the road passing these. (*Hexham Courant*)

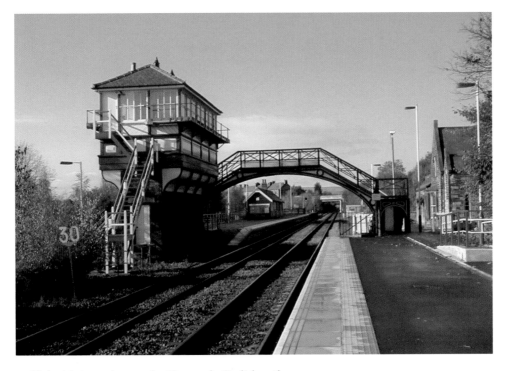

2. Haltwhistle station on the Newcastle-Carlisle railway.

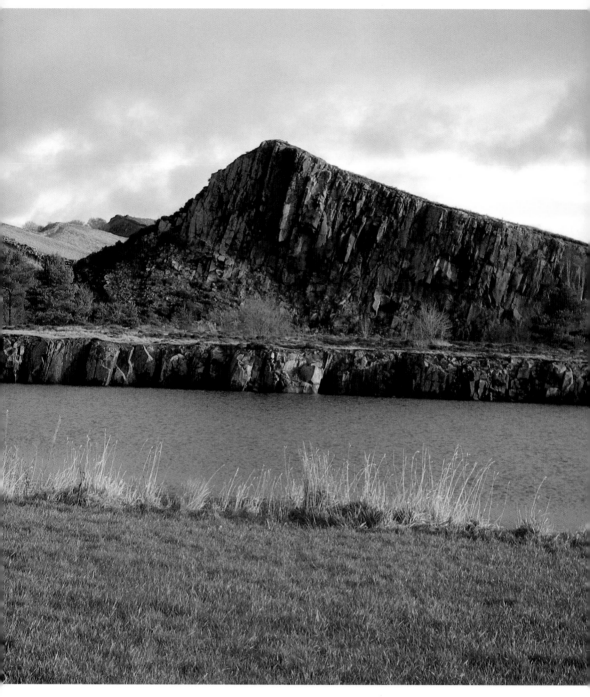

3. Cawfields whinstone quarry has left the Wall high in the air and formed a lake.

4. Elrington Farm, near Haydon Bridge, lies at the centre of the picture, with the Tyne valley beyond.

5. Hexham Abbey in January, 2010.

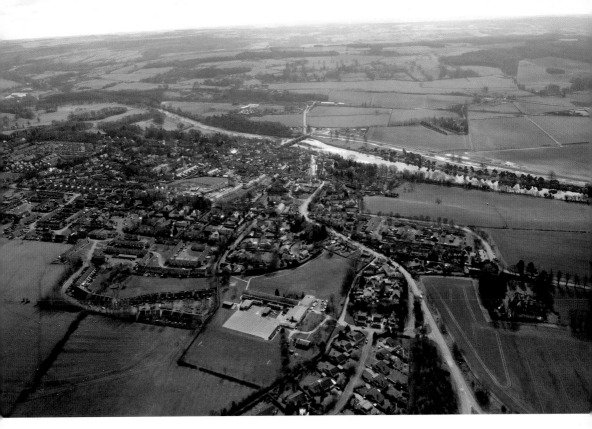

Above: 6. Corbridge: the River Tyne is spanned by a bridge leading into the medieval town. Roman *Coria* is in fields to the right. Below is the Middle School, and old rig and furrow systems of arable farming. (*Hexham Courant*)

Below: 7. Dilston castle from the east, with the site of recent excavations.

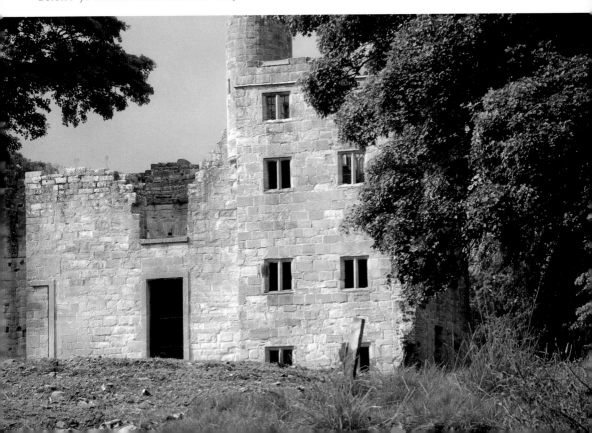

8. Bywell, a spring on the river bend, has the church of St Peter in the bend. St Andrew's and Bywell Hall lie close by (right). On the lower part of the river is a castle tower. (*Hexham Courant*)

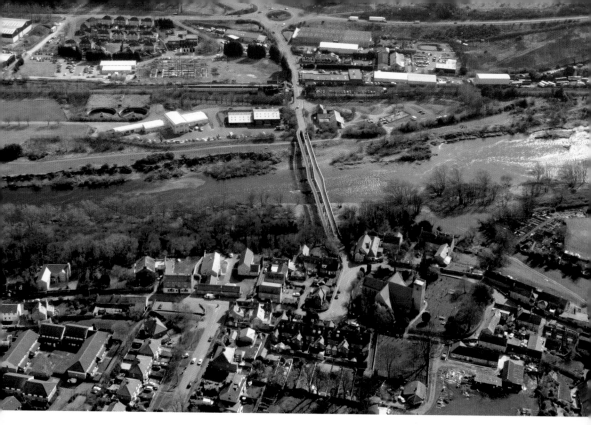

Above: 9. Ovingham Bridge crosses the Tyne from Prudhoe with its industries to the village, where the church of St Mary is prominent. (*Hexham Courant*)

Below: 10. The rich farmland of the Vale of Whittingham near Callaly, looking north towards the eastern edge of the Cheviot Hills.

Top: 11. The Alnwick Gardens Tree House.

Bottom: 12. From the Hunterheugh moorland to Thrunton Crags, with Jenny's Lantern, left, above the burn valley.

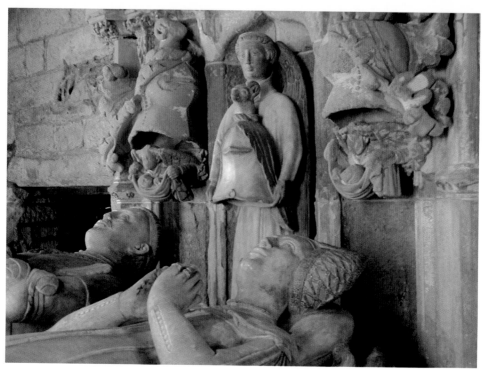

Top: 13. Part of Alnwick Castle Gardens.

Bottom: 14. The tomb of Sir Ralph and Lady Elizabeth Grey (1443) in St Peter's church, Chillingham.

Above: 15. A young bull in the Chillingham White cattle herd.
Below: 16. Ford village, largely the creation of the Marchioness of Waterford.

Previous page: 17. Cocklaw beach, Scremerston.

Above, top: 18. Roughting Linn prehistoric enclosure, unexcavated, and one of many such survivors in Northumberland.

Above, bottom: 19. Berwick's eastern ramparts.

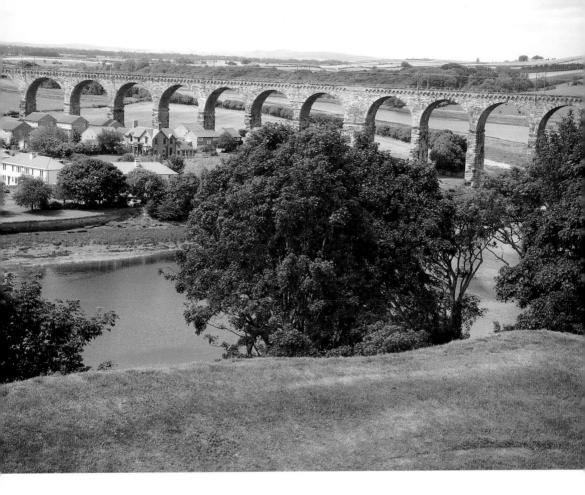

Top: 20. Berwick's railway bridge.
Bottom: 21. Duddo stone circle, looking towards Scotland and the Tweed valley.

22. From Weetwood Bridge gap to the Cheviot Hills across the Milfield Plain, with Weetwood Moor to the left.

23. Branxton churchyard towards Scotland.

There are two highlights of the area that I wish to dwell on: the church and the Park as special features.

The area around the castle had been enclosed in the thirteenth century to create a park of some 6,000 acres (2,430 ha), and there now exists a special environment for a unique herd of cattle. A glance at the aerial photograph shows that the Chillingham estate is well-ordered, divided by trees and planned buildings. Just outside the castle walls is St Peter's church which, like one at Old Bewick, has very large old sandstone blocks in its foundation walls, in this case from the twelfth century.

Everywhere there are signs of rebuilding over a long period, but one gem inside the church is a 1443 monument to Sir Ralph Grey and his wife, sculpted in alabaster, lying elevated, and side by side. Recently restored, this out-of scale tomb for such a small church is a magnificent period piece that somehow managed to escape destruction in the Reformation and later. The lord and his lady lie under a canopy, he in full armour, supported by a table-tomb which is covered with a rich variety of saints and symbols. Originally it was painted, and some of this paint remains.

Sir Ralph has complete plate armour, over which are a tabard and a richly-embroidered belt; he has a collar round his neck. He wears jewelled gauntlets, his hands joined in prayer. He has a baldric and dagger, and his feet rest on a crouching lion.

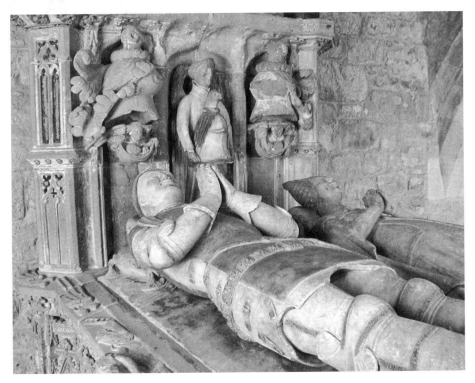

65a. Grey memorial: Sir Ralph and Elizabeth Grey. *See* Plate 14.

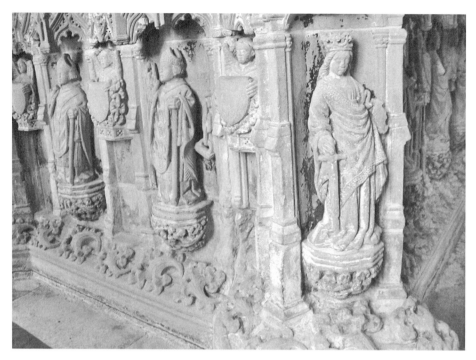

65b. Grey memorial: saints and angels to the south.

Lady Elizabeth has her hair dressed in 'horn' or 'mitre', covered with a jewelled net with a border of chased gold. She wears a kirtle, a fur-bordered 'cote-hardie', and her scarlet mantle reaches her feet in folds, there to rest on two little dogs. Her mantle is fastened to each shoulder with a jewelled brooch, and tied with silken cords. Her jewelled hands are joined in prayer.

The tomb is made of coarse-grained freestone, and its elaborate carving produces niches of tabernacle work, with pedestals and canopies to house the saints, of which there are fourteen, separated by angels in clouds holding shields. Carved foliage covers the plinth and cornice.

The saints have been identified from the west end to south side thus: Thomas the Apostle, Margaret of Scotland, Cuthbert, Sittha of Lucca, Peter, Wilfrid, Ninian, Catherine of Alexandria, John the Baptist, Mary Magdalen, John the Evangelist, Margaret of Antioch, and James the Great. Identification is not certain in all cases, but we have here a mixture of local and international saints.

The back of the tomb rests against the wall, and the stone drapes open up rather like a theatrical show that is beginning, heralded by angels, two of whom are holding helmets. The Grey crest is a ram's head, silver with horns of gold. The strapwork (interlaced bands of leather) and cartouche (bearing a coat of arms) were a seventeenth-century addition. Black and red marble are used for this. Above the Grey shield and crest is the motto: DE BON VOULOIR SERVIR LE ROY, a declaration of loyalty to the king.

When I have taken groups of people to visit this, they have been keen to work out who the saints are, and what symbols such as ladders represent. They are also intrigued by the transept-like setting of the tomb, which includes a modern fire-place, where presumably the owners of the day would have been warmed as they listened to the sermon. Such is power! The ladder is explained as a badge of the Grey family, from the Old French word for grey: *gre*. The cloak is a *grey*friar's cloak.

A cornice of the north and south aisles has a shield of arms with two angels with outspread wings and a lion. At the east end is a large shield supported by two angels with a lion.

The church has a crypt below, as the steps up to the altar and its sheet-glass window indicate. There are many fragments of earlier building in the walls, and the remains of medieval grave-covers. The box pews of 1829 represent that time when seats were strictly reserved for named families, but the view through the large, modern, clear, east window would not have been something with which these rather more formal people were used to. The church, then, represents a local hierarchy, common to many others. Later, the hymn containing the words 'The rich man in his castle, the poor man at his gate' was a vision of God's plan for mankind, for 'He made them high and lowly'.

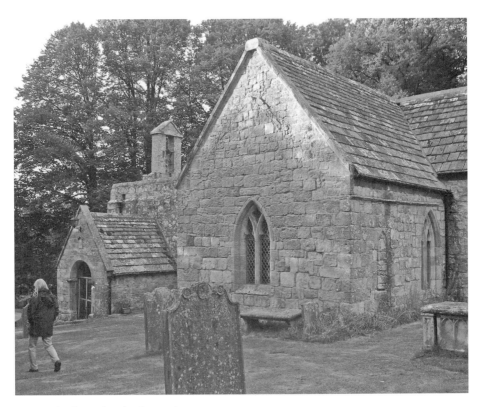

66. Chillingham church: the south.

Even in death, when we are supposed to be equal, our supposed equality in the sight of God was a myth, for those who could afford it made a great show of their earthly achievements that would presumably go ahead of them. No doubt the rich and important had found their way to burials within the church under or around the altar, to take their place closer to God. Outside, the churchyard's symbolism tells us something different, for the eighteenth-century gravestones carry the images that point to judgement, and the hope of heavenly eternity, with the grim reminder of skull and crossbones that we are all facing the same fate. Some of the stones must have been the work of local masons: inside, on the north nave wall, a large carved stone memorial shows how difficult it would have been for such men to produce such sculpture and script.

67. Memorial inside the church.

Around this church and castle, the grounds have lines of trees and fine walls, with a village rebuilt by the Tankervilles in the 1830s. The Earls of Tankerville were the previous family castle owners, and pubs bearing their name are one sign of their holdings and influence. The grounds include a fifteenth-century defensive tower to the south-east, at a point where the scarp begins to rise towards Hepburn and Ros castle, where we are firmly in a prehistoric landscape. Known as **Hepburn Tower**, three storeys high, and named after the place of high burials on the scarp above, it is complete but for its roof, and has not been touched since the seventeenth century. It was abandoned in 1775.

The Park is now administered differently from the castle, and houses the famous wild white herd of cattle. A glance at the OS map shows a considerable amount of green around Chillingham, but much of this is planted coniferous forest that climbs up the scarp, and continues as a great swathe over Amerside Law Moor. The herd itself has, at the moment, about ninety beasts, and roams free in a landscape that has grass and deciduous woodland. The trees include some very ancient alders, which have been pollarded for centuries, and which regenerate from ancient roots. This is a unique landscape. Originally the herd would have been kept to serve the lord's table, and the concept of hunting and killing them survived to an almost absurd degree when a Prince of Wales, better known for his affairs with women, to be King Edward VII, shot a king bull in 1872, safely concealed in a hay cart. There used to be a session of killing, when locals joined in the 'sport'. Kaiser Wilhelm II also shot one, and the Earl of Tankerville presented the brave Prince and Kaiser with the bulls' horns mounted in silver and inscribed.

This was fashionable; big game hunting and photographs of the brave hunters with one foot on their prey were commonplace throughout the days of empire, so places such as the Guest Hall of Alnwick Castle used to have heads of all kinds of animals decorating their walls. I got to know the latter well, looking up at them when I gave blood to the Transfusion Service there for a number of years!

On a lighter note, the engraver Thomas Bewick was drawing the bull when he had to climb a tree for safety.

There are many castles in Northumberland, but nowhere is there one in such a setting, for here we are given a glimpse of what the land might have looked like. Castles have survived when they have been lived in long after their defensive purpose became obsolete, or put to another use. This is certainly true of Chillingham, Ford and Alnwick.

I was allowed to get very close to the Chillingham wild white cattle in 2009, along with two experts on Palaeolithic prehistoric rock-art, one of whom had spent much of his time studying the cave paintings on the European Continent and elsewhere. Dr Paul Bahn was also responsible for discovering the first British Ice-Age animal pictures on the walls of Caves at Creswell Crags, near Sheffield. So I was interested in their comments on their first close sight of these animals, which they at once linked to aurochs. Visitors are allowed to get fairly near to the herd when accompanied by a warden, but we were driven quietly into the herd, so that, with the windows down, we could film them. They can be very dangerous, but the vehicle was reassuring for them, perhaps because in the winter it delivered some hay in lean times. The grass is lush, and their cattle's feet are slightly splayed, so that they do not damage it, except when the bulls get down to the serious business of throwing it up with their hooves to get at the soil, on which they defecate and urinate, roll back into it, and go into the herd with the strong smell of their individuality and challenge. This is a fiercely competitive world, in which some bulls never get a look in, but form a kind of bachelor group away from the herd. Those bulls ready to fight, rich in their own scent and with dirty rears, face each other, bellow, posture, paw the ground

and, when the time is ripe, attack each other. Some are slightly wounded, and carry a dark spot on their white flanks which has been pierced by a horn.

The challenger to the king bull bellows, paws the ground, and seeks to provoke battle with the king. There may be several short attacks, with an interval for grazing, each watching the other to catch him off-guard, until one retires defeated. The vanquished bull then retires from the herd, and lives separately for a long time at a safe distance, but not necessarily out of sight. Death by combat is rare.

The average age for a bull is ten years, but a cow may live for twelve to thirteen. Meanwhile, the king bull has rights to all the females for two or three years, until he is defeated by one stronger. In this way, the calves born are assured to be the offspring of toughies rather than wimps.

H. C. Pawson, surveying the agriculture of Northumberland in 1961, has much detail to give about the herd. The calves are born at any time of the year, not just in the spring.

> The calf is dropped in a secluded spot and remains hidden, being suckled two or three times daily until it is brought into the herd by the dam at about a week to a fortnight old, first being met by the "king" bull, who escorts them in person, when the mother and new arrival are inspected and approved by the other ladies of the herd.

They themselves, with their red ears and long eyelashes, can be rejected and killed by the herd if they don't come up to the mark. If it is approved, that's that; if not the mother takes it away. A weak one will be killed.

The survey also includes some details about an old king bull that died in 1955 after a record reign of eight years.

> He was defeated in combat in 1954, but made a successful come-back, due to the fact that his successor in the fighting developed a hernia from which, because of strangulation, he died in November 1954.
>
> The king, or leader of the herd, establishes his right of absolute monarchy by combat and holds his dominant position until he is defeated in battle and is then temporarily banished from the herd and the successful bull enters into his "reign".

The sex ratio of two males to three females remains fairly constant.

Today the woodland pasture has large oaks that were planted in the late eighteenth to early nineteenth centuries, but the alders can be hundreds of years

The Chillingham Herd. *See* Plate 15.

Opposite, top: 68a. Newly-born.

Opposite, middle: 68b. A scarp background.

Opposite, bottom: 68c. Part of the herd under the alder trees, some in a belligerent mood.

old. Protection from modern intensive farming has safeguarded a great diversity of life, such as birds, deer, and red squirrels. All this can be viewed by visitors from a number of paths around the area, which have been made possible through a DEFRA scheme.

The herd itself has been the subject of scientific observation and investigation. There is a relationship between them and aurochs, and the enclosure of the herd has, although first mentioned in 1645, led it to develop on its own, so that it is thought to be up to 700 years old. At first the enclosure may have been drystone wall, built at a time when the castle was first 'crenellated'. The present one, however, was not built until the early 1800s to enclose 1,500 acres. Within this enclosure the herd bred, inevitably inbreeding, with the fittest bull being the king. Theoretically only the king could breed, but as we know in other herds of animals dominated by one male, some other manages to slip in.

If a calf is handled by a human, the others may kill it when it rejoins the herd. If animals become sick, old, or are wounded and do not leave the herd voluntarily, they can be gored to death by the others.

What happens now to the herd, and to its continued success, is that in 1939 the Chillingham White Wild Cattle Association was formed to manage it. The herd varies in number, according to the weather. In the winter of 1946-7, for example, only thirteen cattle survived – eight cows and five bulls. The herd was given to the Association in 1971 when Lord Tankerville died.

In 2005 the Association bought the park and woodlands, and later the sheep grazing rights were also bought, and the flock removed. One safeguard now is that part of the herd has been re-established in Scotland, and perhaps Ireland will follow. It is certainly something unique which we must preserve.

FORD

Further to the north lies Ford. Whereas Chillingham is Ceola's people's named settlement, from Anglian times, Ford means simply the fording place over the River Till, which it overlooks from a low sandstone ridge. Like Chillingham, its castle is of the courtyard type, with four corner towers that are linked by walls. Again, as at Chillingham, most of the residential part lies between only two of the towers, in this case to the north. Unlike Chillingham, the castle has been extended considerably beyond the courtyard to the south and east, with additional buildings created at a time when defence was no longer a consideration. The rest of the settlement, the village where people lived, was demolished, and a new village created to the east, so that the view of the Cheviot Hills was uninterrupted. This kind of clearance happened, too, at Bywell. The Marchioness of Waterford was responsible for the Ford clearance, and although we do not hear what the people's reaction was to being moved out of their homes (as they seldom have a voice in history), the new housing was very good, and life made pleasant for the children when she built

them a fine school, incorporating them and their parents into the murals of biblical scenes. This was not the act of a rapacious landlord, but of someone who saw this provision as a Christian duty. She inherited the estate from a family, the Delavals, whose morals were on the whole appalling, and their wasteful spending criminal, as it all came off the backs of the tenants, especially the miners of the south-east. This family was responsible for some of the buildings that we see today, a series of decorative mock-Gothic additions. The family spent money like water, and were rescued by one prudent member, so that when the Marchioness took over she was able to convert the castle into a splendid home that has been an incredible boon to generations of children and adults who have been on courses there, for it is now leased from Lord Joicey as a residential educational resource by the County Council. The castle came into the Joicey family in 1907.

I find it impossible to miss out Ford from any of my accounts of Northumberland because it has meant so much to me over many years.

It made a special name for itself in history when it became the headquarters of the king of Scotland, James IV, just before the Battle of Flodden, when it belonged to the Heron family. He slighted it before he went off to his death at that crucial battle between the English and Scots.

So we can view a lovely setting for an old castle that has developed over the years from many points of view: for what happened there, for the present quietness, for the view to the lovely Cheviot Hills. History is like that, presenting us with choices about how to view it. There may be people who like the sensation of battles, and indeed one year when my summer course arrived at Ford, we were given a spectacle of the Sealed Knot fighting a battle re-enactment of the Civil War, with horses, pikes and cannon – all of which we watched from the grandstand of the Flag Tower. Others are taken by the idea of ghosts and other horrors, frequently (ad nauseam) exploited. All old buildings seem capable of producing ghosts, and Ford is no exception; anything in ruins is a target for them.

I will look closer at this estate, for there are many interesting viewpoints.

As we fly in from the north, the pictures on page 138 show areas of productive fields, giving way to a landscape of carefully laid-out gardens and buildings, mostly of stone. What we see represents centuries of change. The earliest building is the thirteenth-century church, St Michael and All Angels, thus pre-dating the castle and the remains of a fortified tower in the field where the village used to be. Its graveyard pushes into that field, with many recent gravestones, traditionally ordered more or less in rows. As we close in on the area, we see the outline plan of the buildings and the landscaped grounds, including a large nursery garden, once the kitchen garden of the castle. The modern village lies to the east, a nineteenth-century creation with later additions.

There is a record that Edward I stayed at Ford in 1292, on his way south from fighting in Scotland, so presumably there was some sort of dwelling there. Robert the Bruce's attack on northern England in 1314 included the devastation of Ford, and because these Scottish attacks were always imminent, this explains

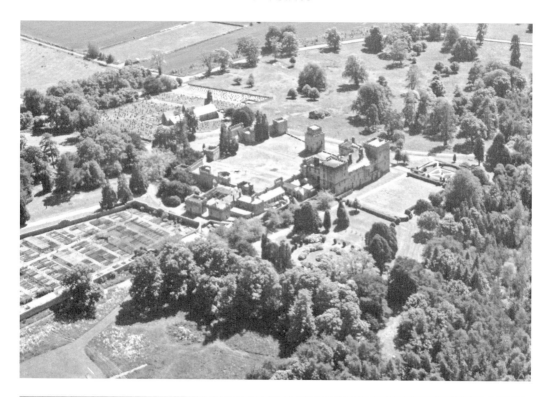

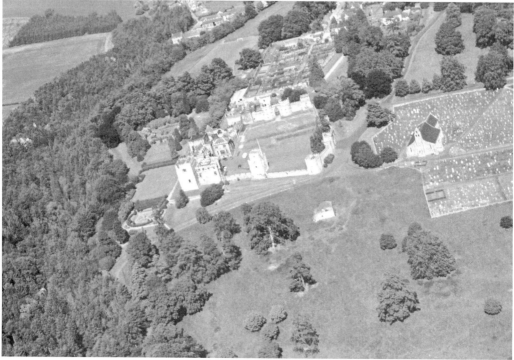

Top: 69a. Ford from the north-east.
Bottom: 69b. Ford from the south-west. The field at the bottom is the original village site.

the lay-out of the castle in its original quadrilateral of corner towers and walls, established by Sir William Heron, when he was allowed to do so by the king in 1338. Even so, Ford was devastated at least twice after that, and the state of the countryside is reflected in the fact that the local people were unable to pay any tax. Always at the heart of warfare, it suffered when it was 'slighted' by James IV as he moved to meet the English army at Flodden, his final act. By the end of the sixteenth century Ford's role in national history ended, and the region settled down to enjoy its farming; by the late eighteenth century it was to the fore in agricultural improvements, when new farms, hedges, and walls were built and old farms renovated. Life was hard, though the local wage was higher than in the rest of the county.

The castle developed further buildings against the north wall, facing into the courtyard, culminating in three major rebuildings: one in Elizabethan times, then remodelled by Sir Francis Blake; one in about 1760, when Sir John Hussey Delaval inserted pointed 'gothic' windows; then in 1861-5 when The Marchioness of Waterford refashioned it by removing the gothic windows, and replacing them with Elizabethan-type windows, so that today it looks like an e-shaped Elizabethan building.

The largest of the four towers at the north-west, now known as the James's Tower, is well incorporated into this design, complete with its original vault,

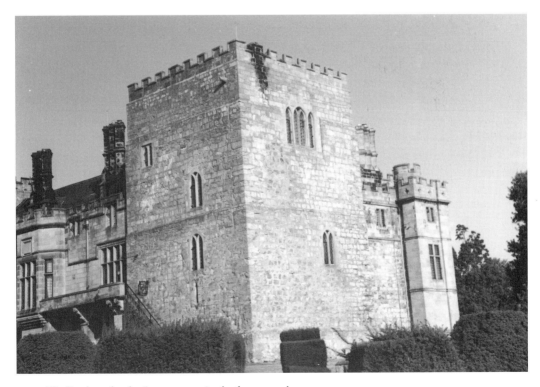

70. Ford castle: the James tower in the foreground.

but the castle has been 'modernised'. Part of the south-west tower, the 'Cow' or 'Flag', remains, but again it has been heavily restored. The north-east tower is well absorbed, but there is a spiral stair in the south-east which may be a survival of the earliest house on the site.

The renovations owe much to Louisa, who had married into the Waterford family; she lost her husband early, and fortunately devoted herself to Ford. She was quite unlike some of the family that had once used Ford for some of its wild parties, though their main base was at Seaton Delaval Hall. The Delavals are responsible for many of the additions, such as the portcullis entrance and the east wall with a clock tower.

Ford castle is not open to visitors, but it hosts various educational groups and encourages social events such as weddings, which bring in some of the income necessary to pay for some of the maintenance.

The other two old buildings visible today are the church, and the 'Parson's Tower'. The church was burnt by the Scots in 1314, having been built in the previous century, and the rectory was ruinous. Much repair work is recorded in 1431, but by the late sixteenth and early seventeenth century it was in decay again; in 1690 there was some restoration. By 1734, it was 'in very good order and well built'; the Delavals spent a lot of money on it. The building that we see today owes its appearance to the work of the architect Dobson in the nineteenth century.

The tower was first described in 1541 as 'a little tower which was the mansion of the parsonage ... and a quarter thereof was cast down by the last king of Scots'. By 1663 there was no house for the parson, but by 1725 it was 'strong and convenient'. By the nineteenth century it had been enlarged with an L-shaped wing, but the rector was moved to a new rectory when the Marchioness included the tower in the castle grounds.

For the visitor (on an open day, or there for a course or a function) there is much to see, including the fine gardens to the north and the unusual Game Tower.

However, Ford is not just the castle and its immediate surroundings, for to the south-east there are the remarkable remains of a totally different economy – the Ford Moss mine, still within the estate.

The photographs show the extent of the site, which is an area of Special Scientific Interest, for the 'moss' has rare plants and fauna. It comes as a surprise to see a tall brick and stone chimney rising out of piles of slag, but this is one of the sources of engine power needed for a mine. There had been coal mining since the seventeenth century using the bell-pit method, which began with the circular shaft on the surface, then went down until it became too dangerous to work. The collared shaft was more or less filled in, and another sunk along the coal seam. The later mine used pit shafts. A big problem was water seeping into the workings, so steam power was necessary for pumping. After being exploited by Delavals and Waterfords, it was closed in 1914. In a sense it was part of the estate, but it must have created two distinct groups of

Ford Moss.

Top: 71a. Mining village.

Bottom: 71b. Over Dove Crags to the North Sea.

people in the area, although nothing is written about this. On the ground and from the air, the outline of the miners' houses is visible, with their garden plots hedged with hawthorn, and there are signs of the waggonways across the area, pit shafts, a large pumping house at its northern edge, and other industrial buildings.

The mine had its own stone quarry, arrested in its extraction and transport system when it was abandoned, and there for us to see to the south. On the same ridge of stone where this quarry is, the long ridge of Hunters Moor/Broomridge, with great views from every part, has patches of outcrop with 5,000-year-old rock-art, more recent evidence of millstone extraction, leading to the rock overhangs of Goatscrag, where the floors were shelters for flint tool makers from some 8,000 years ago, and where the dead were buried in urns 4,000 years ago. The culmination of this vital ridge is the great rock at Roughting Linn, the largest decorated rock surface in prehistoric England.

The ridge overlooks the Milfield Plain to the west, which has abundant evidence of hunters and settlers from just after the retreat of the ice, through early farming, settlement, burial and henge-building period some 4,000 years ago, through the building of Saxon houses and palaces, to modern farming and quarrying. The rock at Roughting Linn is connected to this with a 'hollow way' track that is probably ancient, maybe prehistoric in origin. As we travel towards

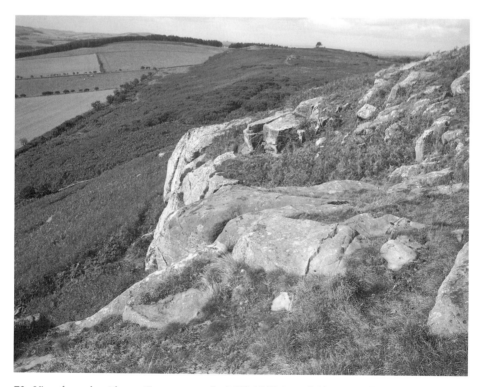

72. View from the ridge at Goatscrag to the Milfield Plain and Cheviot Hills.

the plain along this from the east, the ridge stands out to our right, and on its lower slopes it has interestingly-shaped sandstone outcrops partially hidden by vegetation. The ridge itself ends on the edge of the plain, where a thick band of grey clay marks the join.

Ford itself was a self-sufficient village, and Census and Directory returns list many occupations. Most villages had a blacksmith's and a mill, and the remains of an important forge have survived. The last use was for the making of spades, until it was converted into an estate sawmill.

As Ford lies beside the River Till, advantage was taken of this water-power. The Delaval family made use of this based on existing mills. Thus water power was used in a forge, a fulling mill for cloth, a dye house, and a joiner's shop. What we can see today is the corn mill at Heatherslaw on the way to Etal, which is rare in that it is still working, and open to the public. It is mostly nineteenth-century, in very good working order, and well presented. A miniature railway runs from here to the castle at Etal, which I shall now describe.

ETAL

Etal was *Ethale* in 1232, and is named after an Anglian called Eata; it is either his alluvial land (haugh) beside the river, or it means grazing pasture. Its position makes both possible.

73a. Etal and the River Till.

Etal.

Top: 73b. Castle and village.

Bottom: 73c. The Castle. The field to the left is marked out for dressage.

The aerial views show how the castle, a courtyard type where one of the four towers seems to be missing, is situated, like Ford, close to a fording place. It was fortified in 1342 by the Manners family, and is not lived in. The castle is part of a well-ordered Joicey estate, the one-street 'village' leading to its being an attractive collection of buildings, mostly rebuilt in 1907. The manor house, a plain structure, lies to the east of this, a Georgian building, extended at the back in the nineteenth century. It has its own chapel in the grounds nearby, built in 1858, dedicated to St Mary the Virgin.

The river had buildings alongside, some of which are modern craft studios, and there are the remains of a water mill.

Part of the castle site was used to build a Presbyterian chapel and manse, which is now an English Heritage visitor centre, with a special emphasis on the Battle of Flodden. Like Ford, it was attacked by the Scottish army, but after the campaign there was sufficient of the keep (the Great Tower) left to store the captured Scottish artillery, although this involved making a big hole in the keep wall, and blocking it again. This 'keep', the main living quarters, is a fascinating shell, and I find it particularly valuable for getting young people to stand inside it and work out what the different storeys were used for, and making a mental reconstruction. It also has a fine collection of mason's marks. There is no roof, and

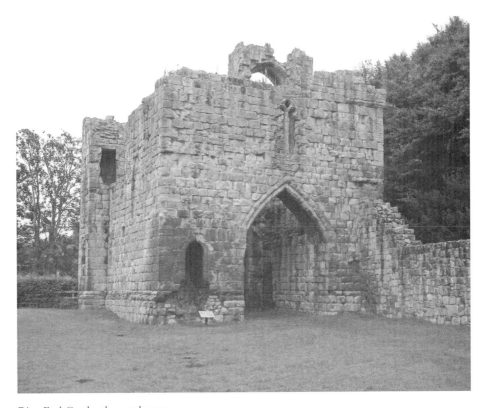

74a. Etal Castle: the gatehouse.

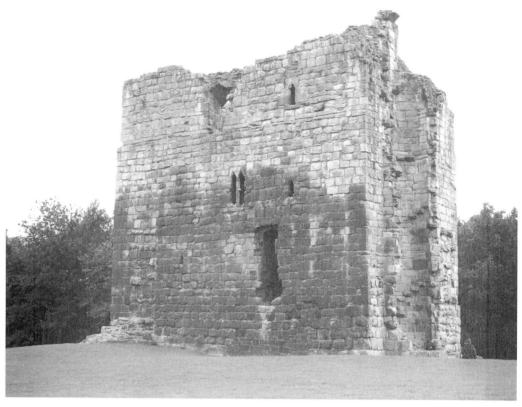

74b. Etal Castle: the keep.

it is a good cross-section of such a building to compare perhaps with the James's Tower at Ford. Next to the museum, a small farm building occupies the site of another, smaller tower, with the vaulting still visible. The north-east corner tower has gone, as an archaeological excavation demonstrated, but the fourth tower is the gatehouse, still largely intact. It has a tunnel-vault, guardrooms on both sides of the tunnel, a straight and a spiral stair leading to the second storey. On the outside, facing the village, there seems to have been a platform that would have overhung the gateway.

This ends the section on the three estates, which tell much of the story of the Border as a buffer state between England and Scotland, and of the different families that had so much influence on the lives of the people.

THE TWEED VALLEY

The town of Berwick-on-Tweed does not actually lie on the Scottish Border, but it is the last major northern English town. It has not always been so, as it has changed hands many times in the battles for territory and influence between England and Scotland. Neither does its present 'Englishness' go unchallenged, and there are many who would like it to belong to Scotland. The town is yet another that owes its status and growth to its position on a major river, and its closeness to the sea gives it further importance. The plain where the Tweed makes its exit is fertile, and arable land follows the river south-eastward. The frontier following this river dips quite sharply to the south-west, through Norham to Coldstream. Parts of Scotland are much further south than Berwick. The area that I shall be viewing is, like so many others, littered with signs of past conflict. The narrow corridor chosen for this view touches Etal to the south.

I began the Tyne and Aln valley surveys from the west, but here I shall begin just south of Berwick and work upstream.

SCREMERSTON

Scremerston, or *Scremestan* as it was in 1130, may mean that that it was the settlement of a fencer. It lies on the coast south of the Tweed estuary, and one reason for including it here is that rock formations that underlie so much of the Border region are highly visible along the coast. We have already seen how peoples' lives are based on the surface geology of the places where they live, and, apart from such features as the basalt dykes seen in sections of Hadrian's Wall, and the deposits left by melting ice and river valley deposits, most of the underlying rocks are sandstones, limestones, shales and coal, containing many minerals such as iron and galena. Some of the rocks are very resistant to erosion, such as whinstone, with sandstone and limestone less so, and clay or shale most vulnerable to erosion. These can be seen particularly well along the coast. Some variations that we see in the landscape are largely caused by the different resistances to erosion.

Soft shales and sandstones, known as Cementstones, are seen in the main river valleys, including the Aln and Tweed, with good agricultural land marked by fields, hedges and trees.

75a and b. Corals in limestone at Cocklaw beach, Scremerston.

Scremerston has given its name to Coal and Limestone Groups, lying below the Fell Sandstones that we see in the Northumberland scarps, such as those overlooking the Aln valley at Whittingham. The coal is in thin seams, but was used locally before the exploitation of richer and thicker seams on the south-east coast.

All the main rivers on either side of the Border rise at, or near, the fire-formed Cheviot Hills. The Aln cuts its way through the sandstone ridges towards the sea along fault-lines through the barrier. The Breamish, on the other hand, cannot cut through the sandstone directly to the east, and follows the scarps north until it breaks through to the Milfield Plain, from where it becomes a tributary of the Tweed.

Berwick itself has cliffs to the east, where the golf course overlooks Ladies Skerrs (i.e. rocks) and Bucket Rocks, where the continuation of these rocks out to sea is best seen at low tide. All these rock formations are the result of huge deposits of sediments, with considerable variation in their layering, and many are spectacularly faulted, folded, and cross-bedded. A minor road to the south, hugging the coast and parallel to the A1, leads to the Cocklaw beach that I find such a good place to see similar formations. Some limestones, like those just north of Alnmouth, look like artificial pavements, and I offer a particularly interesting picture of a thrown-up tree resting on this (see Plate 18).

Within the limestones are fossils, and the ones pictured here are crinoid corals, formed in warm tropical conditions.

Within the sediments are thin coal seams, thus the name Old Colliery Row at Scremerston.

This is only a taste of what there is along this coast, but before leaving it to go north again, I must mention that that has been a persistent idea that some rock-formations that look exactly like the 'cup-and-ring' markings that we have seen elsewhere in this book have been man-made when seen at low tide, but a close examination of these shows that they are made naturally by the sea working on different hardnesses within the layered rocks ('differential erosion').

From these locations we have been able to glimpse some of the deep underlying rock formations on which the Tweed valley rests.

BERWICK

Berwick may have begun as a small settlement famous for its barley, for that is what *berewich* (1167) means. The use of the suffix 'wick' refers to a farm specialising in a product, or at a particular place, such as Alnwick on the Aln, Goswick with its geese and Cheswick with its cheese.

The River Tweed forms a wide, sheltered estuary at the sea, with a pier protecting this outlet. The traveller by road or rail will be impressed at once by the three bridges which span the river, two for road traffic and one for rail.

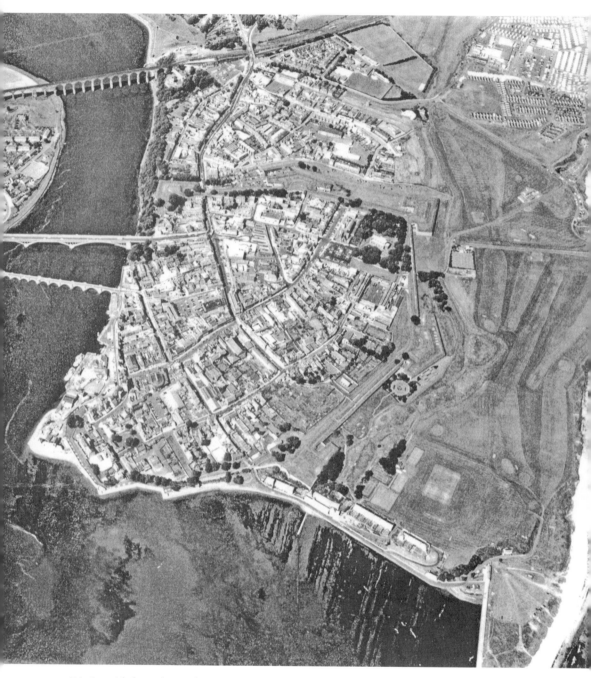

76. Berwick from the south. (*Newcastle University Archive*)

Between the river and the sea is the site of the town – one of the most attractive in northern England. The old town is well-defined by the ramparts that run round most of it, built in Elizabethan times according to the latest military technology, linking its design with many fortifications on the Continent, and to places like Valletta in Malta. The whole structure was based on directed cross-fire that would catch attackers as they stormed the massive walls, with projections outwards that enabled this fire to be even further spread. Ironically, after all the planning and building, it became outdated and redundant when James VI of Scotland became James I of England, so the defences were not tested. However, they now provide a marvellous way of looking at what the town contains: well-planned streets, and a range of very attractive buildings. It is possible to walk all round the town on these defensive walls, with views not only of the interior of the town, but also of the sea and the river.

77. Marygate from the ramparts.

If we begin in the north at Marygate, we can stand on the high wall over the gateway, and look down the street to the Town Hall, built in 1754-61. To our right, the west, the walkway leads to a bastion, and then to the river where the old defensive wall ran, for there were earlier walls and a castle, the latter partly destroyed so that a railway station could be built. To the left, the east, the

walkway runs from bastion to bastion, all projecting beyond the walls, running round the town, and on to the river. The walkway gives the visitor the advantage of being able to view Berwick from a great height, putting many of the roof tops at eye level. On the seaward side, east, there are traces of the medieval wall running outside and in the same direction as the present one, and to the north the Bell Tower belonging to that wall can still be seen.

The town is spaciously set out, planned, and one area of particular interest is Wallace Green to the east, which houses the barracks and a church that was, very unusually, built in the Cromwellian period. We will pause here for a while.

From the wall, we look down on this church of the Holy Trinity, built from 1650-2 from scratch with nothing ancient built into it, unlike so many other Northumberland churches. There had been a dilapidated medieval church at the site, but the governor wanted something grander. The mason responsible for building it was brought in from London; it was restored in 1855, especially on the outside, with Venetian-type windows replacing the Gothic.

The graveyard is also interesting because it reflects the seafaring nature of Berwick's interests, and its position as a garrison. One particular stone may be seen as something amusing today: what is meant to be an angel with its foot on the world blowing the last trumpet call looks rather like a celestial football referee. Tastes change, but death is always serious and distressing.

78. Church of the Holy Trinity, Berwick.

79. Gravestone in a classical style.

Opposite the church are the purpose-built barracks, occupied in 1721 after four year's building, and the earliest in Britain. It has three buildings around a quadrangle, the fourth side having a high wall and gatehouse. Part of this is used as a town museum.

An interesting supplementary building lies outside, with the rampart on one side: the Powder Magazine, with its heavily-buttressed walls in case of an explosion. Elsewhere, various guns have been placed.

From the other parts of this richly-interesting town, one of my favourites is the walk to the end of the pier and the open sea. The stone used to build the east-facing low wall is sandstone that has been etched out by sea spray, wind, and rain into fascinating patterns that are works of art. On the way to the small lighthouse are the remains of maltings, well preserved in their new domestic use. From here we look back to the southern defensive walls, and if we follow them round to return to where we started, we pass some splendid buildings at the Quay walls, with the road from the attractive old bridge passing through them as West Street to join Marygate. This red sandstone bridge was begun in 1611, and took about fifteen years to complete, but it is certainly rivalled by the Royal Border Bridge that carries the railway across the Tweed like a great aqueduct.

On the opposite bank of the river is Tweedmouth, quite different from Berwick. There is a particularly 'old' atmosphere around the church, vicarage

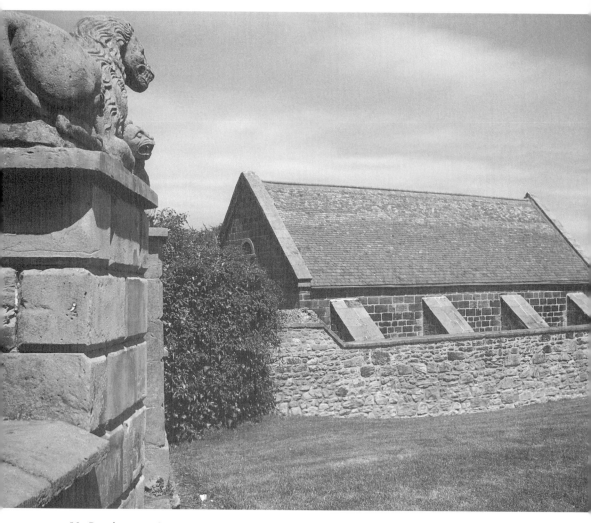

80. Powder magazine.

and overcrowded graveyard, more like a village than a town. It houses the Tweed Dock, opened in 1876, the only wet dock to be built on the Northumberland coast, and with it are a grain mill, brewery, and maltings.

Spittle, so named after a hospital (St Bartholomew), is a continuation of Tweedmouth, mainly mid-nineteenth century, with Wilson Terrace, as Pevsner puts it, having 'some houses with bizarre decoration, every stone of the wall face is carved with patterns, the windows are scrolled and patterned architraves, and the parapet bears busts and is broken by round-headed half-dormers also bearing busts.'

This area, then, is one of concentrated buildings reflecting a past that speaks not just of warfare – though that has its fair share of the architecture – but of a town with industries and fine buildings. Just outside its boundaries is another

strong element in its development – a huge caravan park, from which other people mingle with the shoppers and diners in town. The history of Berwick continues to be written, through the efforts of professional and independent archaeologists taking advantage of opportunities to look below the surface, as well as examining existing buildings and documents. The town has a flourishing Borders Archaeological Society, whose members are not afraid to get their hands dirty in their pursuit of the past.

THE VALLEY

The Tweed valley is wide and rich, with some of the best arable land in the north. As we move upstream, having seen the splendid bridges at Berwick spanning the Tweed, we come to a small place near Horncliffe called Loan End ('the end of the lane'), where there is another famous construction called the **Union Chain Bridge**. It was in America that iron suspension bridges were first built, but here we have the first in Europe built for vehicles to cross the river, followed by the more famous and larger Menai Bridge in 1826 to Anglesey. The designer invented a wrought-iron chain link which made long-span bridges possible. Here, the links are only about five centimetres in diameter, and are so small that it is difficult to see them against the water. The Scottish side has a support tower, but on the English side the bridge is anchored in solid rock. The bridge had a toll house, but this was removed in 1955. At 146 metres long, there was nothing to equal it in Europe at that time, and it cost much less to build than a masonry bridge. Since it was built it has been modified and strengthened from time to time. The minor road from here to Horncliffe ('cliff in a tongue of land') then heads for Berwick to the east, and to Norham on the west, north of the main A698, the line of which road contrasts with the meandering of the river.

NORHAM

One of the large bends in the river has such a steep bank to the north and west that this, coupled with a ravine to the east, established an ideal site for a castle, built on land that slopes from east to west towards the village and its church. The castle was first built in 1121 by a Bishop, Ranulf Flambard, although little of this one remains. The French name of the bishop reminds us of the castle-building programme that followed the Norman Conquest, and that this area was not part of Northumberland but of the County palatine of Durham. Before 1040 the site was known as *Ubbanford*, or Ubba's ford, but this was changed for the Old English term for northern settlement/estate. The bishops of Durham, often called 'Prince Bishops', rivalled the kings with their power, and this castle was their most important northern stronghold.

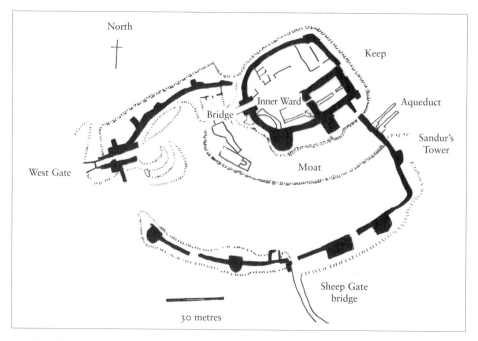

81. Sketch map of Norham Castle.

I have taken many groups to the castle grounds, and they have all been very impressed by the scale of it all. However, it is a very complex site, modified many times, and it is not easy to understand its development. The dominant feature today is a large motte, or mound, built from the upcast of a deep ditch that encircles it. This has a wall with towers on the south and a barbican gateway to the west; the northern part, built in the sixteenth century on earlier foundations, did not need any towers, its strength lying in the steep drop to the river. Inside this D-shaped wall, an area called the Inner Ward, is the great keep, a massive, almost square structure of three storeys, and other buildings such as hall and kitchen built up against the encircling wall and developed later than the keep.

As we cross the moat to the west via the barbican gateway and a bridge, noticing rectangular buildings later built in the moat itself, we are in a much bigger walled enclosure, the Outer Ward, beyond which is another moat. The main access from the west through the Outer Ward is another barbican gate, so one is aware of defence in depth, with the keep being the final stronghold. As the English Heritage guide book shows, there are layers of building in the twelfth, thirteenth, fourteenth, fifteenth, and sixteenth centuries represented. There may have been something earlier too, but the chances of that surviving are slight.

In many ways, the development of the site appears logical, given the terrain, but it seems odd to have buildings in the bottom of the moat, but they used the water that could be controlled in the moat for washing and perhaps the fulling of cloth.

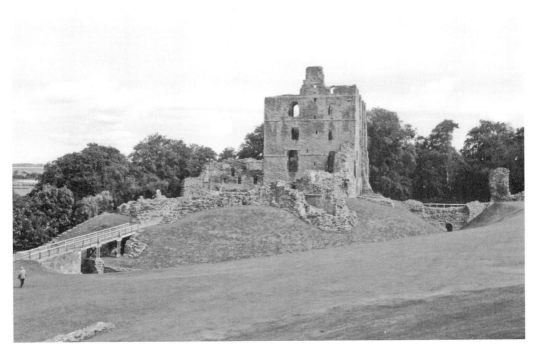

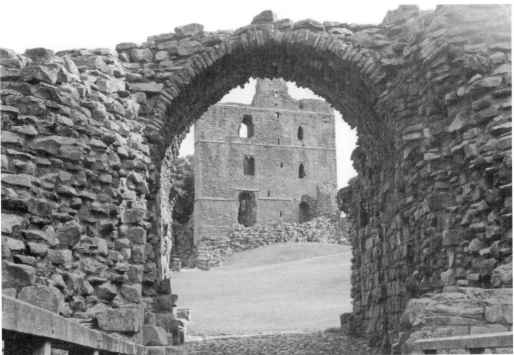

Norham castle.

Top: 82a. The keep on its mound, surrounded by a deep moat.

Bottom: 82b. From the west.

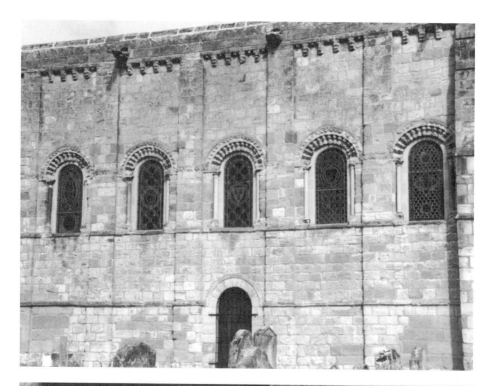

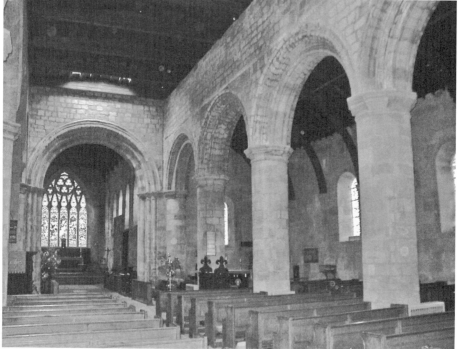

Norham church.

Top: 83a. South wall.

Bottom: 83b. Interior with its Norman arches.

The site is so large that the modern road from the east outside the Sheep Gate, where a bridge crossed over the outer moat, actually cuts through this moat, and you can see the earthworks to the south and south west of the road.

The village lies further west, with a green, the houses ranged on either side of a straight road. It is served by a church dedicated to St Cuthbert, one of the best-loved of all the northern saints. It is of great interest because so many features in it remind us of Durham cathedral that the early part has clearly borrowed from that larger, magnificent building. It is, however, something of a shock to see the oblong west tower which would grace a crematorium; this was built in 1837. The south aisle, porch (1846), north aisle and transept (1852) are also out of keeping with the lovely, surviving part of the church which is Norman. This part truly reflects the power and influence of the Bishops, and emphasises that here is a part detached from Northumberland. Holy Island Priory (in Islandshire) has similar characteristics. The illustrations speak of the skill that went into its building. Another jarring note inside is the way in which fragments of earlier Anglian sculpture have been stuck together, instead of having been displayed separately.

More recent history is seen in the station at Norham, a survivor on the Berwick and Kelso branch of the York, Newcastle and Berwick Railway Company. The platform, stationhouse, and offices are there, and so are a signal tower on a raised brick foundation, goods sheds and coal depot. This is particularly interesting to school parties, along with a visit to the bridge over the Tweed to Ladykirk, and to the railway viaduct to the south over the Newbiggin Dene.

All built in more peaceful times, these structures have not shared the turbulent political history of the castle and its owners. When we come to Flodden, we will see one example of how this castle fared in Anglo-Scottish conflict. That turbulence belies the peacefulness of this small village today.

There are few buildings along the next stretch of the Border, but there are fine fields and wide views. The road runs south-west through these, crossing the River Till just before it reaches the Tweed at Twizel. The name means that here two streams meet (Old English *twisle*) – as it does at Haltwhistle. The bridge is one of the most important in Border history, for here part of the English army in 1513 crossed in order to prevent James IV's Scottish army from retreating over the Tweed without the battle that the English thought essential to stop further invasions. The bridge has only recently been by-passed, and it is an attractive and important structure that may date from the fifteenth century. It is very narrow and very high, spanning twenty-seven metres. Not only does the bridge have a good shape, but its setting is splendid. There is a deep bend in the River Till, and this is flanked by ground that rises to the ruins of Twizel Castle, which is 'modern', a large Gothic structure begun in 1770 on the site of a medieval house for Sir Francis Blake. Building went on for fifty years, but it was never completed, and now it is an intriguing ruin high above the river. It is rectangular with four corner towers, originally five storeys high. I have been with many groups to visit this at the same time as the bridge, and it has been a source of pleasure and interest to

84. Twizel bridge.

young and old alike. There is so much in the landscape that deserves more than a casual trip, and Twizel is a microcosm of Border history. For example, the nearby Tillmouth Park Hotel was built by the son of the man who had built Twizel castle and Tillmouth Park, and the son used material from the demolition of them to build it! Not only that, but we can also see 'Blake's Folly' – one arch of a bridge that Sir Francis had intended to build over the River Till. Such is power, money and caprice, and the strong desire to make a mark. As I said earlier, ownership of land was a sign of your importance, and on that you made your mark.

Another major loop on the Tweed marks the site of Coldstream on the Scottish side of the border, and Cornhill to the south. The western national border is not far to the west of here, with the village of **Wark** on the way there (it shares its name with Wark south of Bellingham, both having a fort – which is what it means).

We have seen the massive defences that guard the Border at Berwick and Norham; here is yet another that was equally important, but now badly decayed. The position was well-chosen, for it was built on a crest of a narrow ridge parallel to the river at a fording-place. It was a motte and bailey castle with wooden

buildings that were replaced with stone. The north was naturally guarded by a cliff above the river. It was commandeered and partly paid for by the crown, as it was of such strategic importance. Although the buildings are now decayed, the massive mound on which the keep was built is clear to see. Partly destroyed by James IV before the battle of Flodden, the keep was restored afterwards to four storeys high, and adapted for artillery. Norham was visible from the top.

The last village west is **Carham**, where there was a small group of Augustinian canons in 1131, and fragments of a tenth-century cross-shaft suggest an earlier Christian presence, although the church, named after St Cuthbert, is now comparatively modern.

It is clear from all these settlements that a priority on this frontier was to control the crossings of the River Tweed, to repel Scottish attacks, and to provide bases for troops that could be sent out to fight. The fact that much of the land along the river and beyond is so rich for farming made it a tempting target, and no doubt there were times when animals and crops were stolen or destroyed, but after the peace which eventually came after the union of the Crowns of England and Scotland, it enabled farmers to begin the serious long-term task of making this land more productive. If we look beyond the massive expenditure of time and energy on fortress-building, we see a landscape of fields that have the purpose of keeping people alive instead of destroying them.

AGRICULTURE

Agriculture was always the main occupation of local people, and is still Northumberland's largest industry, despite the tendency to see rural areas as playgrounds for people from elsewhere, and the growing emphasis on military 'heritage', which is a distortion of how things were. From prehistoric times, from hunter gatherers to more settled farming from Neolithic times onward, the main activity has been to find food and shelter. In the process, of course, people have coveted their neighbour's oxen, asses and other possessions, and often fought for them or defended their own, but the continuing line in history has been the growth of crops and the raising and use of animals, 'the life of the significant soil'. The discovery of minerals on this land has given an extra source of wealth and a strong division of labour, until we have come to a point where in other parts of the country some children hardly see a field of crops or animals in their pastures. Whereas industry, as we have seen in other parts of this book, was at first localised, the Industrial Revolution shifted the bulk of the population to big towns where the work was; this process had been aided for centuries by landlords who got rid of the population who worked in arable agriculture, replaced them with sheep, or made their small fields much bigger, so that Britain is littered with deserted villages and the fossilised remains of old field systems. Rich landlords had the main say in this, and many made vast fortunes at the expense of those

who did the work. Yet the desire to make themselves richer also had the effect of improving agriculture, and eventually of improving the conditions of life of the farm workers on their estates. Some, like the Delavals, spent so lavishly, though, that it is incomprehensible to think that they had any regard for people other than themselves and their kin.

The great changes in agriculture were in the second part of the eighteenth century, and accelerated from there; it is some of these changes that I shall now look at. Because land ownership was in the hands of a few, this made changes easier to introduce, enabling them to enclose large areas of land, a pattern that we see in the large fields with more or less straight boundaries, without anyone's permission. Land that had scarcely been used was easily taken into cultivation too, and new methods such as manuring, and of crop-rotation, along with breeding animals better suited to the land and markets, transformed farming. The way that workers were housed began to change when new farm layouts were planned. New machinery played a crucial part in the new prosperity, such as the threshing machine. Wind and water power had long been harnessed to provide power for corn and other mills, and the use of steam supplemented and then replaced them. This increasing demand for food, as population increased and became concentrated in towns, took advantage of the development of transport, by road and rail.

With Alnwick, I chose to introduce some documentary evidence of the mid-nineteenth century to show what was going on in that town as far as public health issues were concerned. Here I have chosen reports on agriculture of the early nineteenth century to show how the country was being surveyed. I begin here with J. Bailey and G. Culley's reports of 1813; George Culley had enormous influence on farming throughout Britain, yet he is buried in Ford churchyard in a grave marked only with his name, whereas nearby is an elaborate gravestone made for the Marchioness of Waterford. I am not suggesting that the latter did not deserve it – on the contrary, but this does say something of who is valued in our society and how.

The report begins with the fact that Northumberland includes three detached parts; Norhamshire, Islandshire, and Bedlingtonshire, all historically belonging to the Bishops of Durham. The authors see the costal land as having a 'strong, clayey fertile loam, whereas the banks of Tyne, Aln and Tweed are sandy, gravely and dry loam.'

> The aspect of this county, in respect to surface, is marked with great variety; along the sea-coast, it is nearly level; towards the middle, the surface is more diversified and, thrown into large swelling ridges, formed by the principal rivers. These parts are well enclosed; in some places enriched with wood and recent plantations, but the general appearance is destitute of these ornaments.
>
> The western part (apart from a few intervening vales) is an extensive scene of open, mountainous district, where the hand of cultivation is scarcely to be traced.
>
> Of the mountainous districts, those around the Cheviots are the most valuable, being in general fine green hills, thrown into a numberless variety of farms, enclosing

and sheltering many deep, narrow, sequestered glens; they extend from the head of the Coquet down to Allenton; from there Northward to Prendwick, Branton, Ilderton, Wooler, Kirknewton and Mindrim (*sic*), and occupying at least 90,000 acres.

They add that the other 'mountainous districts' extend largely from the Roman Wall to the River Coquet and to the moors north of Rothbury.

> They are not marked by any striking irregularities, of surface, being in general extensive, open, solitary wastes, growing little else but heath, and afford a hard subsistence to the flocks that depasture them.
>
> The most striking parts in a view of Agriculture are, the great extent of farms, leased for 21 years, and the opulence, intelligence, and enterprising spirit of the farmers; but the most prominent feature is, keeping a due balance betwixt the arable and grass lands, so as always to have a large breeding live stock, especially of sheep.

They see that the 'union of stock and tillage' enables farmers to pay such high rents and 'which keeps the land in a due state of fertility, to produce the most profitable crops.'

They stress the value of lime and manure. They say that improvement can be made by re-stocking with better breeds of sheep.

> The misfortune is, that those who know the least about stock, are generally the most bigoted for retaining the original breeds of the country, and the loudest to raise a clamour against innovations and attempts at improvement.

When they look ahead with their suggested improvements they say:

> We hope that the good sense and enterprising spirit of wealthy farmers of this district will no longer be swayed by old customs, but will be ready to make a fair experiment of a system which has been practised on similar soils with success.

They note that farmers are impressed by increase in yields through using alternative strains and practices, but when it comes to stock they are not so ready to change because what they observe is such a slow process.

The final statement of their conclusion is that the rich landed gentry ought to support and pay for change, for on the ideal farm:

> A farm of this kind would not only be a school, where youth might be instructed in agriculture, but even experienced farmers might often visit it with advantage, to learn the results of new experiments, and adopt those that promise to be useful.

In 1808 there was a review and summary 'of the County Reports to the Board of Agriculture' in five volumes, with Northumberland included in the first. The

author, William Marshall, points out how well-qualified his trusted surveyors have to be in agriculture, the sciences, mathematics and the English language, and particularly in their detailed knowledge of the areas they are dealing with. He thus approves totally of George Curry; he has toured the areas himself, but owes the report to Bailey and Culley:

> Mr Culley is publicly and well known, as an authority of livestock. He was...in early life a pupil of Mr. Bakewell of Leicestershire...he has for many years been an extensive occupier in the county under review; namely, in the district of Wooler, and on the southern bank of the Tweed. His breed of sheep are known, even to the "farthest Thule" by the popular name of the "Culley breed." Mr. Culley is also an arable farmer of high distinction; and has perhaps, as much or more than any man, been instrumental is raising the agriculture of Tweedside to its present eminence.
>
> Mr Bailey, too, has long been resident in the district of Wooler; as manager of the extensive landed property of the Earl of Tankerville, in that neighbourhood. His practical knowledge of the management of tenanted estates, and woodlands, must of course be considerable; and his scientific acquirements, are evident in different parts of the report; of which, from expressions that occur in it, Mr. B. is to be considered as *editor*. Mr. Bailey's practical knowledge as an agriculturalist, I cannot well appreciate. But this was the less required, as the mature experience of his able coadjutor, rendered it in a manner unnecessary.

He finds that they have made comparatively few errors, and although he is not prepared to say that it is perfect he says as a great compliment 'we shall not see its like again.'

I will make the point that these two men's names do not appear often in general books on Northumberland, which is why I am stressing their contribution to its history.

More recently, a Survey of the agriculture of Northumberland (Pawson) in 1961 for the Royal Agricultural Society says this of Tweedside:

> It has been described as an "ideal farming district" and whilst it is true that the combination of soil and climatic conditions might well be envied by farmers in most other districts in the county and indeed country, it should also be said that the tradition in respect of skill and management reflects great credit on both farmers and farm workers of Tweedside.

The twentieth century saw switches to and from arable to livestock; for example, the south-south-west increased sugar beet and potato production, and wheat, barley and oats could be grown very successfully, with a barley crop particularly good for malting. The report repeats that it is skill in management that has enabled the region to adapt to changes. The summary is:

Generally a high standard of farming, with a highly skilled but diminishing farm labour force.

Northumberland, by then, had turned its swords into ploughshares and its spears into pruning hooks, but if we look at the reverse, in the same area of Wooler where the likes of Mr Bailey and Culley worked, we encounter The Battle of Flodden, 300 years before they were writing their reports, which took place in that agriculturally-rich area.

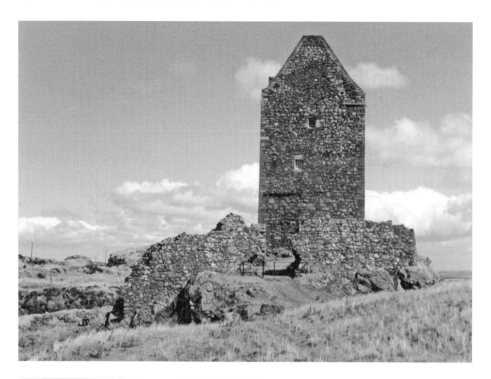

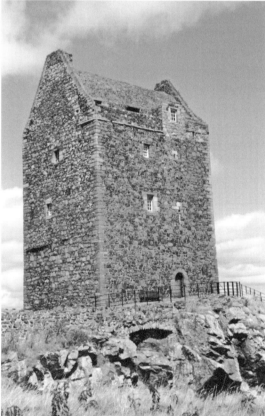

85. Smailholm lies in the Scottish Borders. A father and four sons from the Tower were killed at Flodden in 1513. Sir Walter Scott spent his early childhood there.

5

FLODDEN FIELD

My interest in battles has generally been in what caused them and what resulted. Having spent many weeks over a long period in Ford Castle and visiting the site of Flodden very often, the place has taken on a fascination that has led me to read as much as I can about it. Very often it is the victors who write the accounts, and this can distort the facts, but there is sufficient evidence to enable me to build up a picture, however incomplete, of the battle itself and its effects.

The site is surprisingly tranquil, with wide views from an offshoot of the main Cheviot Hills across miles of country that is sparsely inhabited. North is the River Tweed, and east is the Milfield Plain. The land is not flat, and the undulations in it played an important part in the battle. Scotland is always visible to the north on a clear day – the home of so many thousands of Scots who were to be slaughtered in 1513. A chunky granite cross marks one of the killing fields, on a small rise where the Earl of Surrey came face to face with King James IV's fatal charge. Once a year, a solitary piper climbs the small hill to play a lament. Once a year, riders of all shapes, sizes, and ages on all sorts of horses gallop up the hill to a waiting line of cars, where refreshments await them on Branxton ridge. There is a display board near the cross to show what took place, but if cross and board were to be removed there would be nothing more remarkable to see than sloping fields running down the hill with good crops. The place may have no Power unless you know what happened there; once you know, it is horrific.

Here, the Border has been a place where the last great battle between Scots and English took place, with Borderers in both camps. You would have seen thousands of stripped and mutilated corpses scattered over a mile of ground, many in clusters. If that is difficult to take in, remember that a father and four of his sons who lived in Smailholm Tower across the border were slain there, with one son left at home to continue the family line; the tower became home to the young Walter Scott, who was to be influenced so much by tales of the Borders, breathing in so much local history and legend that he encouraged people to reconsider their past, and to be thrilled by it. History has, unfortunately, reduced battles to symbols on a map, with an arrangement of boxes and arrows, so that the whole business becomes sanitised and impersonal.

There are people who love dressing up in ancient battle gear and enjoy 're-enactments'. I am not sure why; I am not one of them, as I find the reality so distasteful and sickening. If we focus on one individual caught up in battle – a

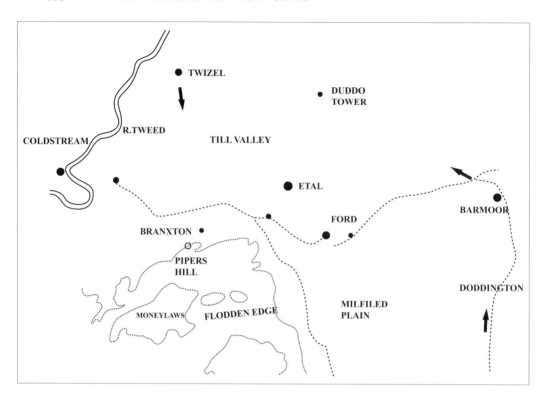

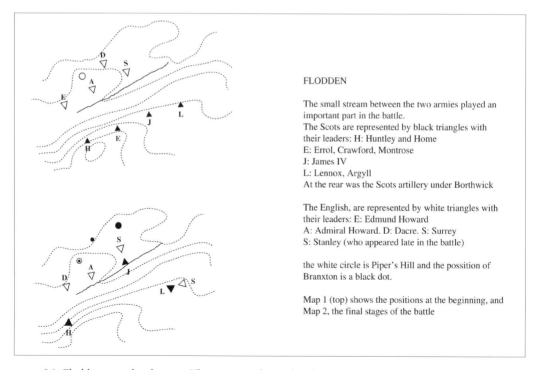

FLODDEN

The small stream between the two armies played an important part in the battle.
The Scots are represented by black triangles with their leaders: H: Huntley and Home
E: Errol, Crawford, Montrose
J: James IV
L: Lennox, Argyll
At the rear was the Scots artillery under Borthwick

The English, are represented by white triangles with their leaders: E: Edmund Howard
A: Admiral Howard. D: Dacre. S: Surrey
S: Stanley (who appeared late in the battle)

the white circle is Piper's Hill and the possition of Branxton is a black dot.

Map 1 (top) shows the positions at the beginning, and Map 2, the final stages of the battle

86. Flodden area sketch maps. The top map shows the places most connected with the battle, and the flanking march of the English army.

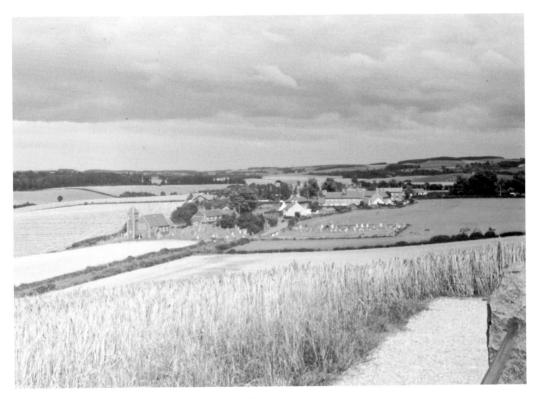

87. View towards Scotland from Piper's Hill.

father, son, lover – his suffering and death, and the impact of that on others is the reality. Most people who went to war then did so because they had no option; others may have relished the idea of travelling away from home, seeing new places, having a possibility of plunder, and tales to tell the folks at home afterward. The cause for which they were fighting may have been obscure to them, but their jobs, their communities, their loyalty to local lords demanded their obedience and service.

So why was a battle fought? National 'interests', ambition, conceit, and stupidity all played their part. There had been years of conflict between England and Scotland in which atrocities had been committed on both sides. As we have seen, the Borders kept the rivalry alive even when the rest of the kingdoms were comparatively peaceful, and were the first parts to feel the full weight of raids. This conflict continued to foster the hatred that Scots felt for the English, and vice versa. What decided war, though, was the ambition of princes. So let us look at the line-up.

On one side was Henry VIII, king of England, who had inherited a full treasury and remarkably stable government from his father, Henry VII. He was thirsting to establish himself as a great force to be reckoned with, looking at the Continent, as some of his ancestors had done, as a means of glory, with Crecy and Agincourt

ringing in his ears. He would have thought nothing of the thousands who had been killed as a result. He had money, he had a united kingdom behind him, so he embarked on expensive wars that achieved very little. However, he had taken the southern English part of the army to France, leaving the Earl of Surrey to deal with any trouble at his back door from the Scots. Surrey was seventy, and at times had to be carried in a litter ('chariot'), but he was shrewd and practised in diplomacy and warfare, so, luckily for Henry, it was a good choice. Surrey had escorted the child bride Margaret, Henry's sister, to Scotland to marry James IV (who was about thirty) in the triumphal procession to Scotland, intended to cement relations, but falling short, especially when Henry had not paid the whole dowry. One advantage to Surrey was that his stay in Scotland gave him time to know his enemy. Henry was fully aware there might be trouble ahead. England and Scotland had sworn to keep peace between them, but Henry's invasion of France, Scotland's ally, had placed James in an impossible position, eventually bringing him out against the traditional 'auld enemy'. James and the Earl of Surrey shared a strong mutual dislike.

So we have Henry, determined to make a name for himself opposed to James, who was a very successful king who had unified the warring factions within his own country to some extent, and was popular – so much so that when the time came he could assemble the largest army in Scottish history. The French provided him with money, military advisers, weapons, and equipped his navy. History has criticised many of his actions in his invasion of England, often based on myth rather than fact, but he was no fool. The fact that he had brought stability and greater prosperity to the nation should have counted more than Henry's vanity and wasting his nation's resources. No matter how fragmented the Scottish kingdom was, in area and clans, they all came when James called. Before the invasion, he had already attacked the Border and sorely tested the defences, including those of Norham Castle.

James was obsessed by artillery, and the building of massive bronze cannons was a delight for him, as he saw the potential of the new destructive power which was to destroy castles and change the nature of warfare. He had learned from continental wars about the superiority of the Swiss long pike massed formations, whose cast-iron discipline made them an example to all who wished to conquer. When the war came, many of his troops would be equipped with them. The English longbow, although still greatly feared, was not the threat that it once had been; artillery and pikes could win battles. Henry's absence was a great opportunity for James, whose object seems to have been to force Henry to stop fighting his ally, the French. The queen of France, it is well known, sent James a large sum of gold and her turquoise ring to take for her a yard of English soil, but that in itself did not account for the invasion. His preparations for war were not hurried. He knew that the coming battle would not be between him and Henry, but against an Earl and the levies mustered in northern England. He was confident in his fire-power and strength of his army; he may have thought of Surrey's men as Second Division.

No castle could withstand the bombardment of guns like Mons Meg (now at Edinburgh Castle), which he thought worth the effort of hundreds of men and beasts to transport them, service them, and fire them at the English.

On a smaller scale, an incursion, James had already invaded the Border in September 1496, and plundered the valley for many days, in support of the Pretender to the English throne, Perkin Warbeck, when Henry VII was king, perhaps hoping to gain Berwick that way and get well paid for his support, but after Warbeck lost his political importance, James was glad to see him go. In August 1497 James attacked Norham Castle in a siege that lasted a week and failed. The Earl of Surrey tried to get him to fight, but James' offer of personal combat to decide the fate of Berwick was not accepted, James slipped back over the Border, and Surrey was left frustrated. The incursion for James, though, had the effect of testing English defences for his future war. As Henry VII was not prepared to go to war, he agreed to what came to be known as the 'Treaty of Perpetual Peace' with England, signed in 1502 and sealed with the marriage of his daughter Margaret to the Scottish king. It could last only as long as it suited either king's interest. It did give James a claim to the English throne. At the time, both rulers were looking for stability in which to improve their countries. But the seeds of conflict were there. Margaret's dowry was not paid in full. There was another factor concerning the Bastard Heron, who was to appear at a crucial point in the preparations for the battle of Flodden. He and two cronies had murdered the Scottish Warden of the Middle Marches, Sir Robert Kerr, on a truce day. Even by the standards of the Border, this was bad. The murderers escaped, and although the owner of Ford Castle, William Heron, the bastard's half-brother, was handed to the Scots as a hostage, the matter was not settled. There were so many provocations, but it was James' decision to help his French ally that caused James to invade after many months of preparation, and careful calculation.

James crossed the Border at Coldstream on 22 August 1513. His big guns were ranged against Norham castle from the north bank, and reduced its walls to rubble. Then they concentrated on the west gatehouse and smashed it. In a short time the garrison had run out of ammunition and surrendered, leaving it open to plunder. Many of the Scots, after having taken their share, went home. There was nothing unusual in this practice, and it was one of the weaknesses of the system that people just went home, for they had got what they had come for. Once word of this destruction got around, castles like Ford, Etal, and Wark, when similarly threatened, realised that they stood no chance. Smaller fortifications, too, like Duddo tower, were destroyed and the countryside was open to plunder. Meanwhile James avoided Berwick, which was perhaps more formidable.

All this, however, might be seen as a raid rather than a full-scale war, not that the scale meant anything to the people who suffered. As James' next step did not seem to be to attack Newcastle and go further south, he waited for the Earl of Surrey and the English army to arrive, choosing his position with great care, so that he would have all the advantages. He had spent until 4 September at Ford Castle,

before setting fire to it and moving to Flodden. Many of his men had gone back to Edinburgh with their plunder before then, so his numbers had become diminished.

The English army arrived, via Newcastle, at the little village of Bolton on 5 September (near Whittingham), then at Wooler, not far from where James was prepared for battle. Having overcome Ford Castle, James had stayed there, giving the gossips and scandal-mangers the story that Lady Heron, whose husband was already a prisoner in Fast Castle, gave her favours to him and betrayed his battle plans to the English. James slighted the castle, and went to join his army at the prepared position of Flodden ridge, which he would have clearly seen from Ford across the Milfield Plain. Today a thick plantation of trees leads to the top of it. The land is a lower outlier of the volcanic Cheviot Hills, and had an Iron Age fortification on top – an indication that it was a natural place to fortify. From here he could see what he expected to be Surrey's army coming from the south, and to the east he had the Milfield Plain, so the idea was that with the siting of his big guns, and with his men in fortified positions, they would ride into the valley of death. The fire-power and range of the big guns had already been tested. All eyes southward, then.

Surrey had marched in bad weather all the way there to what is now a big caravan park just off the A697 beside the Wooler Water, ('Wooler' actually meaning that it was

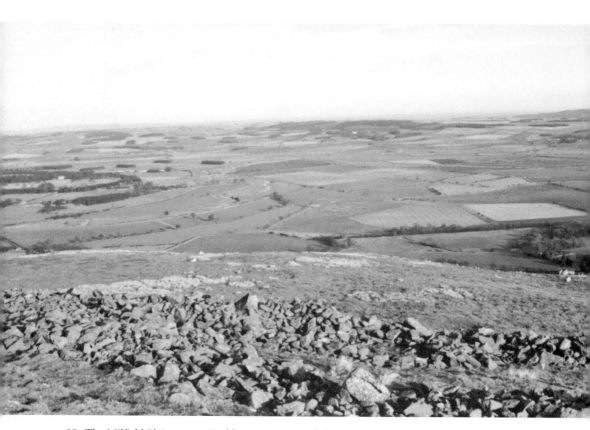

88. The Milfield Plain east to Doddington Moor and the North Sea from the Cheviots.

on the margin). They were to camp there for the night. His army was short of food and beer. He knew that he could not keep them together for long, but his levies were in groups that knew each other, and under the command of leaders that they knew at home. They had to be confident that their leaders knew what they were doing, as they could not see the whole situation. Surrey had to provoke James into fighting, as he could not allow the Scot's army to retreat, only to come back next year. It was now or never for him. He played on the fact that James was a king and that he was a mere Earl, and made his communications seem offensive. His son, the Admiral of England, was even more provocative in his message to James. Very well, James agreed on the date of the battle and gave his word. It was to be on 9 September before noon.

There was the huge problem that Surrey's army would be outgunned and would have to fight uphill to Flodden Edge where the Scots had, unusually, dug themselves in. He would have preferred the flat Milfield Plain, but James was entrenched. What made Surrey devise his master plan we are not sure, but one likely story is that he took advice from people who knew the terrain very well. One such man was the Bastard Heron who had foully murdered the Scottish Warden of the Marches, and caused such trouble between England and Scotland as a result. It was a chance for Heron to be forgiven, perhaps and to get back into favour.

89. The crossing of the River Till at Weetwood Bridge to Doddington Moor.

90. Pipers Hill.

Whatever the cause, Surrey led the army in a different direction, over the Till at what is now Weetwood Bridge, and over the moors of Doddington. The Scots must have wondered what was happening: where were the English going on 8 September? To Berwick? To invade Scotland? He headed for Barmoor, east of Ford, and camped there. His plan was to march his army the next day behind the Scottish position to cut off a retreat to the Tweed, and force them to fight facing the other way. Local people would have known the land; if the army could reach Branxton village, negotiate some swampy ground, they could occupy a ridge north of the Scottish position, forcing them to turn and abandon their advantageous position.

Surrey took the enormous risk of splitting his forces for the march. One large part of it crossed the Till tributary over Twizel bridge, which in itself would have taken at least an hour for all the men and animals to cross. The rest would cross by other fording places to get to Branxton.

If you stand on Piper's Hill, where the Flodden memorial cross is built, and look south, you will be looking at a ridge about one mile long that slopes towards you. A crucial feature of this slope is that it dips south and north into a small natural linear ditch running from east to west. Not a good thing for an army that carries eighteen-feet-long pikes!

If you look north, there are parts of the land that form ridges which are hidden from sight, and make it confusing to know what was going on there.

The arrival of the English army behind the Scots could not have been a sudden surprise, and James had to use limited time to turn his army to face the threat. Surrey, seeing the Scots' disposition, had to revise his own battle plan so that groups faced each of the Scottish battle formations. All of the careful digging at the top was now useless; the guns had to be moved, and there was no time to get the new range accurately. These guns were also facing downhill; although the big bronze cannon made in Scotland and on the continent had smashed castle walls, they were not so suited to ground where light field artillery could fire more rapidly, and be moved into position more easily. Thus James had lost his great advantage. The Swiss mercenary tactics of fighting with long pikes, devastating in Europe in the hands of very well-drilled men, also proved to be a disadvantage on a downward slope that had an unexpected ditch to cause confusion. Armies don't like a sudden change in orders, especially if one is not clear what the new orders are.

Both armies were split into 'battles', or groups. One crucially mobile group of English cavalry under Lord Dacre was kept behind the others to fill in any gaps and to deal with crises – an important consideration when we learn what happened next. Their formation could not be seen, as a ridge hid them.

The battle began with an artillery duel, a novel occurrence, in which the Scottish came off worst, especially after a master gunner was killed straight away. The Scots' heavy guns had a powerful recoil, and took a long time to re-charge, whereas the smaller English weapons could fire more rapidly, and into the massed ranks of soldiers. The outcome of the battle was to be decided by bloody hand-to-hand fighting, when it boiled down to 'kill or be killed', and no prisoners taken. At first the Scots were successful; Huntley and Home on the west won the first engagement against one of Surrey's sons, and he retreated with great difficulty to join his father at the centre. The Scots lords did not follow this up, possibly because they felt they had done their bit, or to be ready to secure the crossings over the Tweed; we do not know, but they were taken to task in Scotland for this after the battle, when scapegoats were needed for failure. The gap was filled with Dacre's cavalry, who could now form a pincer movement from the west. The centre, the main part of the fight, involved James himself leading from the front against Surrey. The pikes proved a disadvantage on the slippery slope, and were abandoned for other weapons, but the English were equipped with billhooks, weapons that cut, hooked, speared, and slashed, and which depended on the strength and skill of individuals acting for themselves. It was a bloodbath in which more Scots than English were killed. On the eastern flank, Lord Stanley had arrived late, his men climbing a steep slope to a wood, and from their position they loosed flights of arrows on the unprotected bodies of Highlanders, forcing them to flee. Bows and arrows had not proved invincible because of the wet weather, but here they were effective.

The aftermath was nauseating. At first it was not clear who had won, but soldiers who had survived set to work to strip the dead of everything they had. So did the borderers. The 'spoils of war' were expected. James' body was treated the same as everyone else's, and was probably unrecognisable.

It is not easy to get exact numbers of casualties, or even of the original strength of the armies, but the significant point is that the Scottish casualties were enormous, the English less so, but still high. No doubt many troops would have knelt on the earth and took the soil in their mouths before battle to show that they were prepared to die, but this was small consolation for those who suffered acute pain before dying. It is difficult to understand what is called 'national pride' in this event, particularly when suffering and death were to affect more than the soldiers who were killed that day. There were hundreds of people who were at home who loved them. The cross on Piper's Hill bears a legend commemorating the dead of both nations, and to speak of one side 'winning' is not good enough to reconcile our humanity to accept what happened there. Sadly, the process is repeated today all over the world.

It is likely that Henry VIII felt upstaged by the Earl of Surrey. He had not achieved that kind of success in France, and returned with nothing except the need to get more money. There was to be no further full-scale war between England and Scotland, and the latter country dissolved into the disunity that had been there before James had brought order. Border raids continued, though, and only eased after the two kingdoms were united under James VI of Scotland, who became James I of England.

I remember particularly an event at Ford castle, where the poignancy of this battle was to affect a course of teachers that was spending a weekend there. In the programme that we had devised there was a talk by the Hexham folk-singer Terry Conway on the Border Ballads, which he accompanied by singing and guitar. The Ballads are an extraordinary powerful and unique collection. One group was experimenting with the use of the new video cameras that were coming into use, and they went to the site of Flodden with Terry, where they recording his singing 'The Flowers of the Forest' against a wet background of the battlefield and red hawthorn berries that dripped tears from the hedgerows. This was played to the whole course at the end when all the activities had been discussed, and there was hardly a dry eye in the place, as all by then knew the story. I hope that they went back to their schools with a more realistic and humane approach to the way they taught history, which is not all glory, but can be the result of prejudice and greed, where little people are caught up in a conflict about which they know little. Surrey's levies were paid off early to save money, and returned home. The Scots would have had a different reception when they returned because they had lost. But who were the victors and who the losers?

The churchyard at Branxton took over 1,000 bodies. The earliest part of the church is Norman, built long before the battle and serving the community there. Branxton itself is an Old English name (*Brankeston* in 1195: Branoc's settlement),

and theoretically should be the name of the battle, but someone found the word Flodden or Floddon, which means a stream by a hill or in a valley, and that was that. Flodden Ridge is where the Scots were encamped, and the battle took place between that and Branxton. Go there, but don't cheer the 'winners' if you are English. It is a place to reflect on what horrors people are capable of.

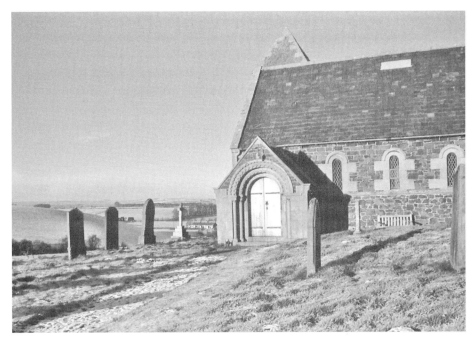

91. Branxton church.

A postscript to this is that many Borderers did well out of Flodden in plunder. While some of them stripped the dead at night on the battlefield, Reivers from Tynedale and Teviotdale plundered the English tents and stole horses. Surrey had left his baggage trains at Barmoor. The Bishop of Durham said,

> They are falser than Scots, and have done more harm to our folks than the Scots did. I would that all the horsemen in the borders were in France with you for there should they do much good, whereas here they do none, but much harm, for, as I have written before, they never lighted from their horses, but when the battle joined then fell they to rifling and robbing as well on our side as of the Scots, and have taken much goods besides horses and cattle.

As Surrey had achieved his aim he did not pursue the Scots; there was no more money to pay his men, and supplies had run out. Dacre was left to harry the Scottish Border as usual, and in one raid lifted 4,000 cattle. The Scots retaliated,

but could not match the English raids, which harried and burnt so many villages
and towns on the Scottish side.

I wonder where all the wealth must have come from, as the wills and inventories
of Border families do not boast many possessions, and I wonder what was left after
all these raids. The national clash may have been over, but the ghastly deprivations
went on along the Border. Dacre even employed the Scots themselves to raid north
of the Border. He also set about re-fortifying Wark. At the same time, the Elliots
burned Hexham and Haltwhistle and many villages … and so it went on.

'THE FLOWERS OF THE FOREST'

The Ballad that has become a lament for those Scots slain at Flodden is not of the
period, but written in the late eighteenth century by Miss Jane Elliot, daughter of
the Lord Chief Justice of Scotland, and is rightly a song that captures the feeling
of desolation that would have afflicted those left behind.

I shall not explain the words as they appear, as translation affects the rhythm
and feeling, but give a helpful 'translation' at the end:

> I've heard the liltin' at our ewe-milkin',
> Lasses a-liltin' before dawn o'day;
> Now there's a moanin' on ilka green loanin',
> The flowers of the forest are a'wede away.
>
> At buchts in the mornin', nae blithe lads are scornin',
> Lasses are lanely, and dowie, and wae;
> Nae daffin', nae gabbin', but sighin' and sabin',
> Ilk ane lifts her leglin and hies her away.
>
> In har'st at the shearin', nae youths are now jeerin',
> The bandsters are runkled, and lyart, and gray;
> At fair or at preachin', nae wooin nae fleechin',
> The flowers of the forest are a'wede away.
>
> At e'en, in the gloamin', nae swankies are roamin'
> 'Bout stacks, 'mang the lassies at bogle to play;
> But each ane sits dreary, lamentin' her dearie,
> The flowers of the forest are a' wede away.
>
> Dool and wae for the order sent our lads to the border,
> The English for ance by guile wan the day;
> The flowers of the forest, that fought aye the foremost,
> The prime o'our land now lie cauld in the clay.

> We'll hear nae mair liltin' at our ewe-miklkin'.
> Women and bairns are dowie and wae;
> Sighin' and moanin' on ilka green loanin',
> The flowers of the forest are a' wede away.

Although the sense and atmosphere and atmosphere are there, I offer a little help:

> I've heard them singing at ewe-milking before the dawn of day, but now they are moaning on that same milking-park.

> At sheep pens in the morning there are no lively lads to pour scorn; lasses are lonely, sad and woeful. There is no dallying or chatter, but sighing and sobbing. One lifts her legs and goes on her way.

> At harvest time at the cutting of the corn there are no jeering youths. The bound sheaves are wrinkled and streaked with grey. At the fair or at church there is no wooing or flattery.

> All evening in the gloaming no gallants are roaming about the stacks playing hide and seek with the lasses, but each girl sits drearily lamenting her lover.

> Grief and woe fall on the order that sent our lads to the border. The English for once by guile won the day. The flowers of the forest that were the foremost in the field, the prime of our land, now lie cold in the clay.

> We'll hear no more songs at our ewe-milking. Women and children are sad and pale, sighing and moaning on the sheep pasture – the flowers of the forest are all faded away.

Readers may be reminded of the much later 'Where have all the flowers gone?' when the answer, my friend, 'is blowing in the wind.'

VIEWPOINTS FROM OTHER
PARTS OF NORTHUMBERLAND

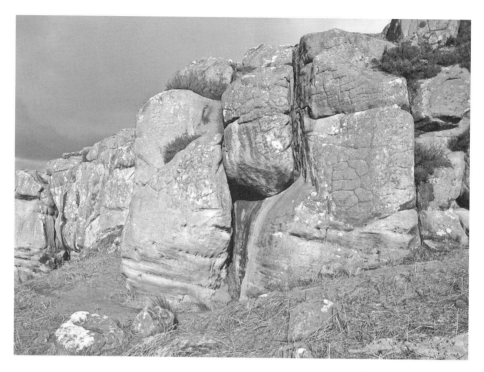

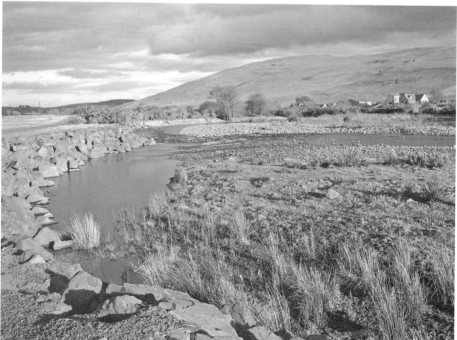

Previous page, top: 92. Alwinton church in the Cheviot Hills.

Previous page, bottom: 93. Rothley Crags sandstone scarp.

Above, top: 94. Caller Crag sandstone.

Above, bottom: 95. The River Breamish in the Ingram valley.

Top: 96. Allenheads: the river flows through an area rich in old lead workings.
Bottom: 97. Bamburgh beach.

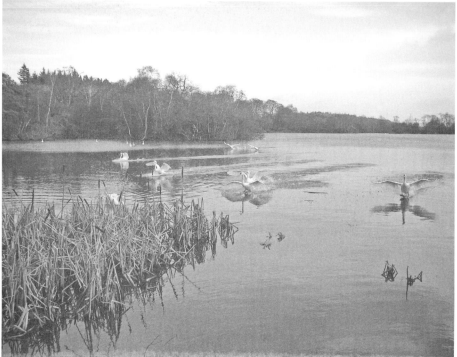

Top: 98. Belsay: a view from the Hall.
Bottom: 99. Bolam Lake.

Right: 102. The Lambley
railway viaduct.

Bottom: 103. Upland
pasture south of Rothbury.

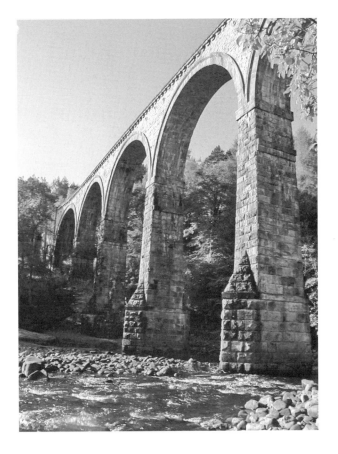

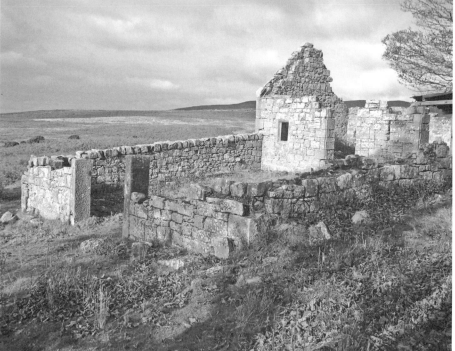

Top: 104. Fowberry beech trees.
Bottom: 105. Blawearie abandoned farm.

ACKNOWLEDGEMENTS

I am very grateful to the *Hexham Courant* and its photographer, Tony Iley, for air photographs of the Tyne valley, to Gordon Tinsley for his, to Sonja Bailes for pictures of the Haydon Bridge area, and to The University of Newcastle. All these are acknowledged in the text.

The base map was again provided freely by Marc Johnstone, to whom I am very grateful. I thank Matthew Hutchinson for ensuring that the text is understood by a wide audience, and for arranging with the kind owners for access to Willimoteswick farm. My thanks to Bridget Winstanley for introducing me to the Eslington Estate map. Finally, I am grateful to my editor, Louis Archard, and to James Pople of Amberley for their skilful production.

BIBLIOGRAPHY

BECKENSALL, S.

There is much appropriate and additional information in the author's previous published work in the following books, with some of it itemised in chapter headings below with page numbers:

2001 and 2006, *Prehistoric Northumberland* (Tempus)

2001, *Northumberland: the Power of Place*
 Chapter 3: War and peace: the Border (60-79)
 Chapter 4: A microcosm: Ford, Etal, Flodden (80-97)
 Chapter 5: The Tyne valley (97-118)
 Chapter 6: Townscapes(119-137)
 Places to visit (180-181)

2003 and 2006, *Prehistoric Northumberland* (Tempus)
 Chapter 1: Northumberland landscape
 Chapter 3: The Great Revolution (farming) (29-36)
 Chapter 4: Settlements and defences (37-88)
 Chapter 5: Burial of the dead (89-118)
 Chapter 6: Prehistoric rock art (119-130)
 Place to visit (164-78)

2005, *Northumberland: Shadows of the Past* (Tempus)
 Chapter 1: In the beginning (11-26)
 Chapter 2: Our going out and our coming in (27-61)
 Chapter 3: The valley of the shadow of death (63-92) (public health)
 Chapter 4: Shadows of an industrial past (93-124)
 Chapter 5: Crossing the land (125-148)
 Chapter 6: Rise and fall (125-148) (abandoned sites)
 Chapter 8: A land of violence (205-212)

2006, *Place names and field names of Northumberland* (Tempus)

2007, *Hexham: history and guide* (Tempus)

2008, *Northumberland from the air* (History Press)

2008, *Unquiet Grave: A Novel for Young People* (Powdene, Newcastle)

2009, *Northumberland's hidden history* (Amberley)

2010, *Empire Halts Here* (Amberley)

1813, Bailey, J. and Culley, G. *General View of the agriculture of the County of Northumberland* (London)

2001, Barr, N. *Flodden* (Tempus)

2009, Birley, R. *Vindolanda* (Amberley)

1895, Dixon D. D. *Whittingham Vale*. Newcastle 1979.

1985, Dixon, P. *Deserted medieval villages of North Northumberland* (2 vols.) Unpublished PhD thesis, University of Wales

McCord, N. *North east England: an economic and social history*. Batsford.

1933, Ed. Dodds, M., H. *A History of Northumberland* Volume 14 (including Chillingham and Whittingham). Newcastle.

1971, Fraser, G. M. *The Steel Bonnets* (Pan)

1925, Gibson, J. *Willimoteswyke Castle*. Society of Antiquities of Newcastle 4th series II No. 10, 75-78.

2000, Hardie, C. and Rushton, S. *The Tides of Time: Archaeology on the Northumberland Coast*. (Northumberland County Council)

1940, The Holmside and South Collieries Ltd., and The owners of Settlingstones Mines.

1935, Hope-Dodds (Ed) *Northumberland County History*. (Newcastle)

1995, Johnson, G. A. L. *Robson's Geology of North East England* (Transactions of the Natural History Society of Northumberland) Newcastle

Jones, G. D. B. and Woolliscroft, D. J. *Hadrian's Wall from the Air* (Tempus)

1937, Leather, G. F. T. *Flodden* (Berwick-on-Tweed)

1808, Marshall, W. *The Review and Abstract of the County Reports to the Board of Agriculture* Volume 1: Northern Department (York)

2008, Oswald, A., Ainsworth, S., Pearson, T. *Iron Age Hillforts in their landscape contexts*. AA. Fifth Series. Vol. 37. p. 1-45

1961, Pawson, H. C. *A Survey of the Agriculture of Northumberland*. (Royal Agricultural Society of England, London)

1992, Pevsner 2nd edition revised by Grundy, J., McCombie, G., Ryder, P., Welfare, H. *Northumberland* (Penguin)

1966, Robson, D. A. *A Guide to the Geology of Northumberland and the Borders* (TNHS of Northumberland, Durham and Newcastle. Newcastle)

2002, Rushworth, A and Carlton, R. *Thirlwall Castle*. (Northumberland National Park Authority)

1866 and 1868-9, Tate, G. *The History of the Borough, Castle, and Barony of Alnwick*. 2 vols. (Alnwick)

1997, Tolan-Smith, C. *Landscape Archaeology in Tynedale*. (Newcastle University)

2004, Waddington, C. and Passmore, D. *Ancient Northumberland* (English Heritage)

1975, Warne, R. *Rocks and Scenery from Tyne to Tweed* (Newcastle)

Witherite (Natural Barium Carbonate) and Its Industrial Uses. (Doig Brothers, Newcastle).

1975, Wrathmell, S. *Deserted and shrunken villages in South Northumberland from the twelfth to twentieth centuries*. Unpublished PhD thesis, University of Cardiff.

INDEX

Bold indicates illustration.